Photocommunication Across Media

Photocommunication Across Media is a must-have for aspiring mass-media professionals who are striving to compete in the new landscape of convergence journalism and media. You will learn principles of photography—both still and video—and how to incorporate them into your storytelling. That's no longer a specialty skill—in today's world of media, it's a necessity.

Editors Ross F. Collins and Keith Greenwood collaborate with highly accomplished photographers to make the concepts and techniques of today's mass-media photography accessible to all readers. *Photocommunication Across Media* speaks directly to journalists, advertisers, and professional communicators who want to round out their toolkit without sifting through dense texts meant specifically for photographers and photojournalists. This guide, edited by experts who teach these concepts to the next generation of media professionals, is everything you need to know—and nothing you don't—to take the next step for your career in communication.

Ross F. Collins

rossfcollins.com/photography

Collins is a professor of communication at North Dakota State University (NDSU), Fargo, U.S.A., where he teaches photography, media history, writing, editing, publication design, and other media-related classes.

A former newspaper photojournalist and freelancer, his photography has been published in a wide variety of books, newspapers, and magazines, including *The New York Times* and *Best of Photography Annual*. He has also shown his work in national, regional, and local art shows and exhibits. Collins holds a Ph.D. from the University of Cambridge, U.K., and in the academic world has published five books and about two dozen scholarly monographs and articles. He is incoming president of the American Journalism Historians Association (AJHA).

Keith Greenwood

keithgreenwood.net

Greenwood is an associate professor in the Missouri School of Journalism at the University of Missouri, U.S.A. He teaches multimedia, photojournalism history, and graduate seminars in the role of photography in society and research methods.

His professional media career includes work at radio stations and as a freelance photographer, web and publication designer, and video editor. His research explores how people and topics are presented in news photographs, and how news organizations adopt technological innovations. He has published articles in *Visual Communication Quarterly*, the *International Communication Gazette*, *Journalism Studies*, and *Journalism Practice*. He holds an M.A. from Michigan State University (MSU) and a Ph.D. from the University of Missouri.

Photocommunication Across Media

Beginning Photography for Professionals in Mass Media

Edited by Ross F. Collins and Keith Greenwood

Routledge
Taylor & Francis Group

NEW YORK AND LONDON

First published 2018
by Routledge
711 Third Avenue, New York, NY 10017

and by Routledge
2 Park Square, Milton Park, Abingdon, Oxon OX14 4RN

Routledge is an imprint of the Taylor & Francis Group, an informa business

© 2018 Taylor & Francis

The right of Ross F. Collins and Keith Greenwood to be identified as the author of this part of the Work has been asserted by him/her in accordance with sections 77 and 78 of the Copyright, Designs and Patents Act of 1988

Library of Congress Cataloging in Publication Data
A catalog record for this book has been requested

ISBN: 978-1-138-12156-0 (hbk)
ISBN: 978-1-138-12155-3 (pbk)
ISBN: 978-1-315-64426-4 (ebk)

Typeset in Myriad
by Servis Filmsetting Ltd, Stockport, Cheshire

Printed and bound in Great Britain
by Bell and Bain Ltd, Glasgow

Contents

About the Contributors

Walter P. Calahan

walterpcalahan.com

Photography is Calahan's passion—whether it is for advertising, corporate annual reports or collateral publications, magazines, websites, or simply for the personal joy of viewing the world with a camera. His photographic career has taken him to many amazing places, including under the Atlantic Ocean aboard a U.S. Navy Trident submarine, down lava tube caves in Idaho, into surgical clinics for Afghan refugees in Peshawar, Pakistan, canoeing the Okefenokee Swamp of Georgia, and celebrating children learning to tap dance. Of the many magazines that have used his work are the *National Geographic*, *The New York Times Magazine*, *Boys' Life*, *Sports Illustrated*, *Time* and *Bon Appétit*. His clients include General Electric, Yamaha, American Express, and many others.

As an adjunct instructor, Calahan teaches both digital and film photography for Stevenson University and McDaniel College's art departments, insuring a love for photography in the next generation of image makers.

Calahan holds a B.A. in photojournalism from Syracuse University and an M.L.A. specializing in the creative process from McDaniel College.

Julie Jones

ou.edu/gaylord/people/faculty/julie-jones.html

Jones teaches at Gaylord College on the campus of the University of Oklahoma. Her courses range from multimedia and data journalism to photojournalism and video storytelling. She tries to be always on the cutting edge of technology and journalism. In 2012, she created one of the first mobile reporting classes in the country. In 2017, her documentary students produced short, episodic podcast video stories covering refugees in America.

Jones has teaching awards from the International Communication Association (ICA) and Kappa Theta Alpha. The National Press Photographers Association (NPPA) recognized her with the Joseph Costa Award, named for a founder and first president of the nearly 70-year-old NPPA. She is also national director for NPPA's annual News Video Workshop, held at the University of Oklahoma since 1960.

Jones holds a master's degree from the Walter Cronkite School of Journalism and Mass Communication at the University of Arizona, and a doctorate from the University of Minnesota, Twin Cities. Before earning her degree in Minnesota, she was an award-winning video journalist working in the southwest. She has 29 Rocky Mountain Emmy Awards, a National Edward R. Murrow Award along with numerous film festival, Associated Press, and NPPA awards for her enterprising news and documentary work during that time.

Denise McGill

denisemcgill.com

In her day job, McGill is an associate professor of visual communications at the University of South Carolina School of Journalism and Mass Communications. She teaches courses in photojournalism, visual literacy, digital media, and religion in the news. She also teaches seminars across the country.

Any time McGill can get away, she's working as a photographer, videographer, and writer. She's stood on five continents gathering images that document the human experience. Her work has featured in many publications, including *Christianity Today*, and has appeared on CNN. Her projects focus on migration and faith issues. More recently, she has created videos about sustainable agriculture in the United States. TheGullahProject.org is an ongoing multimedia documentary about the unique farming and fishing communities on the Sea Islands.

McGill earned her bachelor's degree in photojournalism at the University of Missouri, and her M.A. at Ohio University's School of Visual Communication.

Larry Mayer

larrymayer.com

A self-taught photographer, Mayer built a darkroom in his parents' basement as a teenager, and went to work for the *Enterprise* in Livingston, Montana, after high school. He has been with the *Billings* (MT) *Gazette* since 1977, and is currently chief photographer. His work has appeared in more than 20 coffee-table books as well as many magazines, including *National Geographic Traveler*, *The New York Times Magazine*, *Atlantic Monthly*, *Life*, *Stern*, *Time*, *Wilderness*, and *Cosmopolitan*.

Corporate clients include ConocoPhillips, ExxonMobil, Federal Express, Microsoft, Westinghouse, General Motors, and UPS. Mayer is a commercial pilot providing aerial photography for power, oil, and mining companies, as well as various government agencies.

Introduction: Photocommunication Today

Ross F. Collins and Keith Greenwood

The Changing Landscape of Photography for Mass Media

Digital media have threatened the autonomy of photojournalists, broken up the cultural control of legacy media, and thrust professional communicators into unexpected roles as makers of images. That's quite a broad statement, but in this case it seems no less than easily verifiable. The technical world of photography built on film, chemicals, and paper drove a profession that required years of training, and no inconsiderable expense. Photojournalists joined a craft based on a strong ethical commitment to objectivity, story-telling skill, and specialized knowledge of lighting, composition, and moment that stood behind a professionally produced image. Professional competence in the darkroom required not only knowledge of physics and chemistry, but also a high level of fine motor skills and the luck of immunity to dodgy powders and potions. The many years' work required to develop such knowledge effectively created an elite profession of high standards, expectations, and abilities.

Even if the sophisticated amateur could produce such images, he or she found few ways to reach a mass audience. Legacy media's gatekeepers seldom allowed amateurs to share the page alongside the professionals. The average camera Joe or Jill was expected to take pictures for family albums, with no further ambitions than recording family celebrations or snaps on holiday. Photography for the non-professional was defined as a way to unite families over an album of happy memories, or bore friends over a slide show of the summer vacation. The rest was left to the pros.

Figure 0.1 Lobby, British Library, London

Credit: Ross F. Collins

Professional photography's technical requirements also served to limit most other mass-media professionals from giving it a try—although not completely. Writers do know how to tell a story. Newspapers short on funds or photo staff always did on occasion thrust a camera into the hapless and usually unwilling fingers of a reporter. What a reporter managed to bring back often more displayed the writer's annoyance with an unwelcome added task than it did an interest in creating a usable image. With reason, as what writers clearly were not were photojournalists. The profession of photographer was secure.

Today, not only is that profession no longer so secure, but it is often morphing into a craft shared by all kinds of media practitioners and the public at large. Digital cameras in just a few years grew from bulky curiosities to visual recorders of astounding flexibility, quality, and ease of use. Then they got smaller, and better. Then smaller yet, and better yet. Then they became ubiquitous. One of the perhaps unexpected cultural consequences of the smartphone universe is the recognition that nearly everyone, everywhere now has a visual recorder. Smartphone quality may not reach that of a professional-level camera—yet. But no one is making presumptions.

Digitalization of the camera would not alone have shattered the old ways. Two other technical developments gave digital media currency. One was anticipated. The other mostly was not.

The computer's ability to manipulate the image in ways far beyond what was feasible in film days shifted power from the professional to the amateur.

Figure 0.2 The Audubon Aquarium of the Americas, New Orleans

Credit: Ross F. Collins

True, the snapshooter had to learn image-manipulation software, but that has grown so easy that with filters and auto corrections anyone can produce a photo that at least looks reasonably okay. Maybe even pretty darned good. And nowadays, who even needs a computer? Smartphones can manage a lot of photo fixes. The years of training required to learn film-based darkroom skills became obsolete nearly overnight, and paved the road for non-specialists to compete with professionals.

In the mid-2000s, some professionals who saw this development realized that mass-media students were going to need new kinds of training. It became clear that journalists were going to be expected to do more, as it was now possible for word-based storytellers to be visual storytellers as well. Legacy media, by now universally online, had also shifted beyond still photos to expectations that the pros would also be shooting video, whether they were trained for that or not. Some critics who thought they knew the coming journalistic landscape looked to higher education as the luddites holding students back. The educators moved too slowly. They were living in an obsolete world. They just didn't "get it."

But some of those who smugly thought that they could predict mass media's future didn't quite get it either. Few predicted the rise of social media, the third and perhaps most powerful new tool that not only forced professional photographers to rethink their autonomy but forced the entire legacy media industry to rethink their potency. Social media chopped up the watchdog role of professional journalism into a hodge-podge of endeavors one may or may not call journalism. They emanated from Twitter, Instagram, Facebook, Snapchat, or whatever new idea would come tomorrow. One idea a few years ago was that still photography should be dumped in favor of all video. It perhaps seemed reasonable—who would want to see static shots when video could stream via Wi-Fi to everyone? Well, that idea slammed against the immense power still retained in still photography as uploaded by the ubiquitous smartphone-wielding public. They used stills to make everyday documentaries of their lives from breakfast to bedtime. If photography was now essentially free, then why not take a selfie with your breakfast taco, or a snap of an interesting flower, an afternoon teacup, or the cat snoozing on the sofa?

Photojournalists used to say sometimes that the real stories in the world were not about the politicians and the ambulance chases. They were about the everyday dramas of plain folks living lives the media usually ignored. Well, they aren't ignored anymore. The plain folks themselves have risen to the task of chronicling their lives. The reach of social media has grown to become the unanticipated key development, along with the digital camera and digital editing software, that empowers everyday shooters to challenge professional gatekeepers. Facebook, Twitter, YouTube, Flickr, Huffington Report, AllVoices, Demotix, and even old-fashioned blogs enormously extend the reach of citizen journalists, to use that controversial term. Social media give the people power to visually chronicle their everyday lives for anyone who cares to follow. It's the way we share our pictures nowadays, and even a modest reach is a lot broader than the family album of a few years ago. Blogs or Twitter give plain folk a gatekeeper-free mass-media forum. True, the "mass" may be only a few in the hypercompetitive world of the internet, but average citizens can and do come out of nowhere to gather a huge audience. More industrious citizen journalists can contribute to sites that will display their work right next to the professionals'. Sometimes instead of the professionals.

So today photocommunicators need to understand why the new media landscape changes so much for so many of us. How can we as professionals contribute, and what will we be expected to contribute? What will we need to know? That is the aim of this textbook.

To begin with, it seems clear that definitions based on mass media of the past ought to be reconsidered. The textbook editors propose the term *photocommunication* instead of the word coined by Cliff Edom in the 1940s, photojournalism. The suggestion is not to slight the professionals who still know how to tell a story through photography in a way that most other

journalists can't. It is not to suggest that professional photographers who freelance for magazines or take pictures for corporate newsletters won't produce images with a practiced eye for composition and lighting, something crowdsourcing seldom can manage. The term is suggested instead to reflect a practical reality: the future for visual communication across media will depend not only on professionals, but also on professional mass-media practitioners who may not be visual specialists, but who will be expected to take pictures at a reasonably professional level.

Editors of this textbook recognize the strengths and weaknesses of today's visual images in the mass media coming from a variety of sources and try to place the media professional within this spectrum. For example, citizen journalists may produce images from a natural disaster or accident because they happen to be where the professional was not. The authenticity of these images relies on their production by those who actually experienced the event. But they also have drawbacks. Most random acts of photocommunication are almost by definition grainy, poorly lit, and poorly composed. Much of the time they were taken with smartphone cameras, and while professionals can actually produce reasonably good images with smartphones, most amateurs can't. Viewers will accept some focus and lighting faults in exchange for a certain gritty reality, but only for spot news. Beyond that, faults in quality can't be accepted as credible in professional mass media, be they hard news or public-relations sites.

Those who are already educated in techniques of mass media for a variety of publics understand the need to produce a product reaching a reasonable standard of quality. They also understand how to tell a compelling story to a larger public. Bringing those base skills into the area of visual communication does require some specialized training, and this textbook aims to address that. It also aims to consider the professional standards reflected not only in photojournalism, but in all areas of mass-media education. Mass-media practitioners try to be committed to a high standard of fairness and perhaps even the elusive model of objectivity. They know that in the digital world it is too easy to manipulate a photo in a way that lies or deceives. Deception is hard to detect. Photoshop can do pretty much anything. The only standard of credibility is the reputation of the journalist and the organization for which he or she works. This textbook maintains that in a world awash in amateur imagery, the one thing professional media practitioners still have, and must retain, is their integrity. Citizen journalism may come fast and first, but it is difficult to verify for truth and fairness. And research shows crowdsourcers too often care about neither.

Photocommunicators coming to the camera with a traditional set of journalism skills and values already understand verification and media law. They understand ethics and integrity. They know how to effectively tell a story. But they don't necessarily understand how to tell that story visually. That is a need this textbook is designed to fill. The book is not, to be sure, expected to train professional photographers. Photojournalists are still the

master storytellers in a visual world, with knowledge not easily mimicked by non-specialists in the media or by plain folk who happen to be in the right place. But acknowledging that tomorrow's visual stream will be produced by all sorts of camera people in addition to the pros, the editors of this book contend that at least those who are media professionals should know enough to do a decent job with the pictures.

What You'll Learn

This book covers a range of topics to achieve that goal, grouped into two sections: the first focuses on the skills and practices of creating good visual content followed by a more conceptual section regarding the usage of photographs and video and some historical background.

As we noted above, most random acts of photocommunication lack the characteristics that define good photographs. The skills and principles section begins with a chapter introducing rules for arranging the elements in a photograph, how different types of lenses affect the relationship of elements within a photograph, and how to use those characteristics to direct the viewer's attention where you want it. The chapter also will explore how to control motion in a photograph and creative ways to show motion for communicating vibrancy in a picture. The chapter focuses on still photographs, but many of the composition principles and characteristics of lenses will be useful for videography as well.

After introducing the basic principles, the book turns to using modern equipment to make photographs incorporating those principles. Communication professionals may encounter everything from the professional digital single-lens reflex camera (DSLR) to pocket-sized point-and-shoot digital cameras. They also may encounter hybrid/bridge cameras with characteristics of both DSLR and point-and-shoot cameras, and most people have a smartphone. All of these options are capable of capturing both still images and video, but they'll each have different characteristics and offer different levels of control. In addition, photographs and video require different types of settings on the camera. This chapter focuses on how to use each type of camera, overcoming limitations of more basic models to create high-quality visual photographs and video.

Photographs and video don't exist without light. Understanding how to use and control different types of light is a skill that separates knowledgeable photo communicators from most amateurs with a camera. This chapter explains the differences between natural and artificial sources of light, the different effects they have on pictures and how to manage them for both print and online use. The chapter also addresses controlling light within a photograph or video to highlight or diminish a specific element, adding light to the basic principles of photographic composition that can be applied to create effective photographs and video.

While video shares some composition qualities with still photography, it has its unique characteristics, too. Still photographs capture moments in time. Video captures sequences of time. To be an effective photo communicator in today's world, you need to understand the difference and the ways in which capturing video is different from capturing still photographs. This chapter focuses on the basic principles for videography, including different types of shots commonly used in video and using them to build sequences that tell stories. This chapter also addresses controlling motion within the video frame and when the camera itself should or should not move. Effectively using these principles of videography should make the process of editing video go more smoothly.

Once photographs, video, and audio are captured, they have to be edited for use. Still photographs need adjustments for color and exposure and may need to be adjusted to a specific size or cropped to reduce the area shown in the image. Video files also may need some adjustment for color and exposure, and audio quality may need to be improved, before shots are edited together to create sequences that tell stories. This chapter introduces use of software to edit still and video files. The chapter introduces different software options and how to determine what is the right level of complexity for the work you'll be doing. While it will introduce how to accomplish some tasks in specific software, we know that editing software is constantly evolving. Commands and tools change as new versions of software are released. In light of that, the chapter focuses on the main principles of editing that can be adapted to your choice of a specific software package.

After the chapters devoted to creating visual content, the second section of the book turns to more conceptual ideas about how to use it. Traditional media outlets remain valuable for photocommunication, but internet channels and social media play an increasingly important role each year. Social media have created demands for photocommunication that are distinct from those of more traditional media channels. Twitter, Instagram, Snapchat, and all the products that will follow them introduce new considerations for photo and video selection and editing. They each have their strengths, weaknesses, and roles to play in the social media environment. This chapter introduces some of the main considerations to be mindful of before photographs and video are even planned, to better ensure that what is captured will meet the needs for its use. It also incorporates discussion of using social media channels for functions like crowdsourcing content and for funding projects. The chapter concludes by exploring the concept of the Creative Commons and how it impacts use of photographs and videos, both the ones you create and use of material created by others.

Awareness of the philosophy and current status of laws and ethics is crucial for photocommunicators, and is the focus of the next chapter in this section. Copyright laws set limits on the use of creative materials like photographs and video. Other legal concepts like privacy can also affect use of a photograph

or video but also impact creation of the work in the first place. Laws define public spaces where photography and videography are permitted by default from private spaces where permission must be granted. And in the post-9/11 world, even some photography in public spaces is restricted. This chapter further outlines the photocommunicator's rights for recording police and other officials in public as well as the ethical guidelines that dictate whether someone *should* make a photograph or video even though the law says he or she *can*.

The second section of the book concludes with an overview of the development of photography from a fine art requiring skill and means to what it is today—a medium for the masses. In addition to teaching the skills of photography and videography, both of this book's editors teach journalism history. We know that you can't truly understand where you're going in this field if you don't have an understanding of its evolution.

Figure 0.3 Florence, Italy

Credit: Keith Greenwood

These chapters outline the perspectives of experienced educators and professional image makers with respect to the best techniques for making photographs and video. But you don't have to just take their word for it. This book also incorporates the experiences of several experienced communication photographers. The "My Story" interviews relate the real-life experiences of working professionals, providing the opportunity to connect the skills and concepts you're learning in the various chapters with their real-life application.

Each chapter of the book also is followed by discussion questions and project ideas so you can think more deeply about how the content connects to your goals as a photocommunicator and how you can get started putting your new skills into practice.

Basic Photographic Principles for Communication Photographers

Keith Greenwood

Still photograph or video. Professional digital camera or camera phone. Regardless of the format or device used, a photographer's goal is to create a visual message that will most effectively communicate with a viewer. Compared to camera phones, professional and high-end consumer equipment provide the photographer with many more options for controlling the look of a photograph, but regardless of the equipment there are some basic photographic practices that will result in photographs that are more pleasing to look at and that communicate ideas well. This chapter starts with guidelines for arranging elements within the picture that can be applied when using just about any type of camera. Following that the chapter will introduce principles for controlling exposure, areas of focus, and the appearance of motion. Those more advanced principles are most effectively applied using a camera that allows the user to have more control over the camera settings and options for lenses.

Most of these principles apply to both still photography and video. For simplicity, the term "photograph" will cover both forms unless otherwise indicated.

Composition

Composition refers to the arrangement of the different elements within a photograph. Just as writers give careful attention to the facts and ideas to include and the arrangement of sentences and paragraphs in their work, photographers think about what will be shown within the borders of the image and how the content is arranged. Photographers are visual authors.

Rather than simply pointing the camera at something and clicking, the best photographers learn how to apply visual principles to focus attention on important elements of the photograph. These techniques help the photographer guide the viewer through an image similar to the way authors guide readers through a story and can be used with any type of camera.

Sometimes just focusing on one of these "rules of thumb" is enough to make an interesting photograph. Other times photographers apply many of them within the same photograph. And yes, sometimes photographers ignore these principles. They are guidelines more than rules, and as you improve as a photographer you'll develop instincts for the composition of your photographs that may contradict some of these guidelines. But it's important when starting out to understand the basics and how to apply them. Let's start by considering where to place the main subject within a photograph.

Figure 1.1 Photographs combine lighting and composition to attract interest and guide the viewer's eye.

Credit: Keith Greenwood

Fill the Frame

The subject is the main point of a photograph. The subject might be one or more people, or the area around people might also be important to the message communicated in the image. The important elements of the photograph should take up most of the frame of the image. Beginning photographers often hesitate to get too close to a subject, with the result that the subject is too far away to be the obvious emphasis of the photograph. Getting too close can be uncomfortable for the subject and the viewer, but

Figure 1.2 Beginning photographers often hesitate to get close to their subjects. If this photograph were taken from farther away, the details that are the focus of the photograph would get lost. Fill the frame with the important elements.

Credit: T. J. Thomson

don't hesitate to get close enough, if possible, so that the important elements of the photograph fill the frame of the image.

Positioning the Subject in the Frame

It's tempting to put the main subject of a photograph right in the center of the frame facing the camera head on, but that approach does not create the most visual interest. Placing the main point of interest in the middle of the frame often creates a static image with little need for the viewer's eye to move to any other part of the frame. In contrast, moving the main point of interest out of the center of the image creates visual movement and a more visually interesting photograph. The main emphasis or subject of the photograph can be moved up or down in the frame and off to one side or the other.

In addition to where the subject is positioned within the frame, it's important to consider where the subject is looking or moving. A general rule is to position the subject to one side of the frame and turned toward the other side. The subject will appear to be looking or moving into the empty area of the frame instead of looking or moving out of it. An easy example is a photograph of someone running through the frame. If the person is running from right to left, he or she should be positioned in the right side of the frame so there is more room in front of the runner than there is behind. The guideline applies with subjects standing still, too. If a person is standing in the left part of the frame, her body can be turned slightly and her head pointed toward the right side of the frame. In this way the subject looks or moves into the frame instead of out of it. Moving the subject can be a simple technique to apply, but if the subject isn't going to be in the center of the frame where should it be? There are guidelines to help determine the most pleasing location for elements within the borders of the photograph.

"Rule of Thirds"

While moving the subject out of the center of the frame is a good start, it still leaves a lot of room for deciding just where to locate it. How far off center should the subject be? What part of the subject is most important to pay attention to? A simple answer comes from the "rule of thirds."

To use the rule of thirds, imagine the camera frame is divided into thirds both horizontally and vertically. The imaginary lines divide the image into nine squares, like a tic-tac-toe game. To apply the rule of thirds, place the main subject along one of the lines. For instance, when the photograph contains a horizon or other sharply horizontal feature, like the edge of a table, tilt the camera up or down to place the horizontal line on one of the upper or lower imaginary third lines rather than across the center of the frame. Likewise, with a vertical subject like a person standing, shift the camera left or right to align the person with one of the vertical third lines. The strongest visual interest in the frame is where the vertical and horizontal lines intersect, making those four spots ideal points for placing important elements. For instance, positioning a person in the frame so his or her eyes are located at one of the upper intersections will naturally draw the viewer's eye to the subject's eyes.

Remember to consider direction when positioning a subject along one of the third lines. If the main subject is moving, place it along the third line that allows for movement to continue through the frame. The same principle applies if a subject is looking or turned slightly away from the camera. The subject should have room to look into the frame instead of looking directly out of it. If the subject is looking to the right in the picture, most of the time the person should be located on the left vertical third line.

Many smartphones make the rule of thirds easy to apply in the standard camera app by including a setting to show gridlines when using the camera.

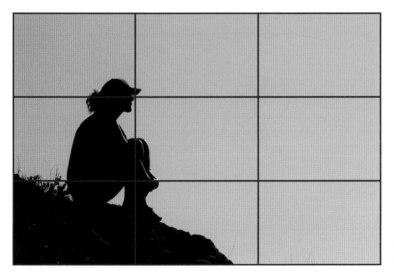

Figure 1.3 Placing important elements on the photograph along and at intersections of the third lines helps achieve a pleasing composition.

Credit: T. J. Thomson

With gridlines on, the horizontal and vertical third lines will be visible on the camera screen, making it easy to line up subjects along the lines or at the intersections. Some third-party smartphone apps for photography also include options to display a grid on the screen to help with composing using the rule of thirds.

Sometimes placing a subject along a third line is simply a matter of tilting the camera up or down or from side to side. Sometimes, however, the photographer has to change position to get one or more subjects in the ideal location in the frame. Two people talking to each other might not easily fit on to the third lines if the photographer is at a 90-degree angle to them. Moving to the left or right and repositioning the camera will change each subject's apparent position within the frame. The viewer will be looking slightly over the shoulder of one of the subjects and will see the other one from more of a head-on angle.

It's important to note that the placement of objects along the third lines does not have to be mathematically exact, and not every important element in a photograph has to line up exactly on a third line. For instance, an interesting photograph can be made with one area of interest along a third line and another area of interest near, but not exactly on, one of the intersections. The rule of thirds may not be the best composition technique for every photograph, but it's a simple and easy to apply technique to improve composition of an image.

"Golden Ratio"

An alternative to the rule of thirds is to align elements of a photograph using another technique called the "golden ratio," which moves the main point of interest a little closer to the center of the frame than the rule of thirds indicates.

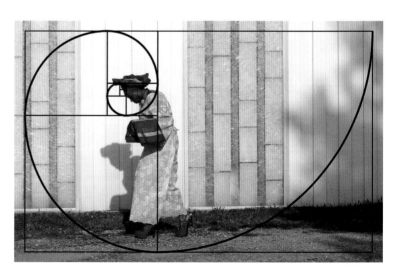

Figure 1.4 Like the rule of thirds, the golden ratio is a technique for determining the most effective location of elements within a photograph.

Credit: T. J. Thomson

The golden ratio is a visually appealing arrangement that can be observed in nature, such as the arrangement of seeds in a sunflower and the shell of a snail. It has been applied in architecture and several works of art, including the proportions of Mona Lisa's face. To understand the golden ratio, you have to understand the math behind it. The golden ratio is achieved when two unequal numbers have the same proportion to each other that the larger number has to both numbers added together. Mathematically, that works out to a value of 1.618 (like pi has a value of 3.14). As an example, a rectangle has this ratio when the ratio of the two sides is the same as the ratio of the long side to the length of both sides added together. The golden ratio also can be applied to a spiral that gets wider as it unwinds, much like the snail's shell.

The rule of thirds has been called a simplified version of the golden ratio, and there does appear to be a relationship. The golden ratio can be applied as a grid of horizontal and vertical lines known as a phi graph. The phi graph is similar to the rule of thirds, but the lines are closer to the center. The middle "third," both vertically and horizontally, is actually narrower than the side thirds, which are equal to each other. As with the rule of thirds, the intersections of the lines in the phi graph are the points of greatest visual interest.

When the golden ratio is applied as a spiral, the spiral starts near one of the intersections of lines in the phi graph. As the spiral unwinds it touches the grid lines before continuing to unwind toward the closest corner of the frame. It touches the shorter edge of the frame before curving to touch the long side and then curving on to the corner on the other long edge of the frame.

Options to display a phi graph or golden spiral in a camera or in the native smartphone camera app are limited, though there are third-party smartphone apps that can be downloaded to aid in using the golden ratio in composition. Some photo-editing software packages include overlays of phi graphs and the golden spiral to aid in cropping images.

The right location for the main subject within a photograph gives it more visual interest and appeal to the viewer, and guidelines like the rule of thirds and golden ratio help the photographer find the right location for the main subject in the frame. Some additional composition techniques can be effective at guiding the viewer's eye to that location.

Framing

Every photograph has a frame. It's what the photographer sees in the viewfinder or on the screen when deciding what to include in the picture. The edges of the image define the frame. But a photographer can also incorporate other elements within the photograph to act as another frame, guiding the viewer's eye toward the main subject and away from distractions. The technique is called framing.

Figure 1.5 Incorporating a frame, such as a doorway, within a photograph is a means to guide the viewer's attention to the focus of the picture.

Credit: Keith Greenwood

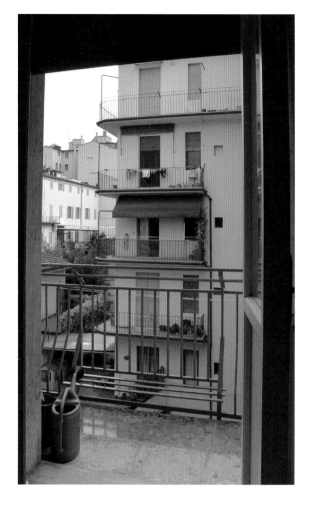

Sometimes a photographer can incorporate a literal frame within a photograph, like a doorway or window. By making a photograph from outside a room and showing the doorway in the image the photographer can use the frame of the door to direct the viewer's attention to the main subject of the picture. Using a frame also can be a useful technique when there are elements within a room that might be distracting in a photograph. The frame of the door can be used to block them out while emphasizing the subject of the picture. At the same time, incorporating the door frame into the picture can be a way to add information. A photograph of someone working in a room that is made by a photographer positioned outside the room can incorporate a nameplate outside the door that might identify the occupant of an office or the purpose of a specific room (like an exam room in a medical office).

The interior of a home or office setting also may provide windows between rooms that can be used as frames. A professional office, for example, may

have an entryway separated from the rest of the office space by a wall. Visitors interact with a receptionist through a window. In a home, a counter and cabinets might separate a kitchen from an eating area. Those windows can act as frames to direct attention to the main subject in the photograph and, in the case of a professional setting, may be another opportunity to include signage that identifies the person or place being shown in the photograph. Windows can literally act as frames, too, narrowing the field of view when looking out or providing a look into another space from outside. Incorporating both the outside and inside in the same photograph can be a way to communicate contrasts, such as a person working in a lighted office when it's obviously dark outside or someone reading by a warm fire when it's snowing.

Frames in photographs do not have to be literal frames. Any element that can direct the viewer's eye to the subject while limiting distractions in another area of the photograph can act as a frame. In landscapes, for example, there is often a horizon line and sky, which can be a big empty space drawing the viewer's eye away from the main subject of the picture. A photographer might instead look for a position where the image can incorporate a tree branch extending into the picture, acting as a frame to fill the empty sky and focus attention toward the intended subject of the picture. A tree trunk and a tree branch could form a partial frame along one side and across the top of a photograph. Many things can act as a frame in a photograph: plants, buildings, machinery, even other people. Photographing a speaker from behind members of the audience provides an opportunity to use those people as a way to frame the speaker in a photograph. Once you start looking, you will see plenty of framing opportunities.

Leading Lines

Lines can be used as part of composition to direct a viewer's attention through a photograph. Either real or implied, lines help the viewer's eye move between different elements or subjects in the picture.

Real lines are things that are visible in the frame of the photograph. Some are physical, such as when a photographer stands on a sidewalk and positions the subject further down the sidewalk. The sidewalk becomes a line that draws the viewer to the main subject. Roads and their edges, walkways, bridges, and fences are physical structures that can be used as leading lines. Other structures that repeat could also form a line. A set of benches lining a walkway could be used as a line to lead the viewer's eye into the photograph to a subject sitting alone on a bench farther away from the photographer. Parking meters, traffic cones, or steps could all be used as leading lines.

Real lines are not limited to physical structures, however. Shadows can be used to create leading lines, as can the gestures of the people in the photograph. Someone literally pointing to or holding the main point of interest of the photograph can create a leading line in the composition.

Figure 1.6 A path bordered by trees works as a leading line to draw the viewer's eye to the focus of the photograph. The canopy of the trees also acts as a frame.

Credit: Keith Greenwood

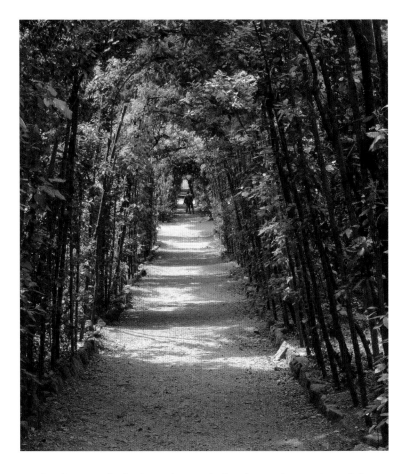

Leading lines can be horizontal or vertical and can take a variety of shapes within a photograph. Some lines are straight, such as roadways, buildings, or parts of a structure like a bridge. They take the viewer directly to the main point. Other lines can be curved, like a sidewalk, stream, or line of people. The curved path can take the viewer through different parts of a photograph and can also imply a more calming feel compared to the straight line.

In addition to real, visible lines, other leading lines are implied or suggested in the arrangement of a photograph. The human eye tries to find order in nature. The photographer can take advantage of this characteristic by selecting a point of view where items that seem to be placed randomly can actually form an implied line. The viewer might be drawn to a lighter rock in the foreground, and then to a flower beyond that before finding a pile of leaves in the background. Even though the items aren't in a straight line or even the same type of items, the viewer's eye will create a path between the objects.

Other lines can be implied through the direction someone is looking within an image. A person's head may be physically turned in that direction, or it may appear that the subject is looking sideways at another person or item,

trying to steal a glance without being noticed. The viewer's eye will follow that glance, leading to the item of the subject's attention. The line doesn't have to be obviously communicated in the photograph. Even a slight shift of a head or body can suggest a line of sight in the image. The earlier discussion of placing the subject within the frame and the direction of movement relates to the creation of implied lines within the photograph.

Layers

Many times, the most effective photograph involves a focus on one main subject with few distractions in the rest of the frame. For many beginning photographers it's a challenge to just get that photograph, as they focus on the subject and overlook the rest of the frame.

Sometimes, however, photographs become more engaging when there are interesting elements in the foreground, middle, and background of the picture. Each layer can add something new to the overall image. The subjects of the individual areas should be distinct, however, and should add to the overall message in the photograph. A photograph of a crowd of people typically does not have a distinct foreground, middle, and background. A

Figure 1.7 Layers add areas of interest to a photograph. The cars in the foreground lead to the bridges in the middle distance while the city skyline fills the background.

Credit: T. J. Thomson

photograph at a carnival might have a couple in the foreground, another couple in the middle at a game booth, and then a Ferris wheel in the background. The three layers add distinct parts to the overall message, and their arrangement within the frame could even represent implied leading lines to guide the viewer through the image.

Move the Subject Closer to the Camera

A photograph almost always focuses on a person, but there are times when the person's relationship with something else is an important part of the image, too. Think about photographs people take with their first cars. The subject often stands next to the car, and the photographer stands far enough back to get the whole car in the frame. The same practice is often apparent in vacation pictures, such as where the subject stands at the rim of the Grand Canyon and the photographer stands far enough back to get the scale of the canyon in the picture. In both these cases, the subject is far away from the camera. Instead of being the focal point of the photograph, the person gets lost in the rest of the picture.

In many instances there is no reason the people in the image have to be as far away as the other main point of the picture (especially when that other main point is large and needs to be farther away to fit in the frame). Instead, bring people closer to the camera, allowing the viewer to get a better look at the person featured in the image as well as see the context of the photograph (new car, Grand Canyon). This technique works in news and feature situations. Business owners are often photographed behind the counter or in the middle of the factory floor. By bringing the subject closer to the camera the viewer can make a better connection with the person while also seeing the important context. This is often referred to as an environmental portrait as the subject is posed for a portrait but in a setting that reflects some key aspect of the message in the photograph. It's similar to the idea behind layering in an image.

Camera Angle

In addition to where the subject is positioned, photographs can be made more interesting by varying where the photographer is positioned. Photographs made at the photographer's eye level when standing up communicate a perspective that would be familiar to most viewers, but changing the vertical position of the camera allows photographers to present a different view in the image.

Sometimes changing the height of the camera reflects the view of the subject of the image. Young children are shorter than adults. By dropping down to one knee the photographer puts the camera on the same eye level as the subject, communicating what the scene looks like from the child's perspective. The same is true for photographing a person who might be

sitting on the ground while doing some sort of work. Lowering the camera to the subject's eye level gives the viewer the same perspective.

Going further, the photographer can drop down even lower and photograph from near ground level. The "worm's eye" view presents a unique view and allows the photographer to focus on a feature that might otherwise go unnoticed. Few people consider what water looks like as it flows into a storm drain at street level, as opposed to our usual view looking down from above. A distinctive feature of a marching band is that it moves, yet few people see the band at foot level. A ground-level view is also good for showing the heat shimmer coming off pavement on a hot day. (Just don't set up in the middle of the street to get the picture!) Photographs from this perspective have been used to communicate something novel about the scene. Often these photographs can also make creative use of leading lines or frames as part of the composition.

A low camera height does not mean that the camera has to be aimed horizontally. A photographer might use a low camera height to look up at a subject. The low angle can raise the implied status of the subject, making the person or object appear larger than life. A low angle is also a way to take advantage of natural elevations, such as having subjects pose along an open set of stairs or looking down over a balcony.

High camera angles also provide opportunities for interesting photographs. A photograph made at normal eye level of people with umbrellas on a rainy day emphasizes the people but probably doesn't show the viewer much that is new. By moving up to a higher floor and photographing out a window, the photograph becomes about colors and patterns of umbrellas and communicates a perspective that is different from the one that viewers normally see. Patterns that are not apparent from ground level become obvious and interesting when viewed from above.

High angles can also be useful for showing both a subject and an object of her or his attention. For example, a photograph of an artist drawing on a flat surface won't show the artwork if the camera is focused on the artist at eye level. By raising the camera, the photograph can show both the artist and the artwork. Similarly, the higher camera angle can show more of the subject's

Figure 1.8 Changing camera angles gives a different perspective on a subject compared to the standard eye-level photograph.

Credit: T. J. Thomson

surroundings. Remember the earlier example of bringing the factory owner closer to the camera instead of being out in the middle of the floor? Combining the subject's closer location with a higher camera angle allows the user to see more of the environment as well as the factory owner.

High angles can also be useful for group photographs. At eye level, a group of people has to be arranged from side to side and front to back so that all the subjects can be seen. If the photograph is made from a high angle, such as a balcony or in a stairwell, all the faces can be at the same level and the subjects can stand closer together. It's a perspective that is different from the group photography most viewers will be familiar with.

However, photographers should take some care when photographing from high angles. The higher camera perspective puts the subject of the image at a lower level, symbolically diminishing the subject's power or status in relation to the viewer. If the subject is already at a disadvantage, the higher camera angle can magnify the subject's lack of power.

Interaction/Non-Interaction

Interest can be created in photographs by showing moments of interaction between subjects or highlighting the lack of interaction. Two people working in an office could be photographed neutrally, each with his or her attention on their own work. But the photograph becomes more interesting if it shows interaction between the two subjects. When they are talking, looking at the same object, or one gestures to the other there is an interaction. The viewer can be drawn into the interaction. In a similar vein, the apparent lack of interaction can communicate, too. Imagine two people sitting on a bench in a park. They have to be in somewhat close proximity because park benches aren't all that big. They could talk with each other, and the photograph could show the interaction, but they also could be photographed looking in opposite directions (or each just wrapped up in their smartphones). That photograph communicates a different idea, that even when people are physically close to each other they can be isolated.

Mergers

Rather than a technique to apply, these are elements to avoid in a photograph. Mergers refer to objects that interfere with the subject of the photograph. Wires, posts, or tree branches that appear to grow out of a person's head or body are examples of mergers. They are easy to miss because the photographer's attention is on the subject of the image rather than looking beyond the subject to other parts of the frame. As you become more experienced, you'll notice potential mergers more readily as you compose photographs. Mergers can often be avoided by changing the camera's position. Moving to the left or right or using a higher or lower camera angle will change the position of the subject and background object.

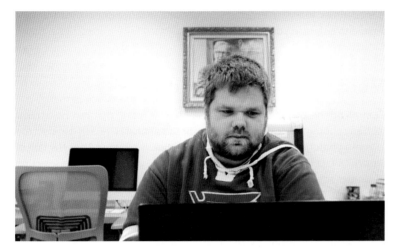

Figure 1.9 Take time to look at the background behind a subject to avoid unwanted objects interfering with the focus of the photograph.

Credit: T. J. Thomson

Depending on location, another object can be used as a frame to block a potential background merger, too.

A Word about Zooming

Many cameras and smartphones are equipped with the capability to "zoom in" on a subject. Zooming can be done optically by changing the arrangement of the glass elements of a lens. Zoom lenses will list the range of available focal lengths, such as 35mm to 70mm. By manipulating the lens length, the photographer using this lens can change from a wider view (35mm) to a more zoomed in/telephoto view (70mm).

Zooming can also be accomplished digitally by magnifying the content captured by part of the camera's sensor. Instead of changing the length of the lens, the camera's software enlarges the image, only capturing part of the entire scene viewed by the lens. The pixels in the digital image will appear larger in the zoomed image, and any digital "noise" in the picture is magnified as well.

Some cameras have the ability to zoom both optically and digitally. The camera zooms optically first, with the digital zoom taking over when the camera reaches the limits of the lens. Smartphones typically have fixed lenses and can only zoom digitally. When possible, use optical zoom instead of digital zoom. Optical zoom produces better results because the image coming through the lens is magnified on to the entire sensor. However, the changed focal length of the lens will have some effect on the arrangement of different elements in the photograph. A more thorough explanation of lens focal length comes later in this chapter.

As an alternative to using optical or digital zoom, a photographer can simply move closer to (or farther from) the subject to fill the frame and place the elements in a pleasing composition. This "zooming with your feet," as it

is sometimes called, is especially useful with smartphones since they are limited to only using digital zoom.

More Advanced Techniques

Controlling the composition of a photograph is a skill that can be applied with any photographic device, but there are additional factors that impact the look of a photograph. The image has to be properly exposed. The selection of lens will affect the appearance of elements in the photograph. The selection of shutter speed will determine whether objects that are moving will be in sharp focus. Some smartphone apps will give the user some degree of control over where the camera focuses or the exposure of the image, but for the most part the amount of control a photographer has over these factors is limited when using a smartphone. This part of the chapter is more applicable to cameras, but keep in mind that as photography apps evolve the smartphone user may have more control over these techniques, too.

Exposure

Exposure refers to the amount of light that strikes the sensor of a digital camera (or the film if you're going old school). A properly exposed photograph will have a range of tones from light to dark and visible details throughout the tonal ranges. An underexposed photograph occurs when not enough light is captured. The image will be dark, and subjects may look sort of transparent. An overexposed photograph occurs when too much light is captured. It will be very bright, and details may be hard to see. A photograph's exposure is controlled by three elements: sensitivity to light, lens opening, and shutter speed. All three also have an impact on the look of a photograph.

Sensitivity

Sensitivity refers to how much light is required to properly expose a photograph and is designated by a number called the ISO rating. Cameras have a control to set the ISO rating, which adjusts the camera's light meter so it will indicate when a proper exposure can be made. Higher ISO numbers indicate a higher sensitivity to light. Photographs made outside on a bright sunny day might use a lower ISO rating, while photographs made indoors might require a higher ISO rating.

In film photography each roll of film has a specific ISO rating, such as 100, 200, 400, 800, and so on. If conditions change that would require different sensitivity to light, such as moving from outside to inside to photograph, a film photographer would need to remove the roll of film from the camera and load it with a new roll that was more sensitive to light and then change

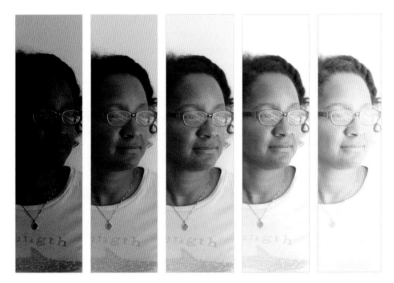

Figure 1.10 Underexposed photographs appear too dark (left), while overexposed photographs are washed out (right).

Credit: T. J. Thomson

the camera setting to match the rating of the new film. If the ISO rating were not changed, the light meter would not accurately reflect whether the image would be properly exposed.

In digital cameras the software inside the camera adjusts how the camera sensor gathers light rather than having to change to a different sensor (like changing to a different type of film). Digital cameras can have a wider range of ISO numbers. They have settings like 100, 200, 400, and so on that reflect the heritage of film, but they also can incorporate "in-between" ISO numbers like 160 or 240. This flexibility allows a photographer using a digital camera to change ISO ratings at will as conditions change or as the photographer wants to achieve a different effect.

The sensitivity rating is related to the clarity and resolution of the image. Film with a lower ISO rating uses smaller light-sensitive silver crystals than film with a higher rating. Photographs printed from film with a very high ISO rating looked "grainy." In some cases the viewer could sort of see the crystals, compared to photographs made from film with a low ISO rating that looked much sharper. There is a similar effect with digital cameras. Photographs made at a low ISO rating will look sharp, but photographs made at a higher ISO rating may appear to be less sharp. The edges of objects may be fuzzy, or the subject may appear to be made of individual points rather than a solid surface. This digital counterpart to grain is referred to as digital noise. Photographs made in low light with high ISO typically exhibit more noise compared to photographs made with adequate lighting and lower ISO settings.

This is a trade-off the photographer must consider when making images. A higher ISO setting will allow photographs to be properly exposed in lower light situations, but the photographs contain a lot of digital noise or grain. If the goal is to create images with sharper resolution, the photographer

has to add light to the scene somehow to work at a lower ISO setting. On the other hand, a photographer may wish to use a high ISO rating even in situations with plenty of light to achieve a creative effect from digital noise. Journalistic images generally benefit from the best resolution possible, so it's recommended that you work at the lowest ISO setting the light and other conditions will allow to still make a proper exposure.

Lenses

Lenses have great impact on the look of a photograph. The lens affects exposure because the lens opening controls how much light will pass through to the film or camera sensor in a set amount of time. The lens opening also has an effect on how much of the photograph is sharply focused. The focal length of a lens determines how close or far from the subject the photographer can be and also affects visual relationships between different elements within a photograph. These three areas will all be discussed in this section.

Exposure

Camera lenses are built with an overlapping set of blades inside that can be manipulated to create larger or smaller openings, known as apertures. A smaller aperture lets in much less light during the same fraction of a second than a larger aperture does. On a bright sunny day when a lot of light is available, a photographer may be able to use a smaller aperture to properly expose the image. Inside with less light available, the photographer may need a much larger aperture to let enough light into the camera to properly expose the photograph. The specific size of the aperture required to properly expose the photograph depends on the ISO setting of the camera and the length of time light is allowed to strike the film or sensor.

Lens openings in still photography are referred to as f-stops. The f-stop number is actually the bottom part of a fraction comparing the size of the aperture and the focal length of the lens. Since it's the bottom of a fraction, smaller numbers indicate larger apertures. The "standard" f-stop range is 2, 2.8, 4, 5.6, 8, 11, 16, and 22, with 2 indicating the largest aperture and 22 indicating the smallest. The f-stops are calibrated so that each "stop" lets in either half as much light as the next bigger aperture or twice as much light as the next smaller aperture. For instance, f/8 lets in twice as much light in the same time as f/11 but only half as much light as f/5.6.

Depth of Field

The selected lens opening affects more than how much light strikes the camera sensor or film. Aperture also controls a characteristic of the photograph called "depth of field."

Depth of field refers to how much of the photograph, from foreground to background, is in sharp focus. The amount of light available has a big impact on the apertures that can be used to properly expose a photograph, but photographers also choose an aperture to creatively focus the viewer's attention by controlling the elements of the photograph that are in focus.

A photograph that has only a small area between the foreground and background in sharp focus is said to have shallow depth of field. A large aperture such as f/2 or f/4 creates shallow depth of field. Photographers often incorporate shallow depth of field in portraits, where distinct items in the background would distract the viewer's attention from the subject of the portrait. By using a large aperture, the photographer can make the subject's face in sharp focus. Anything behind the subject, and possibly between the subject and the camera, will be out of focus and less distracting. The degree to which the background will be out of focus depends on the size of the aperture and how far away the objects are. The farther away the background object is, the less in focus it will be.

Sometimes, though, a photographer wants all the parts of the photograph to be in sharp focus. Photographs that have all the content in sharp focus are said to have a great depth of field, which is created by a small aperture like f/11 or f/16. Outdoor landscape photographs often are sharp from the foreground all the way through the background. A photographer may want all the people in a room to be equally in focus. Remember the example of the

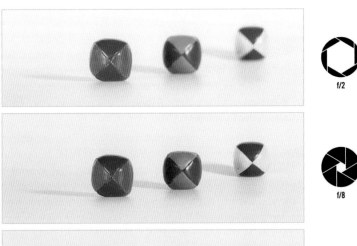

Figure 1.11 A change in the lens aperture will create a difference in the area of the photograph that is in sharp focus. Small apertures create greater depth of field.

Credit: T. J. Thomson

factory owner out on the workshop floor? The photographer may want all the equipment to be in focus as well as the owner and might choose a smaller aperture to achieve the effect, if enough light is available to properly expose the photograph at the selected ISO.

Focal Length

In addition to the aperture, the choice of lens affects depth of field in a photograph. Lenses are named by their focal length, which is the distance between the point where the light rays converge inside the lens and the film or sensor in the camera. The distance usually is measured in millimeters. Lenses with smaller numbers, such as 28mm, have a short focal length. They typically capture a wider field of view and are known as wide-angle lenses. A visual characteristic of wide-angle lenses is that they increase apparent distances between foreground and background and create greater depth of field.

Lenses with long focal lengths, such as 85mm or higher, are known as telephoto lenses. They have a narrower field of view as they appear to bring the subject of focus closer to the camera. A characteristic of these lenses is that they tend to compress the apparent distance between subject and background and create shallower depth of field in the photograph.

Distance

The distance between the camera and the subject also plays a role in determining depth of field. The available depth of field is a ratio, with one-third of the area of sharp focus coming in front of the focal point and the remaining two-thirds behind the focal point. As the camera is moved closer to the subject, the available range of distance that could be in sharp focus decreases as well. Depth of field diminishes. Conversely, as the camera moves away from the subject the potential range that can be in sharp focus increases, and so does depth of field.

That ratio of sharp-focus area also means that the distance between objects in a photograph can be manipulated to control depth of field. Since more of the area behind the subject will be in sharp focus than that in front of the subject, objects behind the subject may be in focus and distracting. For example, let's say you want to make a portrait and put the subject in front of a large bush for a background. If the subject is standing right in front of the bush, it may be in the sharp-focus area. The definition of the leaves could distract the viewer from the subject of the portrait. But if you move the camera and subject out away from the bush, it's less likely to be in sharp focus. The bush becomes a background that won't distract the viewer from focusing on the subject of the picture.

You should be starting to see how photographers choose combinations of lens, aperture, and distance to achieve a desired depth of field in a

Sidebar 1.1: What Is Wide Angle? Telephoto?

The designation of whether a lens is wide angle or telephoto depends on the size of the film or sensor in the camera. A "normal" lens would be one that approximates what the human eye would see. In a 35mm camera, that is typically a 50mm lens. A lens with a shorter focal length, such as 28mm, would be wide angle, and a lens with a longer focal length, such as 105mm, would be telephoto.

The designations change as the film or sensor size increases or decreases. For medium-format cameras that have larger image areas, the "normal" lens is typically longer than 50mm, meaning that on these cameras a 50mm lens would be considered a wide-angle lens.

Digital cameras often have sensors that are smaller than the area of a 35mm negative. The "normal" lens for those cameras would be shorter than 50mm. For instance, on a camera with a smaller sensor a 35mm lens might provide the view that most closely represents the human eye. On those cameras a 17mm lens might be wide angle, while the 50mm lens would be a short telephoto.

Consult your camera's manual and experiment to determine the focal length that would be considered "normal" for your camera. Then you can easily determine what is a wide-angle or telephoto lens.

photograph. To make a portrait of a friend with shallow depth of field, a photographer might pick a lens with a long focal length, stand close to the subject, and use a large aperture. To make a photograph with maximum depth of field, a photographer might choose a wide-angle lens, increase the distance to the subject and use a small aperture. There is one caution to using a wide-angle lens, especially in portraiture. The wide-angle lens "sees" a wider field of view then the human eye does, bending the content into the area of the film or sensor. This bending can cause distortion in a photograph. When the object is farther away the distortion is less apparent, but using a wide-angle lens to make a portrait close-up can distort the subject. For a real-world example, look at how a person looks through the peephole of a door. It may be a neat artistic effect, but it's not typically a desirable effect in photography for mass communication.

Shutter Speed

Along with the amount of light coming through the aperture, a photograph also is affected by how long the light strikes the film or sensor. The shutter speed determines the length of time lights enters the camera, and it also has an aesthetic effect as the selection of shutter speed determines whether motion will be frozen in the photograph.

Shutter speeds are most often measured in fractions of a second. Like f-stops, shutter speeds are often referred to simply by the bottom number of the fraction. For instance, a shutter speed of 125 actually means 1/125 of a second. Similar to f-stops, successive shutter speeds either double or cut in half the time light enters the camera. A change in shutter speed is equal to a change in lens opening and is also sometimes referred to as a "stop."

Starting at a full second and moving toward shorter times, a "standard" range of shutter speeds might include: 1, 1/2, 1/4, 1/8, 1/16, 1/30, 1/60, 1/125, 1/250, 1/500, 1/1000, 1/2000, and so on. Modern digital cameras can make a photograph in even smaller fractions of seconds, and they also can use shutter speeds in between the standard ones such as 1/160 or 1/45.

Cameras can make longer exposures as well. A camera may have programmed shutter speeds of 2 or 4 seconds, and many also will have a shutter speed simply marked "B," which stands for bulb. The B setting is not related to a pre-set time. Instead, the camera shutter will be open as long as the photographer presses down on the shutter button or holds a remote that keeps the shutter open. The B setting is useful for long-exposure photography like pictures of the sky at night.

Controlling Motion

Like apertures, shutter speed has an impact on the look of a photograph. Instead of depth of field, the shutter speed controls the appearance of motion in a photograph.

When a subject is standing still, as in a portrait, there is little motion that happens during the exposure time of the photograph. But when the subject is moving, a lot can happen in front of the camera. Shorter exposure times freeze the motion by providing a smaller window of time for motion to occur when the photograph is made. The length of time needed to freeze motion depends on the type of motion and where it occurs in relation to the camera.

Very fast motion requires fast shutter speeds. A sprinter running on a track, a pitcher sending the ball to the plate or a race car all move very quickly. Fast motion is not limited to sports though. A drummer's sticks, a chef's knife, or leaves on a windy day also can move quickly. A fast shutter speed is required to freeze the motion. During a fast exposure, less motion will occur during the time the shutter is open and light strikes the film or camera sensor. If the shutter speed is too slow, more movement will occur and the subject will be blurred in the photograph. It might take a shutter speed of 1/500 or faster to stop motion in instances where motion is occurring quickly.

Slower motion, on the other hand, can be stopped with a slower shutter speed. The motion of a person walking or a duck floating on a running stream can most likely be frozen at a shutter speed of 1/125 or even 1/60. When in doubt, select a higher shutter speed to increase your chances of freezing motion in the photograph.

The ability to stop motion in a photograph is a function of how much the position of the subject changes during the exposure. How fast the motion occurs is one aspect to consider, but the direction of the motion relative to the camera and the distance from the camera also are factors to consider.

If the motion occurs from side to side or top to bottom in the frame, the subject's position potentially changes greatly during the exposure. On the other hand, if the motion is toward or away from the camera, the subject largely stays in the same location in the frame. Here's an example: a person riding a bicycle across the frame could move quite a bit during the exposure time. A shutter speed of 1/125 or higher might be needed to freeze the motion, depending on how fast the person is going. But if the photographer stands in front of the bicycle rider, the subject doesn't change location relative to the camera as much in the same period of time. Instead of moving across the frame, the subject simply would appear to get bigger. This action might be frozen at a slower shutter speed like 1/60.

Similarly, motion that is occurring farther away from the camera crosses a much smaller area of the total frame that the camera sees during the exposure and can be captured with a slower shutter speed. That bicycle might cover a lot of the camera frame if the photographer is standing right next to the street where it's being ridden, and motion will occur across a large part of the frame. But if the bicycle is crossing an intersection a block away, it's a smaller part of the overall image and the motion occurs across a much smaller part of the frame. Most of the time in communication photography the subject should be close to the camera, but understanding the impact of

distance on stopping motion in a photograph is helpful when a fast shutter speed cannot be selected.

There are times when a photographer might not want to freeze the action in a photograph. Opting to show motion as a blur in a photograph is a creative technique for highlighting the speed of a subject. Showing motion as a blur is as simple as selecting a slower shutter speed than would be necessary to stop motion. The slower the shutter speed, the more the action will be blurred in the photograph. If a tennis player is photographed serving the ball with a slow shutter speed, such as 1/60, the player's arm and racket, along with the ball, will be blurred while the background will be in sharp focus. The technique could be used to emphasize the speed of a player's serve.

Motion in front of the camera is not the only type of motion a photographer needs to be concerned with. Photographers also should take care not to move the camera as they hold it when an exposure is being made or else the entire image will be blurred. A shutter speed fast enough to stop action occurring in front of the camera also should be fast enough to stop any motion from slight movements of the camera. Generally speaking, shutter speeds of 1/60 and faster will be sufficient to stop motion that might occur when holding a camera. A good rule of thumb is that the minimum shutter speed for hand holding a camera is equal to the focal length of the lens. A photographer using a 50mm lens should use a shutter speed of 1/50 or faster when holding the camera by hand. A photographer using a 200mm lens should use a minimum shutter speed of 1/200 or faster.

Whatever the lens, shutter speeds of 1/30 or slower generally require additional support to avoid camera motion while the photograph is being made. The best option at slower shutter speeds is to use a tripod. If a tripod is not available or can't be used for some reason, some other means to anchor

Figure 1.12 The apparent motion of objects in a photograph can be controlled by the selection of shutter speed. A faster shutter speed will freeze action, showing the drops of water suspended on the left. Slower shutter speeds will show motion as a blur, as with the water on the right.

Credit: T. J. Thomson

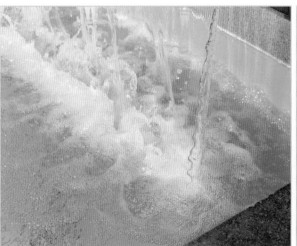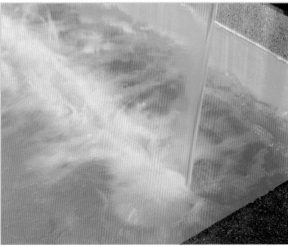

Sidebar 1.2: Stabilized Lenses

A technological evolution in lens design has been the addition of electronics to control inadvertent lens movement. These "stabilized lenses" go by a variety of names, but the common feature is that they reduce the potential that photographs will be blurred at slower shutter speeds.

The stabilization allows the photographer to gain two or three shutter speeds for hand holding the camera. Using the rule of thumb that the minimum shutter speed would be equal to the focal length of the lens, a photographer using a 200mm lens would be limited to a standard shutter speed of 1/250 before using a tripod or some other sort of support. However, if the lens has image stabilization, the photographer might hold the camera at a shutter speed as low as 1/60 or maybe 1/30 without affecting the sharpness of the photograph.

An important point to note is that image-stabilized lenses only reduce apparent motion from the camera on a stationary subject. They will not freeze the motion of a moving subject.

Image-stabilization lenses can be used on both still and video cameras. When using the camera on a tripod for a video interview, it's generally best to turn off the image stabilization to avoid potential electronic interference with the audio and to conserve battery life.

the camera should be found. Options include setting the camera on a sturdy surface or holding it against a door frame, tree, or similar object.

There are times, however, when a photographer might purposely move the camera while making a photograph to creatively show a sense of speed. The technique is called "panning." Just like the earlier explanation, a slow shutter speed is necessary to show the motion. When panning, the photographer attempts to turn with the camera to follow the movement of the subject. To accomplish this, the photographer holds the camera tightly, keeping the elbows tight against the body. The photographer sets his or her feet and turns at the waist toward the direction the subject will come from. As the subject moves, the photographer twists at the waist to follow the motion, attempting to keep the subject in the same part of the frame. At about the time that the subject is directly in front of the photographer the shutter button is pressed to make the exposure while the photographer continues to turn and track the subject. If executed well, some parts of the subject will be in focus while the background of the image will be blurry. The result gives the impression of speed, but the subject is more recognizable to the viewer compared to the earlier example when the camera did not move.

PASM

You may have seen these letters on a dial on a camera. They designate camera settings that provide more or less control to the photographer.

The P designation means program, which is equivalent to putting the camera in automatic mode. When P is selected, the camera's sensors will evaluate the scene and select an aperture and shutter speed that will create a properly exposed photograph at the selected ISO. On some cameras a range of ISO options can be designated, giving the camera's software greater flexibility in suggesting a combination of settings. Using the program designation does not mean that the photographer should not pay attention to the suggested exposure settings. The photographer usually can use the camera controls to change aperture or shutter speed to achieve a desired effect. The camera will change the other settings to compensate.

The A setting refers to aperture. When A is selected, the camera gives priority to a selected aperture and selects a shutter speed and/or ISO that will create a proper exposure. If a photographer wants to ensure a certain depth of field, using the A designation will lock in the desired aperture.

The S setting refers to shutter. When S is selected, the photographer can select a specific shutter speed that will remain constant. The camera then will select the aperture and/or ISO that will result in a properly exposed photograph. This setting is useful when a photographer wants to select a specific shutter speed for controlling motion.

The M setting refers to manual. In this setting the photographer has complete control over selecting the camera settings. The ISO is often set first, with the

photographer using aperture and shutter speed to control the exposure. In manual mode, the photographer must refer to the display in the camera's viewfinder or liquid crystal display (LCD) screen that indicates when the selected settings will create a properly exposed image.

Putting it Together

As mentioned earlier in the chapter, sensitivity (ISO), aperture, and shutter speed all work together to properly expose a photograph. A change in one is offset by a change in another one (or both) to keep the exposure consistent. For instance, suppose a photographer is making a portrait and the camera is set to f/8 at a shutter speed of 1/60 and ISO 400. But the photographer realizes that f/2 would be a better aperture for a portrait because it would create shallower depth of field. The change in aperture is equal to four stops more light coming into the camera (from 8 to 5.6, 4, 2.8, and then 2). To keep the exposure consistent, an equivalent four stops of light must be reduced. This could be achieved by increasing the shutter speed to 1/1000 (from 60 to 125, 250, 500, and then 1000), or by decreasing the ISO to a less sensitive 32 (the standard "stops" would be from 400 to 200, 100, 64, and then 32). Or the photographer could compensate by decreasing the sensitivity just two stops to 100 and increasing the shutter speed the remaining two stops to 250.

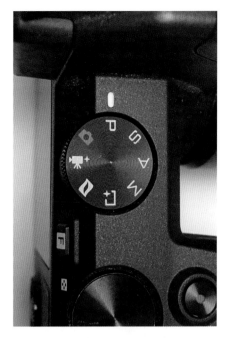

Figure 1.13 Your camera may have a control dial similar to this one. The selection determines how much or how little the photographer has to control to make a proper exposure.

Credit: Keith Greenwood

Here's another example. A photographer is attempting to freeze the action of a football game. The camera is set to f/8 with a shutter speed of 1/60 at ISO 200, but the photographer knows that that shutter speed won't freeze motion. The photographer decides to increase the shutter speed to 1/500, a change of three stops less light entering the camera. To offset the change, the photographer would either open up the aperture three stops to f/2.8, increase the sensitivity to ISO 1600, or use a combination of the two options.

Photography is an active process. Whether using a smartphone or a camera, photographers make decisions that determine what's included in the photograph and how it communicates to a viewer. These techniques and guidelines are tools to be applied as appropriate. As you become more experienced with photography, many of them will become second nature. Sometimes the techniques are easy to implement, and sometimes compromises must be made, such as when a subject can't be placed exactly on an intersection of lines using the rule of thirds, or a high camera angle may not be possible. The available light might limit choices of aperture, shutter speed, or ISO, all of which affect the photograph.

For now, smartphones have some limitations compared to cameras. They don't offer the same exposure controls, and lenses limit the ability to zoom with clarity. Smartphones and apps are catching up, but no matter what the device it's the person using it that has the biggest impact on the photograph.

Figure 1.14 Framing, leading lines, layers, and light all come together to make an interesting photograph.

Credit: T. J. Thomson

What Do You Think?

1. Photographers use different lens apertures to control how much of the photograph is in sharp focus, called depth of field. When might a photographer want to achieve a shallow depth of field? When might a photographer want great depth of field in a photograph?

2. Most composition techniques can be applied to photography with a smartphone or a camera, and multiple techniques can be applied in the same photograph. Can you think of instances when attempting to apply too many techniques would be detrimental?

3. Using a high or low camera angle can be an effective way to present a new perspective on a scene. They also can be useful for eliminating unwanted elements in a photograph. Can you think of reasons why using a unique camera angle could be misleading?

What Can You Do?

With your camera or smartphone, look for opportunities to experiment with different composition tools:

1. Try framing a subject through a door and then moving past the door and photographing the same subject without the frame. Does the photograph without the frame have the same impact?

2. Make a portrait of a friend centered in the frame. Then make another portrait using the rule of thirds with your subject looking slightly away from the camera into the empty area of the frame. Which looks more interesting?

3. Find a situation where you could photograph a scene from different camera angles. Make a photograph from eye level. Then look for ways to photograph from low and high angles. Which ones look more interesting?

 You'll need a camera with the ability to control aperture and shutter for these two:

4. Using the optical zoom (not digital) or using different lenses, photograph the same scene at different focal lengths. Notice the change in depth of field.

5. Photograph a friend riding a bicycle or using a swing. Experiment with different shutter speeds to make a photograph from the side and from the front. Which ones do a better job freezing the motion? Can you freeze motion from the front with a slower shutter speed?

CHAPTER 2

Using Today's Equipment

DSLRs, Hybrid/Bridge Cameras, Snapshot Cameras, and Smartphones

Walter P. Calahan

Introduction

The digital revolution has changed photography forever. Not only can we view our images immediately after making them, but we can share them around the world through a telecommunication revolution called the internet. What once took a large learning curve of chemistry, optical physics, and artistic prowess is now contained in a tiny computer chip engineered by people who have researched the needs of photographers. Anyone can purchase a smartphone and start sharing the camera results within minutes of hitting the on button. All you have to do is tap the screen and follow the prompts. It is that easy.

Of course, that doesn't mean that your image is any good. Or that it fits your needs as a professional communicator to be interesting to someone else. But the high level of technology built into today's gear has lowered the level of chance to the point that making a decent image is within reach of everyone.

So are we going to tell you that all you need as a professional communicator is a smartphone and Wi-Fi? Depends. To begin with, we need to remember this: there has never been a camera that can do it all, at least not so far. Smartphones are not designed to transport your audience from the sidelines and into the middle of the action on a football field. Large studio cameras used for high-end advertising work can't be put into a small shoulder bag for street photography. We need to know what's available, and what we intend to photograph, so we select the correct camera to fill our need. And that's what we'll take a look at in this chapter, from the most simple to the more complex.

But before we jump into the gadgeteer's world, a word of advice from Ansel Adams. One of the world's premier 20th-century landscape photographers working in the U.S. West, Adams specialized in dramatic black-and-white photographs of nature. "You don't make a photograph just with a camera," Adams said. "You bring to the act of photography all the pictures you have seen, the books you have read, the music you have heard, the people you have loved."

To pick up a camera and use it well we must bring to the process our entire self as a human being. The digital revolution is an exciting time for those shooters who choose wisely.

Figure 2.1 Digital photography has put a camera into the reach of everybody, everywhere.

Credit: Walter P. Calahan

The Paralyzing Choice

We have so many camera choices that it can almost paralyze one's thinking. But with common sense, and a little help from this chapter, we can begin

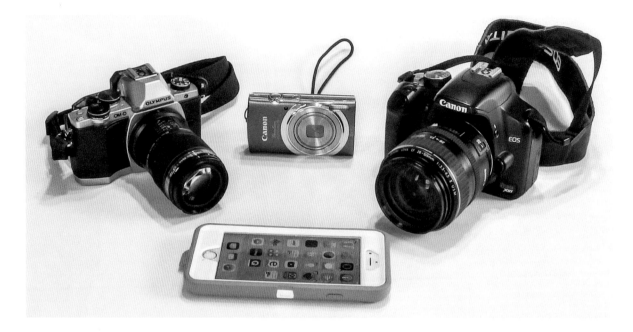

Figure 2.2 Today's camera choices include point-and-shoot, mirrorless, DSLR, and the ubiquitous smartphone.

Credit: Ross F. Collins

by asking ourselves one question: what type of photography do we wish to pursue?

If architectural photography is your game, it will drive your gear choice toward an extremely expensive solution of large-format bellows-style camera encasing a large digital sensor that functions when tethered to a laptop computer. On the other hand, when commissioned to make a *Vanity Fair* cover photo, famed celebrity photographer Annie Leibovitz works with a (also expensive) medium-format style camera that contains an image sensor considerably larger than the best cameras used by a *Sports Illustrated* photographer. But at home with her children, Leibovitz would reach for something different: a much simpler "point-and-shoot" style camera for family snapshots. As a communication photography student, you face the same dilemma. It comes down to what you're planning to shoot and, of course, how much money you have to pay for the equipment. And one old adage is still true—"What is the best camera? The one you have with you at the time you need it."

So we have to face it: the camera we own will impose limits. It will also alter your view of reality. Henri Cartier-Bresson, the 20th-century French photographer often called the father of modern photojournalism, said: "To photograph is to position the head, eye, and heart in one place." But he could not have made most of his great images if the small 35mm Leica film camera he favored had not been invented. The very machine he brought to his eye shaped Cartier-Bresson's masterful street photography and portraiture. His Leica imposed limits, but only in how it was used. In the 1950s Cartier-Bresson sold one of his Leicas to the American fashion photographer William

Klein. Klein went on to make a body of work that was completely different from Cartier-Bresson's. Klein's gritty street images looked nothing like Henri Cartier-Bresson photos. Yet both were made with the same machine.

At that time of the last century, it seemed like photographers had quite a few cameras to choose from. We know now in the digital age that their choices were comparatively few. And the rapid change in digital camera and lens technology will probably only speed up as engineers innovate newer hardware and software solutions to meet photographers' needs. It is true, of course, that photography has always been driven by technology. In the days of film we would always seek out improvements. But, for a while, the camera choice of most professionals or serious camera bugs pretty much stayed the same. Sure, we saw incremental changes in the speed of motor drives, automatic exposure, or focus functions. But you could use a 1960s era Nikon F body with the newest Nikon lens and low ISO transparency film, and match the image quality of a Nikon film camera manufactured in the early 2000s. In the world of film-based photography a camera was simply a tight box that kept the light out until you opened the shutter.

Not so with digital. In digital the camera body *is* our film. We cannot swap out image sensors as they advance in size and quality. So we must be realistic in choice of cameras and their sensors. Do you need a machine with a sensor size capable of making billboard displays if you are shooting for newspaper or Web reproduction? Do you need a camera that can capture Hollywood-grade video when you are shooting for a podcast? As much as we all want the latest and greatest, remember, the more functions a camera has, the more it can get in your way—and the faster it can empty your savings account. So with that in mind, let's take a closer look at the myriad choices so we can make more intelligent decisions.

To begin with, we are presuming you are not going to become an architectural photographer, and you are not going to need the kind of medium-format digital gear that Leibovitz uses for magazine covers. The typical solution, then, is to go with digital single-lens reflex (DSLR) technology. DSLR is the direct descendant of film-based single-lens reflex cameras that were introduced by William F. Folmer in 1898 with the Graflex Reflex. The advantage of all reflex camera bodies is that you are looking through the lens that will make the image. The major (but relatively minor) disadvantage is that you do not see the moment the image is captured because the mirror that reflects the image into the viewfinder needs to flip up and out of the way. This blocks the viewfinder while the image is recorded. Do we really care? Not usually.

Nikon was first to revolutionize how we view our investment in a camera by designing an entire "system" around it. A system-style camera offers a wide variety of plug-and-play gear that modifies the camera in a way that makes the system larger than the sum of its parts. And key ingredient for communicators today is Wi-Fi. Don't invest in a camera that cannot link to an internet-capable device, such as a laptop, tablet, or cell phone.

Figure 2.3 DSLR mirror assembly. The mirror flips up when the shutter is pressed.

Credit: Ross F. Collins

That's the gold standard for photojournalists and others who communicate to a mass audience using photography. We cover it in more detail below. But first, here's the question more and more advanced amateurs, and even professionals, are asking: do we need it, really?

Cell Phones and Tablets

We know these new devices (well, not so new anymore) can take pretty good pictures. And if you are a holdout with your ancient flip phone, time to upgrade. It might be retro-cool, but the number one tool you'll need for starting your more serious photographic communication is a smartphone. It doesn't matter if it is an Apple iOS- or a Google Android-equipped device. A good smartphone is the link to the outside world of social media that most journalists and many others in the industry need to reach. It is within the world of social media that they build an audience. Time no longer waits for the visual journalist; we need to report instantly. The exciting part of that is, for a professional or even accidental photojournalist, this opens a huge window to record the visual world. When Captain "Sully" Sullenberger and First Officer Jeffrey Skiles landed their US Airways Flight Airbus A320-214 from LaGuardia Airport in the Hudson River on January 15, 2009, it was one of the first news events recorded by cell phones and security cameras, transmitted all over the world within minutes. What was the best camera on that day? The one that people had with them.

Many photographers seem to think only two smartphones exist: the Apple iPhone and everything else. But that's not because the iPhone camera is necessarily the best. The dominance of the iPhone comes from Apple's market penetration. And, yes, there are better phone cameras, particularly (in 2017) the Samsung Galaxy line of phones using the Google Android operating system (OS). Why? Because the newest Android OS can shoot Camera RAW format using third-party camera apps.

What is Camera RAW? To understand that is a first step away from snapshot photography, and a first step toward making an informed camera choice for mass communication photography. "RAW" files are so named because they are not yet processed. They contain almost all the data captured by the image sensor. But they are not ready for editing or viewing until they are "processed," to borrow an old darkroom term, by a digital editor. (We expect Apple will soon offer RAW format on its smartphones.) RAW files are written to a memory card using proprietary software, so the file extension varies.

The most common alternative to RAW is JPEG, always indicated by a .jpg file extension. JPEG means Joint Photographic Experts Group, a group that set the standard for this format in 1992 and amended it in 2012. JPEG is a photographic recording method that compresses a file so that it requires less space on a memory chip or hard drive. It does that by throwing away some data. While the photo may look nearly as good, to a photographer this means that fixing errors of exposure and white balance are harder, if not impossible to achieve, because the image files no longer have all the data to correct. Most advanced photographers nowadays shoot RAW, as memory cards have gotten bigger and devices can process the files without need to download. RAW format images retain the highest standards of image capture for postproduction editing, but a downside of RAW files is that you must process them after shooting. JPEG files are pretty much ready to use moments after they are created.

Smartphone cameras are adding more and more postproduction features, including exposure adjustment and high dynamic range (HDR) for higher quality. They also allow you to change your focus placement within the scene by tapping on the phone's or tablet's screen in the exact place you want in focus. To simulate the controls of more advanced camera systems, professional photographers can find third-party camera and editing apps. These are getting better and better, and there's no reason not to expect that they will not soon include many more features now only available on DSLRs. Some cameras don't require the third-party add-ons, however, giving photographers right-out-of-the-box control over the sensor's sensitivity to light (ISO), exposure and white balance adjustment, along with panoramic, HDR, and low-light controls. These controls can give you photographs that are more acceptable when uploading to professional media websites and social media or when submitting for publication. (For more detailed treatment of postproduction, see Chapter 4.)

What about megapixels? Generally, the more the higher the quality (along with sensor size). Many smartphones are shooting in the 16mp range, a reasonable size for professional use. That said, with properly edited JPEG files captured with an 8mp cell-phone camera, I have produced beautiful prints up to 24 x 36-inch in size. But probably 8mp smartphones will become obsolete as technology leaps forward.

Photographers hotly debate the issue of screen size, smartphone, or tablet. A larger screen makes the photographer less stable, and the resulting images more likely to be fuzzy. And if you decide to use a tablet, the larger the screen the more likely you'll have to hold it with two hands. That makes it tough to press the shutter-release button. If you like the mini-tablets you gain the larger screen size and retro feel of the old 4 x 5 sheet film camera, but you can still use one hand to hold it like a phone—if you can do that and maintain stability. Some of us overestimate our ability to remain steady, and underestimate the damage of camera shake. A point worth remembering if you choose to shoot with tablets: manufacturers generally do not install their best cameras in tablets, reserving them for their smartphone models.

The fun of "smart" technology is found in the wide variety of apps for shooting and editing. We can digitally reproduce the look of a 19th-century daguerreotype or a Civil War era wet-plate collodion image, without all the nasty chemicals. Maybe you want to try sequential images, as Eadweard Muybridge did in 1878 to prove that a race horse left the ground with all four hoofs tucked under its body. If you want the look and feel of instant Polaroid images, you can do that on your phone. More seriously, the makers of editing apps are listening to professional photographers by bringing to these devices many of the same tools we use in digital editing software such as Photoshop and Lightroom.

So is your smartphone the way to go for all your photocommunication needs? Maybe not. The number one drawback to all cell-phone and tablet cameras is the digital zoom. The lens on most phones and tablets is set at a fixed wide angle. When you zoom you are not doing it optically, but instead cropping the image size to simulate a zoom, known as a "digital zoom" from point-and-shoot camera technology. The phone's zoom feature will magnify the pixels of an already tiny image sensor. So how to use a digital zoom? Answer: don't. The only quality solution with our phones and tablets is to zoom with our feet. That is, walk closer. In many ways our phones are encouraging us to work as photographers with their restrictive equipment worked in the past. The modern conveniences of super telephoto lenses and razor sharp zooms have made us lazy. Like Henri Cartier-Bresson using his Leica, we must move our smartphone cameras to frame the photo. We must become intimate with the scene.

As well, you may note we said that smartphones are equipped with tiny image sensors. This limits the quality of your photo to the extent that it often is not adequate for print or some Web applications. Sharpness falls off quickly as the image is enlarged. Depth of field control is limited (see discussion on lighting).

Quality is mediocre, and while you can improve that in post-processing, you usually won't be able to pull miracles from a smartphone snapshot. Most serious photographers working for professional mass media rely on higher-quality cameras for day-to-day work, and probably you will, too.

A final consideration regarding cell phones is the carrier. To use your phone successfully for sharing your photographs to the internet via social media, you need a good 4G connection. Choose the best cell-phone provider for your area that gives consistent broadband coverage. If you are a traveling, you want a carrier that can travel with you, particularly overseas if you work internationally. Your smartphone is your gateway to the internet, and to your audience. If you can't get online, you are sunk.

The Digital Single-Lens Reflex (DSLR)

Photojournalists traditionally recognized only two major players in the single-lens reflex (SLR) market: Canon and Nikon. Other major manufacturers, notably Olympus and Pentax, did acquire a share of the pro market, but then, as today, they have not seen the market penetration of the two big names in what has now become the D (digital) SLR. Photojournalists nowadays seem to agree that today's less familiar brands—Sony, Pentax, and Sigma (Olympus has moved to exclusively mirrorless—do have high-quality equipment, but do not have the same market penetration. Think about what could happen if your gear breaks while on deadline, or you are traveling to a distant location but will need a specialty lens. The advantage of investing in Nikon or Canon is the confidence of knowing that equipment and repair is available just about anywhere. You'll be able to rent or borrow gear because Canon and

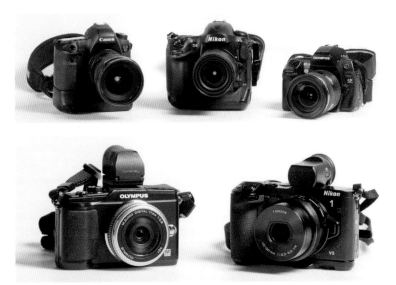

Figure 2.4.1 and 2.4.2 While Canon and Nikon have been for decades the major players in pro-level SLR cameras, today several other companies supply excellent equipment for serious photographers. Lighter mirrorless cameras, left, dominated by the Olympus brand, have become more and more common among serious photographers.

Credit: T. J. Thomson

Nikon are ubiquitous. The choices in the world of today's DSLR are brilliantly engineered, but only Canon and Nikon provide a full assortment of body styles from which to choose and a deep well of lenses and accessories. So if your goal, for example, is to be a sports photojournalist, you will probably want at least one of their top models for the most robust capture rate and auto-focus.

But the rest of us need to think twice about that. Are we getting this expensive camera body to "look cool" or to do a job? Remember, the entry-level choices from Canon, Nikon, and others today are superior to the very best professional digital cameras of only a decade ago. Any of these will serve many of us at a level that matches our needs and abilities. So long as the body has Wi-Fi you are in business. As an example, Nikon's D3300 entry-level camera has a Wi-Fi adaptor to connect this camera to any smartphone or tablet. The Canon EOS Rebel T6i camera comes with built-in Near Field Communication (NFC) Wi-Fi connectivity. Both cost hundreds of dollars less than the pro models, maybe thousands less. And you'll usually get a basic "kit" lens thrown in. Pros who buy mid-range or higher DSLRs expect to buy lenses separately.

As mentioned above, a main advantage of the DSLR is that you are looking through the very lens that will project the image on the sensor. This liberates the photographer from guessing how the lens is shaping the image, and will give the eye the precise view of how the photograph is framed. Top-of-the-line DSLR viewfinders always give the photographer a 100 percent accurate frame of reference. This is not always true in DSLRs at a lower price point. The "prosumer" camera bodies that many professionals actually often use will usually render the viewfinder to about 98 percent accuracy. This means you might have surprises at the edge of your images when you view them on a computer screen. But does that matter for most of us? Since most images need a little cropping anyway in post-production to improve the composition, being 98 percent accurate is probably good enough. You will pay for 100 percent accuracy. Instead, we recommend that a beginning photographer invest in lenses, and not the top-of-the-line camera body.

Another major advantage that separates Nikon and Canon from competitors is the wide choice of lenses and other equipment in the system. No one expects to own every lens, but having a wide choice allows us to grow into a system of lenses that match our shooting needs, as well as being able on occasion to rent specialty lenses. Lenses shape the social distance between the subject and the viewer of your image. The more choices we have in composing the image the wider variety of photographic challenges we can solve.

Regarding lenses, we are now living in a new era of quality zoom technology. At a time before computer-engineered optics most professional photographers used only fixed focal length lenses. Zooms were handy, but compromised image quality, and so were mostly marketed for the cost-savings and convenience of the amateur. Not true today. Yes, in every pro's

camera bag you'll probably find two prime (fixed focal length) lenses: a short telephoto such as an 85mm, and a 28mm or 24mm wide angle. (Full-frame equivalent. See discussion on sensor sizes.) If this fits your needs, look for fixed focal length primes with maximum apertures of f/1.8 or f/1.4.

But for the rest of us who won't be full-time professionals, what should you choose? Ideally, you can rely on three workhorse zoom lenses: wide angle, 14–24mm; midrange, 24–80mm; and finally the ever-popular 70–200mm. If your wallet can afford it, it is best to purchase fast fixed-aperture zooms such at the f/2.8, but they are pricey. Maybe you don't need those fast zoom lenses that you might have required a few years ago. Today's sensors with low digital noise let you shoot with a higher ISO number (more sensitive to low light),

Figure 2.5 More sophisticated cameras offer the possibility of selecting from a large collection of both prime and zoom lenses that advanced photographers need for special purposes.

Credit: Ross F. Collins

with less quality loss. The less expensive variable aperture zooms are smaller and lighter, and so are actually seeing their way into the camera bags of some professionals.

This suggests that most beginners can save money by purchasing the slower variable aperture f/3.5-5.6 zooms, instead of the faster f/2.8 fixed aperture zooms. Before investing in a lot of glass, learn to zoom with your feet to make sure you are putting your camera in the correct location for framing the subject. Robert Capa, the great World War II photojournalist who stormed ashore during the first hours of D-Day, said, "If your pictures aren't good enough, you're not close enough." (Warning: don't take good advice to extremes. Capa died while covering war in 1954. Trying to get closer, he stepped on a landmine.)

Even slower DSLR lenses cost hundreds of dollars. If you are planning to invest in DSLR technology for photo work, but don't expect it to be your entire job, can you get by with just one zoom lens? Perhaps. Most non-professionals doing mass-media work will need a moderate wide angle to a moderate telephoto. A lens of about 18mm to 135mm (such as the f/3.5-5.6 by Canon), or 18mm to 200mm (same f/stop range) by Nikon, offer a little bit of everything. Still too much for the savings account? Begin with a low-end DSLR and the "kit" lens, usually 18–55mm. Sometimes a camera dealer will even throw in a second lens for free.

A disadvantage of the DSLR comes down to complexity and weight. The more robust a camera is, the heavier it becomes to house the batteries and electronics that make the technology possible. DSLR lenses are heavier than mirrorless, and a lot heavier than built-in lenses of point-and-shoots and smartphones. Ask yourself: are you planning to go pro? If so, do you really need to work eight hours a day, five days a week with the most tricked-out Canon or Nikon, knowing that most of the time you just hope to blend unnoticed into the daily flow of your community? There is a reason Cartier-Bresson, or Helen Levitt, an American street photographer from the 1950s, used the small Leica—because no one noticed them. Levitt and Bresson with their little Leicas did not appear to be a "professional." Being unobtrusive today probably means using a hybrid, point-and-shoot, or, honestly, a smartphone. That is why so many photojournalists are attracted to the smaller Canon and Nikon cameras. Most of us don't need to shoot 10 frames per second, as *Sports Illustrated* and ESPN photographers do regularly. Most of us don't need those huge, fast telephoto lenses. Sure, if your subject is about speed, then you need a camera that matches. If your subject is far away in low light, you need a lens that accommodates that. The rest of us just need to make that one great frame.

With less weight and complexity you will be able to work faster, with less intrusion, and for a longer period of time. Do you want to hold a six-pound camera and lens to your eye while waiting for the "decisive moment." You'll probably have greater success with something lighter and quieter? This is why the mirrorless or "hybrid" technology is becoming more popular.

We can't, however, discount another possibility: that you *do* want to hang a DSLR around your neck, because it makes you look more professional. The public-relations writer who needs to take pictures of a subject does need to be taken seriously. Does her smartphone ooze competence? But a Canon or Nikon might.

The other consideration regarding choice of DSLR (and comparisons to other styles of camera) is sensor size. Photographers today compare DSLR sensors to what was familiar when they were first introduced: the 35mm film. Sensor size of the first DSLRs was much smaller than a 35mm piece of film. This drove many professionals crazy because they had hardwired their brain for choosing lenses in 35mm film format. The image produced by a lens of a particular focal length is related to size of film or sensor. (See discussion of focal lengths in the lighting chapter.) So a smaller chip size meant that none of the 35mm film-based focal lengths they had grown accustomed to made sense anymore. The 50mm formally "normal" lens became a short telephoto, and the 28mm wide angle became "normal." The smaller chip size was called "digital format" or DX. A few generations of sensors later, engineers could design a chip matching the old 35mm film format. This was called a "full frame" (FX) camera. Photographers nicknamed anything smaller "crop sensors."

The irony is this: all cameras are "full frame." When photojournalists were smoking cigars and wearing fedoras, their huge 4 x 5-inch sheet film was considered "full frame" to achieve maximum quality. Young upstarts in the 1950s used the smaller, medium-format 2¼ x 2¼-inch roll film. The cameras were comparatively smaller and more flexible, the same

Figure 2.6 "Full frame" negatives from different eras: sheet film, 2¼ x 2¼, and 35mm.

Credit: Ross F. Collins

advantages we search for today. But those were not "full frame" for the earlier photographers.

The truly radical in the 1960s embraced the once-tiny 35mm format, following early street photographers such as Cartier-Bresson who used it decades earlier. So what is "full frame"? Do you need to pay for cameras capable of that? It depends. What is your end publication goal for choosing a format? If you are planning to sell huge, salon-style landscape photos, you probably need full-frame. If you are planning to upload photos of your corporate picnic to Instagram, any old sensor size will work. Or maybe you just need something in the middle. It's not a compromise to choose what you need instead of choosing the top of the line just because it's available. Many of us drive Toyota Corollas without shame.

The choice of sensor size will also drive your selection of lenses. Notably, if you only buy FX format lenses they will work fine on DX format DSLRs, but usually not the other way around. And, of course, none of the DSLR lenses will work on hybrids, nor vice versa. One possible option worth a mention: your employer has some oldie but goodie lenses lying around from film days. Will they work on a DSLR? Usually, with an adapter, the answer is yes, and the quality of those lenses generally was good. It's worth considering.

The Case of Video

Video is another option we did not have to consider at the start of the digital revolution. Unless you need to capture 4K video all the time, you don't need to purchase the best of the best. After Canon stunned the world with its first DSLR camera that also recorded brilliant video, all camera manufacturers have stepped up to the plate to offer quality video. And we expect today's video is only going to get better, along with better sound, better autofocus, better everything.

Just as in still photography, in choosing video capability you must ask yourself: what does my client need? If you know you will be shooting for small Web page content you don't need the best high-definition formats. But if you wish to grow into a higher level of production, then you need to pay attention to choices each camera system offers. High-quality video production will require you to invest in a greater variety of prime lenses, along with dollies, sliders, stabilizers, sound recording gear, continuous lights, and light modifiers. These will bring a polished studio appearance to your location lighting. Don't forget that with higher-quality formats you will also have to invest in large external storage arrays for your computer. If you are editing in the field on a laptop, shooting 4K is going to hog your RAM memory and disk storage.

So, obviously, the quantity of money you can spend on video is nearly limitless. As is the learning curve to use the equipment competently. Do

you need it? If you will be uploading short videos of last night's art opening for your nonprofit YouTube channel, well, no. If you will be preparing a high-quality 30-second commercial for YouTube use, however, you probably will. And, admittedly, if you are working at that level, you need a different textbook.

Lighting and Accessories

We consider lighting equipment in more detail in the chapter on that subject. But it's worth an introduction because it's so closely connected to camera choice. An advantage of Canon and Nikon DSLR technology for the near-pro is their "speedlight" systems (electronic flash). We do not photograph people, objects, and places—we photograph the light that is reflecting off people, objects, and places. You can snap the Loch Ness Monster meeting Bigfoot in London's Hyde Park, but if the light is lousy your viewers will only be a little impressed. But if you use the gorgeous light from a Tahitian sunrise to illuminate the face of a child, everyone will stop to look. Photography is all about light, but light in a photograph is traditionally invisible to the eye. In

Figure 2.7 Photography: sculpting with light.

Credit: Walter P. Calahan

the ideal world of photography we want to sculpt our subjects in beautiful light. When nature is not forthcoming, we rely on artificial-light sources, usually electronic flash, except for video, when we need a continuous source of light. If we shoot still images combined with video, we would want to stick to continuous light. Nowadays, the trend is toward using light-emitting diode (LED) lighting over old-fashioned hot lights, so we don't cook our subjects.

Many beginners and occasional mass-media photographers will seldom use electronic flash beyond the pop-up versions on the camera. These small flashes do offer ability to add light to shadow areas on bright sunny days. We call this fill flash. If close enough, a pop-up flash will illuminate entire scenes. But they leave a stamp that cries "amateur!" We hope to avoid that as professional communicators. This is because when you use the pop-up flash as your main light source in low-light situations your image takes on a two-dimensional look and your subject will appear to be standing in front of a black cave, or showing a monster shadow in the background. Using available light offers one solution. Speedlights offer another.

Nikon speedlights have had an advantage within the industry with their "iTTL" technology (TTL means through the lens exposure control). But this advantage can be eliminated by purchasing PocketWizard's radio flash triggers. This makes Canon gear a bit more pricy, but then again, the Nikon iTTL system uses infrared signaling that doesn't always work in bright sunlight: nature's infrared radiation disrupts the system. Nikon has introduced radio iTTL with their latest speedlight, but if you have the older gear you might wish to invest in PocketWizard's triggers as well.

We point this out by way of introduction to advanced lighting. But do you need this advanced photography equipment? Most of the time, for most of us, no. Most photographers can get by with one speedlight, normally connected to the camera via the hot shoe ("hot" meaning that it makes an electrical connection to the flash). Many combine this with a three-foot sync cord that allows the flash to be held at arm's length so it can be aimed at a subject from the right or left, instead of straight on. Nikon and Canon speedlights work brilliantly in this configuration. To add fill light to the deep shadows thrown by a bright sun, many photographers mount a speedlight to the camera's hot shoe. They dial down the flash intensity to reach a pleasing light ratio between highlights and shadows. Lighting on location can be kept simple.

The number one accessory overlooked by most photographers is the tripod—a good tripod. Why do we need a tripod? Don't we have image-stabilized lenses nowadays? Yes—somewhat. Image stabilization can fix some of the shake when we hand-hold a long zoom lens, or when we dial a shutter speed down to about 1/30 of a second or slower. But it can't beat a rock solid tripod. We who take pictures for journalism or other mass-media uses tend not to want to be burdened by the weight of a tripod. Maybe some of us already have two cameras hanging from our necks, and a camera bag filled with lenses and a speedlight. Still, word to the wise: if you are going to shoot

Figures 2.8.1 and 2.8.2 Bounced light fills the deep shadows cast by the key (main) light in this studio portrait.

Credit: T. J. Thomson

in low ambient light and don't want to crank the camera's ISO to a setting so high that you get golfball-sized pixellation, you will need a quality tripod. Particularly a tripod is important for video. Handheld video is obvious, and usually amateurish, unless you hope to give your work a feeling of gritty spot news. Even then, a medium-sized carbon-fiber tripod will reduce the weight burden. A tripod is also an answer when we don't want to light a room with speedlights, or attract attention with flash in a quiet setting. A tripod enables us to wait for the moment without the camera glued to our eye, especially when shooting a portrait. In a portrait setting many times you'll have to have a conversation with your subject. Having your head up for eye contact can put a person at ease while the camera on a tripod remains perfectly framed on the face. With a remote trigger, a camera on a tripod also allows us to shoot with two cameras at once. The camera on the tripod captures the overall scene, while the one you can bring to your eye grabs the storytelling

details. Has this persuaded you to buy a tripod? Probably not, but if you are serious about improving your photos, consider.

Hybrids

Hybrid cameras are changing the world of photography. Also called compact system cameras (CSCs), investing in a hybrid camera might be the best entry-level choice for the beginner who plans to take photos for professional mass media. These cameras offer great image quality in a somewhat less costly package. They also don't have the spine-curling weight that comes with DSLR technology. Almost every manufacturer of DSLRs, and many who do not make DSLRs, offer a hybrid camera that can serve you well in many shooting situations.

What makes a hybrid different from a point-and-shoot? The basic difference is this: you can change lenses. That ability offers a more serious photographer options for telephoto, wide angle, zooms, and macros that go far beyond those available in a point-and-shoot or smartphone. Moreover, a hybrid nearly always offers advanced exposure controls, a viewfinder (electronically operated), RAW technology, and a larger sensor for higher-quality photos.

What makes it different from a DSLR? The basic DSLR difference is that the viewfinder allows you to see exactly what the camera sees, because a mirror in front of the sensor reflects the image to your eye. The mirror flips up when you take a picture. But the DSLR offers serious photographers more options than just that one, as we'll see below.

A hybrid can look like a smaller version of the DSLR, Panasonic being a champion of this design, or it can look like a rangefinder camera of the famous Leica style. Its mirrorless technology is hardly new. The Leica rangefinder (mirrorless) camera was a huge liberating factor in photojournalism since its introduction in 1924. It was small and quiet. One or two bodies and perhaps three lenses and you could document pretty much anything. If you could zoom with your feet, you could use a Leica. Today's hybrids offer the same portability, with the addition of zoom lenses for those of us who can't always zoom with our feet. And one or two lenses might be enough for many communicators who won't be professional photographers but need professional-quality output.

In the digital world the hybrid camera has evolved into a powerful competitor for many situations. A DSLR-style hybrid uses a viewfinder through which you see the image shielded from ambient light. This way you can work in bright sunlight without worrying about a washed-out, hard-to-see LED screen on the back of the camera. A smaller sensor size offers users the opportunity to choose smaller lenses with the same capabilities as larger DSLR brothers. This produces a camera that is light and nimble. A professional photojournalist can imagine working with a 300mm instead of a 600mm full-frame (FX) format

DSLR lens to get the same angle of view. At the end of the championship game, his arms, neck, and wallet will say thank you. Also hybrid designs have no mirror blackout as there is no mirror to flip up and block the viewfinder during exposure. With a hybrid you actually see the moment the image is made. Finally, hybrids generally cost less than DSLRs for comparable technology.

So why choose the more expensive, heavier DSLR instead of the nimble hybrid? Several good reasons.

Most seriously today, the hybrid camera usually works with a smaller sensor than professional-grade DSLRs. (See discussion of sensor sizes.) Megapixels make a difference in quality of image, but not as much as you'd think. What critically matters is sensor size. Sony and Leica do offer two hybrid camera options using full-frame (FX) sensor format, the current "gold standard" for professional photojournalists. But these will cost you. The Leica may have style and quality on its side, but at a price acceptable mostly to those who also drive a Ferrari.

We find it interesting that so many photographers who complained in the early days of digital that the DSLR DX (smaller digital) format was too small are now championing hybrid cameras with four-thirds sensor size. Perhaps their lower back is voting for them. The more popular hybrid styles come with either APS-C (DX) or micro four-thirds sensors. If you are shooting for Web-based upload only, you have no need for a huge sensor capable of making 44 x 60-inch prints. If you are shooting video for Web broadcast only, do you need the highest resolution video? But perhaps we don't have to compromise as much as we think. Just as DSLR manufacturers have brought quality video to their cameras, hybrid systems are giving us better quality in a smaller package.

Another perhaps less serious weakness of today's hybrid technology for still photographers is inability to deliver a ultra-quick burst rate topping 10 frames per second, and limited continuous follow-focus found on a professional-grade DSLR body. This may be of concern to photographers specializing in sports action.

For those who need to shoot more formally considered video, hybrid technology is lighter, so video accessories, such as tripods, stabilizers, dollies, sliders, cranes, and jibs don't need to be as robust and as expensive as those required in the DSLR world. Video lighting for hybrids is no different from that used in larger DSLR cameras.

If you are working as a photographer at this near-professional level, know that one way to save on weight when using lights is to invest in LED technology instead of hot lights. LED has the advantage of allowing you to dial in the white balance, saving you from having to pack color-correction filters. The main reason many photographers opt for hybrid technology (along with price) is a lighter load, especially when they are traveling alone. Why not match lightweight LED lights to the hybrid camera system?

Okay, so let's recap with a checklist. A hybrid is a betweener's camera, above a point-and-shoot but (perhaps) below a DSLR. Why choose a hybrid?

1. You want lighter and smaller, less obtrusive equipment.
2. You want reasonable quality for less money.
3. You are ready to step up from your point-and-shoot, but not ready for the heavyweight of the photojournalism industry.

On the other hand, why would you not choose a hybrid?

1. You need higher-quality images than most hybrids offer.
2. You need advanced features of a DSLR.
3. You are probably going to spend much of your time taking pictures and video.
4. You prefer the professional look and cachet of the media-industry standard.

Point-and-Shoot

We consider the compact, simple, fumble-free digital camera to offer better quality than the smartphone camera—slightly. The differences seem small, but may be significant: a larger sensor size (usually) and an optical zoom. Smartphones are catching up, but they haven't caught up yet, and most professional photographers actually do also carry one of these little snapshot cameras in addition to their serious, but bulky gear. Should you carry one, too?

Maybe. You will not get the quality and features of the DSLRs or hybrids we consider below. But you may get a lot more than a smartphone. And certainly

Figure 2.9 Can you find good photos with a point-and-shoot style camera? You decide: this photograph was made with a cellphone.

Credit: Walter P. Calahan

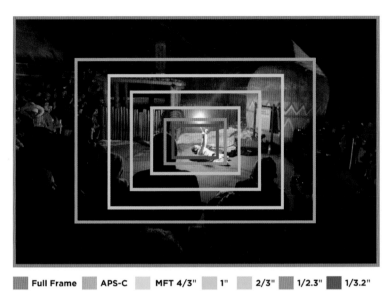

Full Frame | **APS-C** | **MFT 4/3"** | **1"** | **2/3"** | **1/2.3"** | **1/3.2"**

Figure 2.11 A comparison of common sensor sizes and crop factors.
Credit: T. J. Thomson

are a more serious photographer who wishes to go beyond those low-end cameras. Should you skip the fully equipped DSLR by embracing a hybrid camera system? Some photographers are doing so, but educate yourself to the limits of each piece of technology before you buy. Nothing is more frustrating than spending thousands of dollars on a camera system only to discover it doesn't really do what you thought it would. Today's world of camera technology seems daunting. But also, the joy today is that we have so many choices to craft visual solutions. Match your gear to your client's needs. These tools are not fashion accessories that brand you as a professional photographer. That comes from crafting quality images.

What Do You Think?

1. What kind of camera do you usually use now? Based on this chapter, do you think it will be adequate for more serious or professionally oriented photography?

2. In what situations would you not want to photograph in camera RAW format?

3. Can you think of any professional situations in which a digital zoom would be acceptable?

4. Why would a photographer prefer to move closer to a subject ("zoom with your feet") instead of just choosing a longer zoom lens?

5. Why would you choose a more advanced detachable flash ("speedlight") instead of the pop-up flash on a camera? Why might you not want to choose the detachable option?

because they offer 2x crop. A 50mm becomes 100mm. The really small sensors in most smartphones and point-and-shoot cameras have a 6x crop. That means what would be a dramatic wide-angle lens for a full-frame camera, 8mm, is about normal for the little cameras.

The presumption here is that the larger the sensor the better the image quality. This is somewhat true, but not entirely. It also depends on the camera's digital processing capability, and that's getting better and better. And it depends on the number of megapixels. Is more better? It's often advertised that way, but, actually, while a manufacturer can cram more pixels into a small area, a better gauge of quality is sensor size. Small sensor size produces more noise, that objectionable grainy look. So the photographs are of lower quality, and can't be enlarged to the same size as photographs taken with a better-endowed camera.

So why don't we always use full-frame sensors for best quality? Perhaps most obviously, price. Cameras with large sensors seldom sell for less than four figures. But less obviously—at least until you've owned one—full-frame DSLRs require larger bodies and larger lenses. These are big and heavy. They are not the kind of thing you can slip in your pocket and pull out for unobtrusive street photography. Smaller sensors can be housed in smaller cameras and require smaller lenses. The smallest can squeeze into a smartphone along with all the other things we expect today in these handheld computers. As so much in photography, sensor size is a trade-off.

Note that the smallest sensor sizes seem very small indeed. Yet actually they are used in some fairly sophisticated (and expensive) hybrid cameras. Most digital point-and-shoot cameras use the small 1/2.3-inch size. High-end hybrid or point-and-shoot camera generally use the next size up, 1/1.7, or four-thirds. These are twice the size of the compacts. A few actually use full-frame.

What Can You Do?

1. If you have access to a hybrid or DSLR, try photographing the same subject with these plus your smartphone. Open up an image at 100 percent zoom in Photoshop or other photo-manipulation software. Can you see a difference in quality?

2. Shoot an image using the digital zoom on your smartphone. Shoot another without using the zoom, but instead by walking closer to your subject. Compare the two images for quality.

3. Compare viewing options: compose a photograph on the LCD screen of your smartphone or hybrid. Compose a similar scene using the eyepiece-style viewfinder of a DSLR or more advanced hybrid. Do you consider composition differently based on these different composing options?

4. From a pro's perspective: to help build your professional competence, attend an event (preferably outdoor) with a goal of reporting the story for viewers who are not your friends or relatives. What photographs would help them to understand what the event was about? What photographs would perhaps not be appropriate for a "mass-media" audience? Shoot photos with the goal of telling a visual story and, if you can, post a half dozen of these to your blog or social media. Solicit responses from your viewers.

CHAPTER 3

Lighting for Photocommunicators

Natural and Artificial for Print and Online

Walter P. Calahan

Introduction

Look around you and what do you see? You do not see things; you see light reflecting off things. Light is invisible, yet we see nothing without it. Only when light is unusual do we notice, such as during a stormy day when a hole opens in the clouds bringing forth shafts of intense sunlight, or at sunrise and sunset when we are bathed in awe-inspiring golden light. The root Greek words—Photo = Light, and Graph = to Draw—was not initially how the mechanical method of capturing an image was defined. Early on people called it Heliograph—Sun Drawing. So in photography we "draw with light" using a machine. This means that every student of photography, beginner to worldly professional, must constantly study light's effect on what they see. The secret to quality photographic lighting is to use any light available— ambient, studio strobes, or any combination.

To use light well, photographers need to know a little about what physics and astronomy have to teach us. To use light well means photographers need to know a little human physiology on how the brain constructs three dimensions. To use light well requires a constant awareness of how nature provides us with a living classroom full of lighting solutions.

Source of All Light: Nature

Except for distant stars twinkling in the night sky, all ambient light originates with the sun. Even the light from fire is stored sunlight. The more we understand sunlight the better equipped we'll be in capturing photographs

Figure 3.1 Sunset road, Prince Edward Island, Canada.

Credit: Walter P. Calahan

that resonate with our audience. If all you do is attempt to emulate natural sunlight with other forms of lighting equipment, you'll be well on your way to making photographs with impact.

The nuclear furnace that bathes Earth in light is 93 million miles (150 million kilometers) away. This means that when we step outside, the light on a photo subject 5 feet in front of us has the same illumination as something more distant—20, 60, 100 feet behind our subject. Physics explains this through "The Inverse Square Law": the farther away the light source is from your photo subject the more quickly the light intensity diminishes. In this case, since your subject and the background behind are both 93 million miles from the sun, the illumination is the same. You can set your exposure without having to worry that your subject appears to be standing in front of a cave.

This is not true at night when you turn on the flash built into your smartphone. Either the flash will illuminate your subject well with the scene behind in almost total blackness, or your subject will look like a ghostly aberration of bleached out detail and the background will look well exposed. All human-made light is relatively close to our subject, not 93 million miles away. So our

light will fall off dramatically to a weak reflection as the background moves farther away from our subject. The Inverse Square Law offers a way to precisely calculate this fall-off, but most of us don't really need that. The solution is simple. When lighting your subject, you must also light the background with a separate light source. We'll talk more about that later.

A second thing we need to know about our sun we learn from astronomy. Stars come in different colors. Astronomers call our own sun a "K" star for its particular yellow color. We measure color temperature on the Kelvin scale. The sun's chromosphere is burning at 5200 degrees Kelvin. Stars that burn cooler than our sun appear more orange to red. Stars that burn hotter than our sun appear bluer. Star temperature does seem counterintuitive to how we think about cool or warm colors, but the reason is easy to explain. Suppose we associate blue with frozen water and yellow with the warm glow of a candle. But if you wanted to melt a piece of steel would you use a *yellow* flame from a candle? Of course not, a candle is too cool to melt steel. You'd use a welder's torch, the one with an extremely hot *blue* flame to cut through steel. So in physics we know the hotter something gets the bluer it appears, whether a welder's torch or a distant star. In astronomy a blue star burns at 10000 degrees Kelvin.

That blue color is similar to the blue color we associate with our sky. A blue sky appears because indirect sunlight scatters when it hits dust and water molecules in our atmosphere. Because that blue light has more energy, it continues on its straight path to our eye while the other colors in sunlight scatter away from our eye. This means what we call "daylight" on Earth is a combination of direct sunlight at 5200 degrees K and the weaker indirect sunlight, called the sky, at 10000 degrees K. When these two temperatures are combined in proportion to their strength, we get a color temperature of 5500 degrees K, or what color film was chemically adjusted for to produce what we consider to be natural color tones. We call this white balance.

Figure 3.2 Bright daylight is a higher color temperature, so more bluish, but our eyes correct for the difference.

Credit: Walter P. Calahan

When setting your digital camera's white balance, some manufacturers use 5200°K. as the standard for daylight, and others use the film standard of 5500°K.

The Lighting Challenge of Weather

As we can imagine, when the sun is shining on the surface of the moon it is always a bright sunny day. But not here on Earth. That's because we have weather in our atmosphere. Depending on the amount of water in the air to form clouds we get hard or soft light. Hard light makes distinct shadows, but on a thickly cloudy day we have no shadows at all. This is important in photography for two reasons. The most important reason is based on how our two-dimensional image represents three-dimensional depth. Second, our culture gives us expectations regarding how we like to see features on people. Hard light is thought to be masculine and soft light, feminine. You don't stick grandmother in hard, direct sunshine that reveals every wrinkle.

When we photograph, we remove our binocular vision that the brain uses for calculating distance. This is called parallax, and is how a rangefinder camera tells the user when something is sharply in focus. But a photograph is a monocular view of the world, so the brain uses something else to calculate distance, and that is the "cast shadow." Even in binocular vision, when our subject is more than 100 feet away we lose binocular ability, but the distant objects don't look flat. That is because the brain is using shadows to calculate distance. The more pastel a shadow the farther away it is. Perhaps you've seen this effect when looking at a photograph of layers of mountains. The mountains that are closer appear saturated in color, but the distant peaks become bluer and less saturated.

This difference in tonal contrast is what we must understand when adjusting the contrast in a photograph during post-production, and when using natural or artificial lighting. The lighting ratio from highlight to shadow is defined by how dense or how pastel the image shadows are. The modification of this ratio can control the emotional mood of a picture. The other lighting factors that adjust the emotional mood are light direction and color temperature.

Since in nature the sun is our main, or key light, we need to study how the key light shapes a scene. If the sun is directly to your back you have directionally flat lighting, meaning the shadows will fall away from the camera behind your subject. The left and right side of a person's face will have the same exposure. Of course if the light behind you is high enough you'll see a shadow under a person's nose and chin. When a small shadow appears under the nose looking like a little butterfly, that's called butterfly lighting. The moment you move the key light off center of the camera, either to the left or right, the more pronounced shadows appear on your subject. One of the most popular forms of light shaping the face from the side is called "Rembrandt" lighting,

Figure 3.3.1 Hard lighting produces strong highlights and shadows (Oklahoma City).

Credit: Ross F. Collins

Figure 3.3.2 Soft lighting appears shadowless (Ibaraki, Japan).

Credit: Ross F. Collins

named for the master painter who would leave a triangular patch of light under the subject's shaded eye. This triangular patch of light will equal the brightness of the opposite side of the face being illuminated by the key light.

When our key light continues to move so that it is striking the face from a 90° angle to the camera, we lose the Rembrandt triangle, forming a "half moon" illumination on the face. The Italian Renaissance paintings call the

Figures 3.4.1 and 3.4.2 The strong key lighting in the left photo emphasizes the triangle of light on the cheek, a characteristic of "Rembrandt" lighting, named after the famous artist who favored it. The second photo adds a fill light.

Credit: Ross F. Collins

contrast from bright to dark "chiaroscuro," or the contrast between light and shadow. It is what makes the face appear three-dimensional in a painting or photograph. Once our key light begins to move behind our subject we enter the dramatic world of backlighting, which will put our subject in complete silhouette if the light is facing directly into the camera.

Where you put your key light is all about drama and three dimensions. In portraiture, every face needs to be respected for its unique appearance, so how we light one person is not necessarily how we want to light someone else. This is why it is so important to study how light shapes various faces when you are out in public. Everywhere you go and all the people you meet will be an opportunity to learn lighting.

Working with Daylight

It is important to remember that the tools built into our cameras for measuring light, exposure, and white balance, can be fooled. We need to master how our light meters work so that we have complete control over the final outcome. So let's review how both meters work so their limitations can be overcome.

Back in the 19th century some wise scientist asked, "What is the average reflectiveness of everything?" This was a profound step for the invention of the light meter. We know that a black lump of coal does not reflect sunlight with the same intensity as polished silver, but our camera does not. The engineers who program light meters set them to "see" the world as if everything is the universal average. In classic film photography this was known as 18 percent gray. Others will mention that this average is different in digital photography, saying the meter "sees" 12 percent gray. The truth is they see both depending

LIGHTING FOR PHOTOCOMMUNICATORS

on the mathematics used to measure the average. For us shooting in the field, not in a studio where light can be controlled, the average middle gray doesn't need to be held too accurately. Just remember that most of nature is middle gray, so most of the time our light meter works fine.

Problems with exposure happen when our subject is not middle gray. The best example of this is at a wedding. Where should the light meter read when the bride is in white and the groom in black? Our light meter wants to set our camera's exposure (shutter speed and lens aperture) to make the bride and groom middle gray. No bride wants her beautiful white wedding gown looking dingy gray.

Fortunately, modern cameras have exposure compensation overrides when our camera exposure mode is set to Program, Aperture Priority, or Shutter Priority. We can dial in the perfect correction of plus or minus (bright or dark) to compensate for the reflectiveness of our subjects. The key is to be consistent with your correction. If you set the compensation for the bride's gown, you will set the meter to a plus, to let more light strike the image sensor. If, after making this plus compensation, you then meter the groom's black tuxedo, your exposure will be too bright.

The best solution for complex subjects with wide ranges of reflection is to switch to Manual exposure mode, measure the known middle gray, set the shutter speed and aperture for that middle gray based on the sensor's ISO setting, and then not change your exposure setting as the bride's white dress or the groom's dark suit fools the camera meter into suggesting changes. This only works when the scene's light level does not change throughout the shoot. Fortunately, if you are photographing outside with green lawns in the same light as your subject, meter off the green grass because it is middle gray.

The Lighting Triangle

Cameras control the amount of light striking the sensor (or film) in two ways, and control the ability of the sensor to record the level of light in a third way. The intensity of light allowed to reach the sensor is regulated by a series of (usually) overlapping metal plates in a lens that physically block some of the light. It's measured based on a ratio of the length of the lens (focal length) and the diameter of the largest opening (aperture), in millimeters. This is called f/stop. If, for example, you have a 100mm prime (a single focal length, as opposed to zoom) lens, and you've set the diameter of the aperture to 25mm, the radio is 1/4, or f/4. If you decide to reduce the aperture to, say, 12.5mm, the ratio is now 1/8, or f/8. This lets less light on to the sensor.

The second way to control the amount of light is to limit the amount of time it strikes a sensor. This is called shutter speed. A shutter is a device that opens a window to the sensor and then quickly closes it based usually on fractions of a second. To express shutter speeds we normally drop the fraction, so 1/30 of a second becomes a shutter speed of 30. We seldom need long exposures of more than a second.

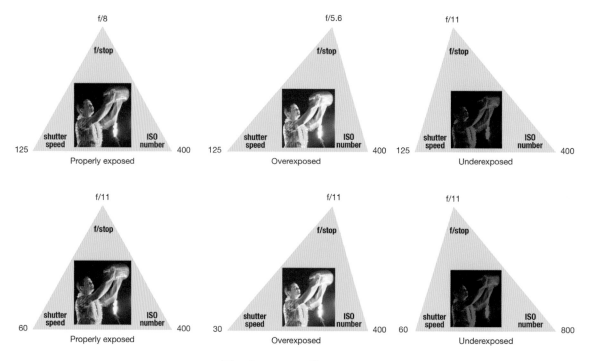

Figure 3.5 The lighting triangle.

Credit: Ross F. Collins

Shutter speeds and f/stops are calibrated so that they are directly interchangeable regarding the amount of light they allow to the sensor. This means a photographer can choose to move an f/stop from f/4 to f/8, and (in Manual mode) move a shutter speed from 125 to 30 and allow the same amount of light to strike a sensor. These are called stops. Each full stop lets precisely one-half or double the amount of light into the camera. (We are ignoring half and third stops here, although most digital cameras allow these more precise exposure possibilities.)

Common full stops are usually numbered in this shorthand: f/stops 1.4, 2, 2.8, 4, 5.6, 8, 11, 16, 22, 32. Shutter speeds 1 (one second), 2 (one-half second) 4, 8, 15, 30, 60, 125, 250, 500, 1000, 2000, 4000.

So, for example, if you decide to change your f/stop from f/4 to f/11, you are letting precisely three stops less light into your camera, or one-eighth as much. To compensate for the same exposure, you dial your shutter speed from 500 to 60, also three stops.

The third side of the lighting triangle does not control the amount of light entering the camera. Instead it controls the ability of the sensor to record that light, expressed in ISO (International Standards Organization, now called International Organization for Standardization) numbers. In film days, the ISO reflected sensitivity of the film to light. It was set by the manufacturer

to an arbitrary number, commonly 400 for photojournalists working in black and white. The photographer could possibly increase the effective sensitivity chemically in the darkroom, but could not change it in the camera. Digital cameras allow a photographer to set a sensor to record light with more or less sensitivity as needed. On a bright, sunny day, for example, you will want a less sensitive sensor, perhaps ISO 100. In a dark indoor sports stadium, on the other hand, you may want ISO of 1600 or higher.

Again, standard ISO numbers are typically numbered in shorthand: 100, 200, 400, 800, 1600, 3200 (and usually higher in most digital cameras, although the trade-off is lower-quality images). These numbers correspond to stops.

So, for example, you are shooting at f/4 and 15. You would like a little higher shutter speed, 30, but your aperture is "wide open," that is, at its largest setting. You can compensate by ISO number, making your sensor twice as sensitive: from ISO 400 to ISO 800. Now you can shoot at f/4 but at 30, gaining one stop.

I find it helpful to think of good exposure as if the camera sensor's ISO, shutter speed, and lens aperture are linked to one other forming a triangle. As a triangle you'll see that if you keep the ISO unchanged at 100, but change the shutter speed to a slower time (1/1000 to a 1/250), you then need to change the aperture to bring the triangle back into balance (f/2.8 to f/5.6). Likewise, if your pictures are underexposed (too dark by two stops), your lens is wide open at f/1.4 and can't get any wider, the shutter speed is at 60 and you don't have a tripod to stop camera shake, you will need to raise the sensor's ISO to a higher setting (a change from 100 ISO to 400 ISO), so you get a proper exposure with 1/60 at f/1.4.

A photographer who plans to shoot at a more advanced level for professional mass media needs to thoroughly understand this relationship.

Figure 3.6 Typical digital camera menu accessible through LCD screen.

Credit: Ross F. Collins

Why? Because the combinations you choose dramatically affects the visual goals you wish to pursue.

Goal Number One: You Want Things to Be in Focus

So you want everything to be in focus, right? This is the beginner's presumption, and it's half right. Sometimes you actually do want everything to be sharp. But at the other half of the question, sometimes you don't. And the question misses one basic fact: you can't have everything sharp anyway. A lot of things, maybe. But not everything.

The expression that photographers use to describe the quandary of focus is "depth of field." "Depth" is a measurement of focus beginning at your camera and extending back through your scene. "Field" is your entire scene, from one inch in front of the camera to the curvature of Earth. Regarding that field, how much is going to appear to be in focus? If it's a lot, you have great depth, so great depth of field. If it's a little, you have shallow depth, so shallow depth of field.

Depth of field is ruled by laws of physics, or more precisely, laws of optics. We consider that a lens collects light reflecting (or possibly emanating) from our subject, and focuses that light to a precise spot behind it, like a magnifying glass can focus sunlight to a point on a piece of paper. In photography that point is called the focal point. The lines on that point are as converged as

Figure 3.7 A bicycle tire detail emphasizes shallow depth of field.

Credit: Walter P. Calahan

possible (within rules of optics and lens quality), giving us an area that's "in focus." When we point the auto-focus (or manual focus) of a camera at a certain part of the scene we want to be in focus, we are setting the focal point so that area will be sharp in exactly the place our sensor collects the light.

Anything not on the focal point is out of focus, or fuzzy. That is optically true, but in practice to an extent we can't tell the difference in a photo between the true focal point and nearly the focal point. That gives us the depth of field.

So the key to great depth of field (lots of things apparently in focus from front to back) is to manipulate the lens so that the area that's "good enough" around the focal point is broad.

We have just one way to control this optically: the aperture, or f/stop. A small aperture (larger f/stop number) sets a broader depth of field. More objects from closer to the camera to farther away appear to be in focus. A larger aperture (smaller f/stop number) sets fewer objects front to back in apparent focus.

This means that if we want to make sure that both our subject, who is standing five feet (1.5 meters) from our camera is in focus, and a person standing 15 feet (4.5 meters) behind her is also in focus, we have to choose an f/stop that allows great depth of field, say f/11 or f/16.

Do we always want great depth of field? Perhaps more often than not, but not always. Shallow depth of field throws a background out of focus. This can help nicely isolate our subject from a busy background. For that, then, we need a lower f/stop, say f/2.8 or f/4.

Many photographers shoot test photos to evaluate depth of field, so they are certain that what is in focus is what they intend to be in focus.

Is that all there is to it? Hardly! Depth of field is also affected by two variables: the focal length of a lens, and the size of a sensor.

Consider a telephoto lens (or a telephoto zoom). This lens is designed to bring your subject closer to your camera. If you shoot at a car parked down the street in front of your apartment with, say, a 50mm lens, and then, without moving, replace that with a 200mm lens, that car will appear closer. But the street in front of and in back of that car will appear to be more out of focus as well. The principle is this: telephoto lenses have shallower depth of field, while wide angle lenses have greater depth of field. A 50mm (film equivalent; see discussion in camera chapter) is considered a "normal" lens. Any smaller number is called wide angle; any larger number is called telephoto. Many photographers use zoom lenses nowadays, properly called variable focal length. These may include options at both wide angle and telephoto areas. Becoming less common are fixed focal length lenses, sometimes called prime lenses.

So we noted that if you change lenses while shooting down a street, depth of field will change. Depth of field also changes depending on how close you are to the subject.

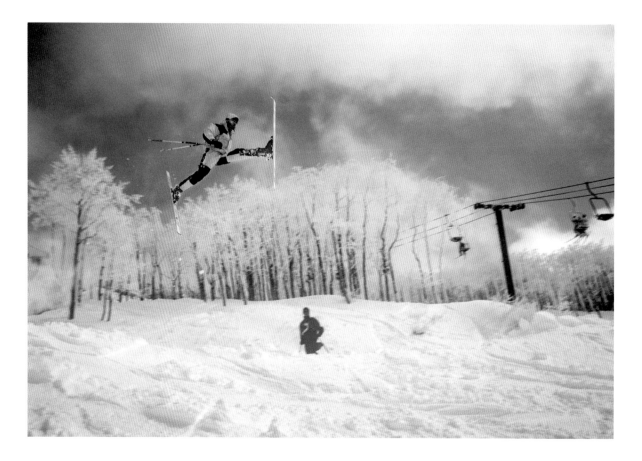

Figure 3.8 Most sports photography requires high shutter speeds to stop action.

Credit: Walter P. Calahan

If your subject is somewhat distant from you (several feet), you can rely on it and some area in front and in back of it being in focus, even at a fairly low f/stop number. But if you decide to close in on your subject, pointing your lens only a few inches away, at the same f/stop a lot less will be in focus. This can get more extreme than you might expect: photograph a friend from a few inches away with a normal lens. Focus on the eyes. The nose will be out of focus. At its extreme, almost nothing beyond the absolute focal point is in focus. This is why photographers who use macro lenses—lenses that take extreme close-ups—must focus carefully and use the highest f/stop numbers possible to avoid blur.

Goal Number Two: You Want to Stop Movement

So the question then is this: why not just dial up the f/stop when you want depth of field, and dial it down when you don't? We forgot the reason we have f/stops: to control the amount of light coming into the camera.

If you need a high f/stop for great depth of field, it means you are not letting very much light into the camera. That's okay if you're at the beach on a sunny

day. But usually it's more likely you're photographing volleyball players near sunset, or children playing in weak indoor light. To compensate for a higher f/stop, you need a lower shutter speed. That introduces a new set of trade-offs.

A high shutter speed freezes movement, both from your subject and from your own shaky hands. Usually, you want to freeze movement for a sharp photo. But you can't do that if you've lowered the shutter speed to compensate for a higher f/stop. What can you do? You can wait for your subject to stop moving. If that works, you can also lean against a light pole to steady your hands, or brace your elbows against your chest (no flailing elbows, please). You could pull out a tripod if you had remembered to take it with you. Or…you could choose a higher ISO number.

Each higher ISO stop gives you one extra stop in shutter speed. That means you can freeze faster action. Let's say you want to keep your camera at f/16, but your exposure meter is showing a shutter speed of 4 (1/4th second). Pretty much no one can hand-hold a camera at that shutter speed and expect sharp photos, even with stabilized lenses. What you want is at least 30—a stabilized lens (as most modern lenses are) should give a reasonably sharp photo at that shutter speed.

So you dial your ISO three stops up, from 400 to 3200, and you're set.

Or are you? Not quite. Photographers seldom can evade the tradeoffs of physics. And one of those tells us this: the more sensitive (higher ISO number) your sensor, the more noise (apparent grain that lowers quality) you'll see in your image. It is here that expensive DSLRs with larger sensors can do what smartphones can't: maintain quality at higher ISOs.

Got it? Good. Because there's more. The first is something you can't do anything about beyond buying another camera, but you need to know: tiny sensors reflect lower image quality, but also don't give much control over depth of field. This means your smartphone, normally with the tiniest

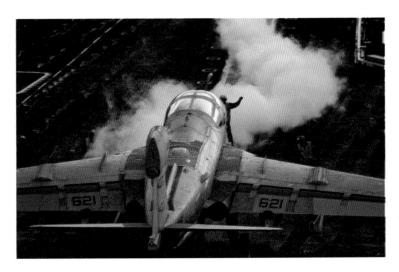

Figure 3.9 Low light: Launch of a jet from the aircraft carrier USS John C. Stennis (CVN-74)

Credit: Walter P. Calahan

sensor of all, can't offer much possibility of blurring a background to isolate a subject. Second, only optical zoom (not digital zoom) offers depth of field control.

And one last thing… focal lengths do more than simply pull your subject closer to you, or push it farther away from you. They also control the subject's apparent relationship to objects in the foreground and background. This is called perspective.

Let's go back to that street you've been photographing. You have a no-parking sign in the foreground. You replace your 50mm lens with a 200mm telephoto. Then, instead of staying put, you walk back until that no-parking sign takes up about the same amount of space in your viewfinder as it did before.

This time the perspective has changed dramatically! The car down the street looks a lot closer to the sign. This is called stacking. It allows us to photograph objects as if they were closer together, or farther apart (stretching), than they actually are. Many advanced photographers rely on the differences of perspective to suggest relationships between objects in a scene.

White Balance

The other exposure problem is white balance, and it is based on how engineers define "white." How white is defined is based on the color of our sun. As we know, sunlight changes during the course of the day from golden sunrises and sunsets, to neutral in the middle of the day, to bluish when the sun is obscured by clouds. Paying attention to these changes in nature helps us understand why our camera needs to adjust white balance. Most of the time we want the "average" white balance, just as we want the average middle gray in our ISO, shutter speed, and aperture combination for an accurate exposure. This is why our digital cameras have an "Auto White Balance" setting so that the scene's color tone is adjusted automatically to what we believe is pleasing. The reason our cameras have other settings is for those times when "automatic" gets fooled.

The best example of when the camera's white balance can be fooled is during the golden hour of sunrise and sunset. This is when our scene is flooded with reds, oranges, and yellows that don't match "average." Average is the balance between the sun's color temperature, measured at 5200° Kelvin, and the blue of the sky, measured at 10000° Kelvin. If our scene doesn't match that average our camera's Auto White Balance makes adjustments. If our photographic scene seems too warm, the camera cools it down by adding blue. If our scene has the blue of a cold, snowy winter day with lots of cloud over, our camera will add orange. Both times this will not match what we are seeing. Photographers may control white balance in the camera by experimenting with white-balance settings. We may bracket (shoot several frames at different settings) our white-balance exposure at various times of the day. Then on a computer we can see precisely how exact lighting situations change as we adjust our camera white balance.

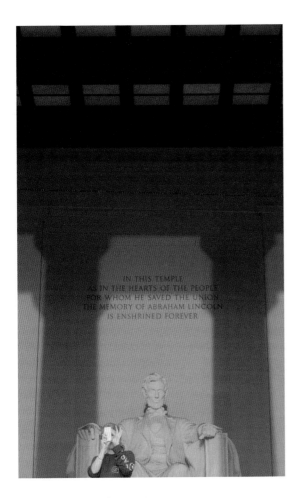

Figure 3.10 The golden hour of sunrise or sunset bathes the scene with warm orange or red tones. Auto white balance may try to control this color, but photographers can control it themselves in the camera or during editing.

Credit: Walter P. Calahan

The Qualities of Light

We expect most casual mass-media photographers will use the light that's around them, that is, ambient light. Most of the time we take this light for granted, unless we see something unusual about it. We may notice the glare of a street light on a dark night, or the lush colors of sunset. But most of the time, people who are not visually oriented don't notice the light except when there's not enough of it to see. More serious photographers, however, notice the interesting variations of light as they go about their day, taking pictures or not.

We see light as three basic characteristics: intensity, quality, and direction. Intensity of light can vary as much as 1000 times from the sun itself to the faintest candle. Because we need to control that intensity, the iris of our eye automatically adjusts. The iris can be closely compared to the aperture of a camera lens. The machine has the additional adjustments of shutter speed and ISO. We may think three is better than one, but no machine can

Figure 3.11 Fill-in flash will help control contrast or bring detail into shadows. This portrait is strongly lit from the left, so needs some light to bring detail to the right side of the face.

Credit: Walter P. Calahan

fine-tune the control of our brain to instantly adjust from the light and dark areas of a scene to produce an image. That is why contrasty areas in which *we see* detail still can't be recorded by the camera.

Quality of light refers to the perceived softness or hardness. Hard light is strongly directional, and casts deep shadows that photographers sometimes struggle to control. The most challenging example of hard light for photographers is high noon on a sunny day, because it really doesn't offer attractive lighting to any subject (you may notice most professional photographer are not roaming about at noon). Soft light, on the other hand, seems to come from no particular direction at all, filling in shadows and details. An overcast day softens sunlight as it is diffused through clouds.

Direction tells us the source of the light shining on a subject. Soft light sometimes seems directionless, and often light comes from several sources. But generally we can see the main, or key direction of the light, whether it is above, to the side, below, or from the back.

Recognizing these qualities helps us to obtain the kind of images we want, and helps us to predict how we will have to manipulate our exposure controls to make the resulting images useable. Harsh, intense light on a summer's day suggests small apertures and high shutter speeds, along with low ISO speeds. It also suggests unattractive shadows that will have to be controlled (see fill light below) or avoided (don't take pictures outside at midday). Soft, directionless light illuminates all the details in our subject. That's good for photos of children or product photography, but may not be very interesting in landscape photos or character portraits where shadow and light emphasize dramatic textures and contrasts.

Direction of light may flatter and suggest drama, may show texture or shape. Backlighting throws subjects into silhouettes. That might be what you want. If not, again, you'll need fill light. Side light may emphasize dramatic texture. But you'll have to think twice when photographing people, because it also accentuates every wrinkle. We are not accustomed to seeing light shining from below, so subjects look slightly creepy. This is why studio photographers call that "ghoul lighting."

Look at these qualities of light as you move through your day, with or without your camera. While it's helpful to have artificial means of controlling light, your eye can also tell you how to control light by choice of location and posing.

Controlling Contrasty Daylight

With a better understanding of how your camera reacts to light through exposure, white balance, and quality, you can now turn to manipulating light to your advantage. First, the best approach is to keep it simple. Two big problems challenge a photographer working in bright daylight. The first is blocked-up shadows, that is, dark areas so dense they

show little or no shadow detail. Second is subjects who are blinded by the intense light.

Regarding the second problem, squinting subjects, the obvious solution is to move them to shade, or move them to an angle in which the sun comes from the back, that is, backlighting. If you set up the latter correctly, you'll get the glorious halo effect professional photographers call rim or halo light. Unfortunately, the contrast between the background and your subject's face is usually so strong that it likely will leave the face too dark—that is, with blocked-up shadows. The solutions range from easy to moderately difficult. Easiest: use your pop-up or auto-firing fill-in flash. "Fill in" means it is designed to add light to the dark shadows (that is, the face) without overpowering the ambient (natural) light. You can adjust the fill-in to control the amount of light it adds. See more below on use of flash.

If that doesn't work, a quick fix is to position your subject with a white or light-colored wall behind you. The wall reflects light back to your subject's face—if it's not so bright that he or she squints again.

The above quick-fixes will fill blocked-up shadows as well as dark faces, but many mass-media photographers rely on more professional solutions. These require props. The most common is to use a photo reflector to bounce the backlight into your subject's face. The reflector can be round, oval, square, or rectangle, made of white or silver, or of gold cloth or foil (gold adds warmth to the scene). But remember again that bright reflected light could make your subjects squint or shut their eyes. The shape of the reflector will determine the catch-light that reflects from the subject's eye.

Alternatively, you can try a diffusion panel (sometimes called a *scrim*) placed between your subject and the sun to reduce the intensity of the bright sunlight falling on the subject. Think of a scrim as a layer of thin clouds softening the sunlight, but still giving a sense of direction to the light. (Note that you don't want the scrim so thick that it gives an overcast-day appearance to the image.) Reflector and scrims can be easily made with materials found at art-supply stores, or they can be purchased specifically designed for photographic use.

Moving from simple to more advanced lighting control, some professional photographers also use a black reflector. These are common among videographers, but many still photographers are not familiar with the black flag. Perhaps you already have a collapsible reflector that comes with a piece of black fabric that can be added, and you've wondered, why black? Well, a black flag does the opposite of a light reflector: it blocks light so the shadows in your image become more dramatically dark. Think of it as a light subtractor. If the sun is shining on someone's face, but the sidewalk reflection leaves shadows that you believe are too bright, place a black flag between the face and the sidewalk to make the shadows denser. Black flags can also be light blockers for speedlights, continuous lights, and studio lights to prevent lens flare from any backlight accidentally spilling on the

lens. Our Western cultural bias encourages us to prefer women and children lit in bright, open light with soft, translucent shadows, but with men we accept more drama, with deep, dense shadows. A black flag aids in making portraits of men more "manly."

We noted above that an easy way to balance out strong sunlight is to use the camera's built-in flash, if it has one, called fill flash. On-camera fill flash is handy, but has drawbacks. These small units do not provide strong illumination, so work well only when you are close to your subject. They quickly drain the camera's battery. (But you do have a spare, right?) They may not cover the angle of view of a wider-angle lens, and any strong light close to the camera's lens can in low-light produce "red-eye." This is the illumination of people's retinas that produces a demonic red glow from their pupils.

Figures 3.12.1 and 3.12.2 Speedlight flash helps to illuminate a pool scene. In the second photo, without the lights, capturing the subjects would be difficult.
Credit: Walter P. Calahan

Red-eye can be fixed in Photoshop. Better is to avoid it to begin with. Sometimes if you use a lens with a long hood to shade from flare, the hood will partially block the built-in flash to throw a shadow on your subject. These drawbacks explain why professionals prefer a flash separate from the one that comes with many cameras. A small "speedlight" flash is usually mounted to the camera's *hot shoe* (a clip on top of the camera wired to produce an electrical pulse when the shutter is pressed). Speedlights are more powerful, can be diffused with the addition of various materials so the light is less harsh, don't drain the camera battery, and move the flash a little farther away from the lens to help prevent red-eye.

Another advantage of using a separate fill flash is that you can adjust the output while shooting in Through-the-Lens (TTL) exposure mode. TTL liberates you from having to worry about exposure because the camera's light meter and flash "talk" to each other. If you find in balancing the sun that the flash is too strong, reduce the output by thirds of an f/stop until you get the look you are after. Remember though, the Inverse Square Law still rules the exposure, so if you get a great balance of fill light on a foreground subject, people or things in the background will not get the same exposure. Objects further back will receive much weaker fill, leaving darker shadows.

Ultimately, the beauty of TTL fill flash is that you can move around more without worrying about exposure. This is extremely important in photojournalism, when your subjects can't be directed. The use of scrims and reflectors are useful when shooting a controlled portrait that needs selected styling to the light, but you aren't always able to set up that kind of control.

Figure 3.13 The unattractive "cave effect" of on-camera flash leaves characters appearing as if they are looming out of a dark background, and often leaves subjects with ugly "red" eye. (Or, in dogs, yellow eye!)

Credit: Ross F. Collins

Finally, don't forget that one of the best natural light accessories to have is a tripod. Working indoors with soft window light requires a tripod so you can work at a low ISO for maximum quality. Too many portraits are ruined by camera shake.

Advanced Lighting

Speedlights as Daylight

Nature doesn't always cooperate. This is why having at least one speedlight with a TTL flash cord in your camera bag is a must for professional photographers. The speedlight becomes your key light, shaping your subjects as if they are bathed in quality natural light. The reason you need a TTL flash cord is to get the speedlight off the camera's hot shoe, as well as not having to worry too much about exposure. The TTL function lets you concentrate 100 percent on the composition while the camera calculates the correct exposure. Holding the flash at arm's length from the camera gives you the ability to create cast shadows on the subject and achieve a three-dimensional look to the image. This is particularly important when working in open shade where the only light is coming from the blue sky. Adding a single speedlight overcomes the blue color balance that the camera sees in open shade. A speedlight adds that kiss of sunshine where sunshine is lacking.

A downside of the one-light solution is the Inverse Square Law. You risk underexposing the background, leaving the subjects to appear as if they are emerging from a cave. An easy solution is to blend the light of the speedlight with the ambient location lighting. If you find the background too dark, simply adjust the camera's shutter speed to a slower setting. This allows more ambient light to register on the sensor. The speedlight remains your key light, but the ambient light becomes the fill. This is also how photographers can add a little action blur to the image, because the speedlight will freeze a subject, but the slow shutter will introduce camera shake, allowing ambient light to blur the scene. You can experiment to learn what is just the right amount of blur, and what is too much.

You may find the light from your speedlight a bit harsh. Remember the sun is huge, so its light spreads over our subject, but the speedlight is similar to holding a spotlight with a narrow beam. We can control this by providing light modifiers to the speedlight. It could be as simple as bouncing the speedlight's flash off a room's ceiling while attaching a small white card to the back of the flash to kick a little white light forward into the subject. Think of it as turning your one speedlight into two—it becomes both your sun and sky illumination. Or we can cover the speedlight with a plastic white dome to spread and soften the light. We can also add colored gels to modify white balance. A few of the better-engineered speedlights have dedicated filters that "talk" to the camera, automatically adjusting white balance to match the filter. This is

particularly useful when working indoors under greenish fluorescent light, so that the white balance of the ambient and flash light match. Warming or cooling filters will change the mood of the scene. Softboxes can modify the light. The catchlight reflecting from a subject's eye can be modified from round to octagon, square, and rectangular, depending on the shape of a softbox. All modifiers to the speedlight are designed to convert hard raw strobe light from a flash to a light that is more pleasing to the eye.

Speedlights can also substitute for larger studio strobes when working on location to craft portraits. Many professional photographers own multiple speedlights to act as the key, fill, hair/accent, and background lights. The beauty of using speedlights as a miniature studio system is the TTL functionality, allowing you to adjust each light's output from the camera. Canon and Nikon make speedlight transmitters using infrared or radio signals to make adjustments on the fly. Canon, Nikon, Sony, Panasonic, etc., also build in camera menu controls that will adjust speedlights when the built-in pop-up camera flash is used as a master controller of a multiple speedlight studio setup. Third-party radio TTL controllers are produced by PocketWizard, Vello, Phottix, and other suppliers.

Similar to any studio system, photographers wishing to build this advanced light setup will also need to seriously consider light stands, multiple-sized light modifiers, strip softboxes, shoot-through umbrellas, reflector umbrellas, parabolic umbrellas, snoots, grids, barn doors, booms, sandbags, mounting adapters, diffuser panels, reflectors of various colors, background stands with multiple backgrounds of seamless paper colors, and muslin-painted backgrounds, and multiple carrying cases (some with wheels) for hauling all this stuff. Not to mention needing to learning how to use it all in an expeditious way. You don't get all day to do a job.

Battery-Powered Strobes

The shortcoming of speedlights is power. If you want to light a large object or a large grouping of people, or if you need greater depth of field, you'll need to own either dozens of speedlights, or a few battery-powered location studio strobes.

Continuous Lighting

Before Dr. Harold Edgerton of the Massachusetts Institute of Technology (MIT) invented the xenon flash tube photographers used either flash bulbs or continuous lighting. Continuous lighting required large tungsten theater lights. They were bright and hot. They also had a different color spectrum than daylight, which meant you needed to filter the lights to balance for daylight, or eliminate daylight completely from the scene. That said, sometimes the imbalance between tungsten and daylight could bring a warm background glow to a scene, or add a cool blue mood depending on color balance of the

film—and now the digital sensor. Some photographers still use this kind of lighting.

Conclusion

The variety of natural lighting available to the serious mass-media photographer reaches as wide as the sky. But it does have its limits. To address those, it is mind boggling how much lighting equipment is available, to the point where a serious photographer might not know where to begin. If you decide to go beyond your camera's flash, go slowly as you learn what you'll need. Consider enrolling in lighting workshops. When crafting a well-lit picture, every photographer is borrowing from nature, and every photographer discovers unique solutions to share. Study books of quality photography. Ask yourself how the scene was lit. We still have a lot to learn from 19th-century masters such as Félix Nadar and Julia Margaret Cameron. The work of 20th-century masters such as Louise Dahl-Wolfe, Cecil Beaton, Horst P. Horst, Irving Penn, and Richard Avedon can teach us how to sculpt with light. Soak up their brilliance in creating the illusion of three-dimensional depth, and how they move your eye to what they want you to look at within the frame. Quality light is not an accident, but when done well it becomes invisible in the content of an image.

Nature is our great teacher. If you want to learn how a reflector works, stand near a white wall. Observe the sun reflecting from it. You can see how reflected light opens up shadows in the people walking near the wall. Weather is also a teacher. A cloudless day at dawn will light a subject differently than at noon. A day with high cirrus clouds can make sunlight as soft as a translucent umbrella, a shoot through a scrim, or a softbox. The

Figure 3.14 Extra lighting in this scene emphasizes the drama of summer fireworks.

Credit: Walter P. Calahan

"Golden Hour" approaching sunset will show us the benefits of a large warm light source. During a dark stormy day watch for holes opening in the clouds, letting strong beams of sunlight through to spotlight the landscape. Try to replicate this look with a single speedlight as a spotlight on an equally dark day.

Mostly have fun. Learning photography is about growing with time. The famous 20th-century landscape photographer Ansel Adams did not print his images the same way when he was 70 years old as when he was 20. How glamour photographer Richard Avedon lit his early work in Paris when he was 20 is not how he lit *Vogue* cover shoots in the 1970s. Later, Avedon showed us the beauty of reflected natural light in his "In The American West" series of portraits. You can go through the same learning curve as you experiment. Pay attention to accidents, for they will teach things about light that can give your images a look and feel that is different than everyone else. The key is to learn how to replicate the mistakes so they are not mistakes anymore.

What Do You Think?

1. The color of light is a reflection of its temperature, measured in degrees Kelvin. But the scientific explanation doesn't help us to experience the mood of a photo depending on the color of the light that is emphasized. What mood would you hope to portray by choosing to take a photo in a lower color temperature, such as that of a candle? What mood would you hope to portray by taking a photo at a higher color temperature, such as on a bright sunny day?

2. Photographers generally consider hard light as "masculine" and soft light as "feminine." But in today's world of presumed equality, do these labels really matter anymore? Can you think of reasons to photograph women in hard light, and men in soft, despite what conventional wisdom tells us?

3. Photographers normally try to avoid strong contrast, that is, strong differences between light and dark areas of a scene. But not always. Can you think of a situation in which strong contrast would be the goal?

What Can You Do?

1. If you have a DLSR or hybrid camera that can be adjusted for exposure, try fooling your light meter to assess the results. Find a contrasty scene, something with both very light and very dark tones. Point your camera's light meter (if you have spot-meter capability) at a very light part of the image. Shoot a photo. Then point at a very dark area. Take another photo. Compare the exposure of the two photos.

2. A photographer who wishes to shoot more professional photos needs to thoroughly master the lighting triangle of f/stops, shutter speeds, and ISO numbers. To practice this, choose a DSLR or advanced hybrid capable of manual controls. Photograph a scene with a combination of f/stop and shutter speed indicated by the light meter. Now try shooting at a higher f/stop. Compensate by choosing a lower shutter speed as needed based on number of stops. The exposure of the second photo should be practically the same (although depth of field will not be). Try changing the ISO number, and again compensate with f/stops or shutter speeds. Again, the exposure should be similar, although a high ISO may produce more noise (grain), and so lower picture quality.

3. Don't believe us: confirm for yourself the differences that depth of field can make. You'll need a DSLR or hybrid camera with a zoom lens. At the smallest focal length (smallest number), photograph a scene that includes objects in the close foreground and the far background. Change your zoom to the largest focal length. Walk backward until the foreground objects take the same amount of space in your viewfinder as they did at the wider angle (smaller focal length). Compare the two photographs.

CHAPTER 4
Editing for Still and Video

Larry Mayer

Introduction

If the goal of copy editing is to improve a story destined for use in mass media, then the goal of photo editing is to improve a picture for the same reason. And the editor's argument, that every story can be improved, applies as well to pictures. So now that you will be taking pictures for professional use in a blog, corporate website, video newsletter, or even an actual newspaper, you will need to edit your work. A quick glance and a share isn't going to make the grade for communication professionals.

Figure 4.1.1 The goal of photo editing is to improve the selection, toning, and reproduction of images.
Credit: Larry Mayer

You can edit on a smartphone. Nearly any modern phone or tablet that can take a picture nowadays can also edit a picture. And a number of free or low-priced apps can do more, possibly a lot more. But quality and features vary a lot, and some features you will seldom use for professional mass-media photography.

Moving to the next level, point-and-shoot cameras generally give you some in-camera options. Hybrids and DSLRs may not give you as many options, actually, because they presume you'll rely on more sophisticated post-production software. And as a professional you may need that. Let's start by looking at basic editing needs for professional photographers. The principles here can actually be adapted to the more sophisticated tools we consider later.

The Basic Tools

Here are the basic editing tools you'll use for nearly every image you capture, tools available from the simple smartphone to the complex Photoshop:

- auto or enhance (sometimes the software knows what you want and will fix it better than you can);
- crop;
- exposure (shadows/highlights);
- color balance.

Sharpening Filter, Other Filters

Here are a few more you'll need often:

- rotation;
- saturation;
- red-eye fix;
- simple retouching.

What are these tools, and why do you need them?

Crop

This is an important tool for even the most basic user. Cropping an image to include important visual information and exclude the unimportant is a huge part of making a good image. An image's crop can make or break its effectiveness. You can also change the dimensions of the image (inches, centimeters, or pixels) and its resolution while cropping.

Figure 4.1.2 Some programs can perform complex editing tasks.

Credit: Larry Mayer

Exposure (Shadows/Highlights)

This tool is a quick way to adjust the depth and brightness of the shadows (darkness) and highlights (lightness) in your image. Shadows and highlights can also be adjusted using curves and levels. A strong difference between the highlights and shadows of an image is called high contrast, such as a photo taken on a sunny day. A weak difference is low contrast, such as a photo taken on an overcast day. Tonal contrast offers differences between colors. We need some contrast, but not so much contrast that shadows are "blocked" (completely black) and highlights are "blown out" (completely white). This is the tool to control that.

Color Balance/Selective Color

These tools allow you to fix and correct the color cast of an image. Depending on lighting conditions, the camera can record inaccurate color information.

Color balance/Selective color helps you bring a photo back to what the eye sees. You can add blue to an extremely yellow photo shot in a dimly lit gymnasium, or add red to warm up an extremely blue wintery image.

Sharpening and Other Filters

Photo-processing software applications offer anything from a few to a vast collection of filters. These can perform any number of actions to an image, whether it be adding or removing warmth, reducing noise (appearance of spots or splotches of color), sharpening, or adding blur.

Most often you'll want to consider sharpening your image. Digital editing software actually "sharpens" an image by adding contrast: darker tones become a little darker, lighter a little lighter. The outlines of objects stand out a little more from the objects around them. Simply speaking, we say this adds snap to a photo, and most digital photos are going to need that. But here's the one thing that sharpening does *not* do: it does not pull a blurry picture into focus. For that, you need ... well, actually, for that, you need to take another picture, because blur can't be cured in editing.

A few of the other filters can be helpful, but overuse of filters in photojournalism can land you in a rough spot ethically. The rule for journalists: choose simple filters that make the job easier but do not change the image from the way it appeared to your eye when you made it.

Image Rotation

This tool allows you to rotate an image to its correct orientation. It's also considered OK ethically for photojournalists to straighten a horizon.

Red-eye Fix

Pupils of the eye may turn pink or red in low-light photos shot with flash. Why? The flash light hits directly on to the blood-engorged retina of dilated pupils in low light, and people complain about you blinding them with the flash. Photographers have ways to avoid that. But what if it's too late? Most editing programs include a color-change cursor that with a click on a red pupil will (perhaps) turn it to a more natural look. You may have to adjust this for best results, but the rule is this: no red-eye in photos destined for professional mass-media use.

Simple Retouching

The tool (called optimistically "healing brush" in Photoshop) tries to improve skin by eliminating acne, freckles, scars, minor wrinkles, warts, cold sores, and, well, more. We begin here to slide down the slippery slope of what's ethical, and where. If that where is a newspaper or news website, the

answer is, usually, do nothing, even if you feel sorry for your subject's nasty pimple and can argue "but it's temporary." On the other hand, in corporate newsletters or brochures, some fixes are going to be acceptable. We know that in advertising photography anything goes, pretty much.

How to find these basic editing functions? Begin by looking on your device. Smartphones and tablets offer many editing functions at a simple click on the camera roll, and on an edit button. But you may wish to enhance these features with free or cheap editing apps you can download or use online. I'm not going to make a comprehensive examination here, because as a professional you'll probably want to move to more sophisticated editing software. But in a pinch, these work, and you can't beat the price (often free). Smartphone/Device editing apps familiar to many more serious photographers include PicsArt, Snapseed, Fotor, and even popular photo-sharing sites such as Instagram and Flickr.

More Serious Image Editing

If you're planning to take more than a few snaps a week, you'll need more serious editing software. To begin with, consider the difficulty of sheer volume. *The New York Times* reported the almost incomprehensible statistic that 1.3 trillion photographs would be made in 2017 and almost 80 percent would be taken on a smartphone. Fortunately, we will not have to file and index this visual tsunami. But we will have to organize our own work, and that can be a chore in itself. This is where more sophisticated editing software steps forward.

Figure 4.2 Editing programs can help determine the best image from the photo assignment.

Credit: Larry Mayer

Organization is important when working for any publication or client. Publishing images, videos, and other content often involves tight deadlines. The easier your work is to search for the quicker those deadlines can be met.

So you've been sent out on an assignment, and it includes photography. Whether it's a portrait of an artist, a crime scene, or a Fourth of July parade, you must have a system in place to ingest and organize your photographs.

Two of the most popular programs among professionals today are Photo Mechanic and Adobe Bridge, both easy to use and relatively inexpensive (or free) programs that allow a photographer to move photographs from camera to computer and from computer to anywhere the image is needed.

The first step when returning from an assignment is to move your photos to your editing software. For most of us this will be a laptop or desktop computer. If you've chosen to save your work on a cloud-based server (see "Understanding the Internet"), you'll download by Wi-Fi. Otherwise, either connect your camera to the computer by wire, or insert the memory card into a reader. Open the organization software to ingest the photos.

Ingesting photographs means transferring them from the card to a folder, hard drive, or server. During this process you can also rename and add some metadata to each image. Metadata summarizes information on the picture file, such as the date a picture was made, camera settings, and the name of the photographer.

As a professional working with others, you'll probably need to add your name, the date, and time the images were shot, name of publication or other planned use, and most importantly a caption. Careful photojournalists add this to every single photograph from a particular assignment. That way, if a client or a publication needs to dig through the archives in the future, these descriptors will make it easier to find a specific photograph.

Most publications have naming systems unique to their organization. For example, the *Billings Gazette* uses the following naming convention to keep everyone on the same page:

070415-loc-parade001lm

MMDDYY-section it will be published it-subject001 photographer initials

Using that convention, editors can determine the day the photograph was captured, the section it will run in both in print and online, a descriptive term to identify the assignment, a sequence number, and the initials of the photographer who captured the image. This is typical, but depending on your needs you'll make up your own naming convention to help keep track of your work. The important thing is to have the convention, and to use it every time.

Picking the Perfect Image

After the ingest, your photos will appear on your device as a grid. While you may have tagged (marked for closer review) or deleted some photos in camera while on assignment, usually this is where the real picking and choosing begins.

Editing and organization software help you work more quickly and easily by giving options to flag and classify favorite photos from a larger group. You'll ignore the duds (the checks for proper exposure, the blurry images, the photos where the referee stepped right in front of you) and focus on choosing the best photographs.

Organizing software features multiple ways to sort and select the best images. You may choose to tag, assign colors, or add one to five stars. Trial and error will bring you to your personal best choice, but to begin this process most professionals choose one of two popular organization software packages, Photo Mechanic or Adobe Bridge. Each of these offer options depending on your editing needs.

Photo Mechanic is a much-loved editing software used by many professional photographers. It is simple, cost-effective, and widely available. Photo Mechanic is mainly used for ingesting, organizing, and classifying photos into groups. It also features FTP (file transfer protocol) client software to use this familiar protocol to transfer files over the internet to and from a remote computer.

Once your photos are ingested, Photo Mechanic offers simple approaches to categorizing the work. Many photographers simply scroll through and tag their favorites by hitting "t" on the keyboard. Tagging simply adds a checkmark to the lower right-hand corner. You can view tagged photos by selecting "Tagged" from the "View by" dropdown menu.

An example is shown in Figure 4.3.

Others prefer a more specific method that allows them to classify their photos from decent to usable to "Wow, prize winner!" Changing the color classification of an image (highlighting the image and pressing "1–5" for a different color) gives you the freedom of separating absolute favorites from less fabulous but still usable. The color-class bar in the lower right allows you to select the specific color class or classes you wish to view.

An example is shown in Figure 4.4.

Aside from letting you classify and organize your photos after every shoot, Photo Mechanic is a great tool for viewing a large body of work and dividing it into easier-to-dig-through pieces. Say you're looking at a folder of your favorite photos over the past five years and you want to divide the large group by year. All you have to do is select the photos you'd like to move first, and choose File-Copy/Move Photos. This allows you to move those photos to a location of your choosing, with the option of renaming and adding new caption information, without leaving Photo Mechanic. This

Figure 4.3 Photo Mechanic is one popular professionals' choice to organize, caption, and select photographs for further editing.

Credit: Larry Mayer

saves time and effort compared to dragging and dropping from folder to folder.

Also useful is Photo Mechanic's ability to offer the possibility of adding an almost infinite amount of caption and location information to a large group of photos. Adding a general caption can be invaluable over time. If you need to look through photos months or even years later, the image will retain the important information.

It's important to add a caption to every photo you shoot. It should include the date and location of the photo. This is easily done while ingesting photos, allowing you to add this information to all photos rather than manually inputting the information for each one. It can also be done in batches after photos are ingested by selecting the photos to batch caption and using the IPTC (International Press Telecommunications Council) Stationary Pad function under Image in the toolbar.

Photo Mechanic can also become an FTP client. Once the settings have been entered in the file uploader, they can be saved so you can quickly transmit photos from the field.

Adobe Bridge is a free file-organization program that works hand-in-hand with Photoshop. Bridge is great for ingesting and organizing photos and retains all the basic functions already listed for Photo Mechanic. However,

because it's an Adobe product, Bridge allows you to execute certain commands and functions directly through Photoshop that Photo Mechanic can't do.

For example, Bridge allows you to directly batch edit photos through Photoshop without dragging each image individually into the program and manually making the changes. This can be especially helpful when you are working with a large group of very similar images, such as studio portraits.

Once you have ingested, renamed, added caption information, and organized your images to your liking, it's time to process your image. The options for photo processing are seemingly endless, but for serious photographers a few familiar software programs stand above the rest for reliability and accessibility.

In addition to its editing capabilities, Bridge offers an option of opening a photo in Camera RAW mode. (See Chapter 2 for a discussion of RAW format.) That's misleading: the mode will also open the two other most common photo formats, Tag Image File Format (.tif) and Joint Photographic Experts Group (.jpg). In this mode Bridge offers a fairly impressive array of basic editing tools, from crop to scale. Some photographers find it faster and easier to use than Photoshop. Most, however, use it in addition to Photoshop. Adobe Lightroom (described below) is a cataloguing/processing program that is more sophisticated, but Bridge has one huge advantage: it's

Figure 4.4 Photos can be scaled to view a wide body of work in Photo Mechanic, making it easier to select the best image.

Credit: Larry Mayer

Figure 4.5 Editing programs offer a wide array of tools to crop, tone, and sharpen images.

Credit: Larry Mayer

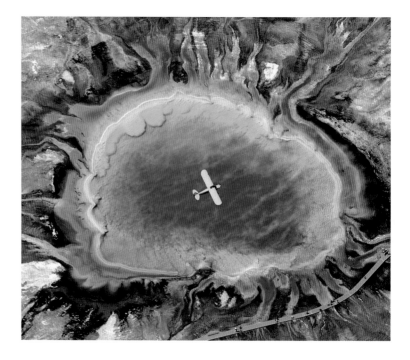

free. Adobe used to bundle it with Photoshop, but now bundles Lightroom instead, and has made Bridge a free download that's pretty hard to resist.

Processing the Photo

Adobe Photoshop

Good photo-processing software should be intuitive, allowing first-time users to quickly learn the basic tools they need for the job. The reigning champion is Adobe Photoshop. It's so ubiquitous that it's become a verb, to "photoshop" an image, and that's for good reason: it dominates the industry and can do just about everything.

Photoshop is available in two different levels of complexity. The professional version offers nearly every tool that photographers, as well as most editors, graphic designers, and printers need to prepare photos or other images for paper or Web. Photoshop Elements offers a fairly wide repertoire of tools, and a more user-friendly interface for amateurs or those who occasionally shoot for mass media. Elements actually does provide almost all the editing tools needed for mass-media image-makers. It is a good choice for photographers and journalists who do not require more high-powered editing tools. And photographers shooting for journalism outlets may wish to consider this: the less you are capable of in post-processing, the less likely you are to step over the ethical boundaries of photo editing. Elements is not as robust for some

professionals. But it is a standalone product that's cheaper than Photoshop, which is now offered only as part of the subscription-based Adobe CC (Creative Cloud) photography bundle.

Despite the clear attractions of Adobe's Bridge or Elements, serious photographers and savvy hobbyists usually opt for the professional version of Photoshop. The photography package of Adobe Photoshop Creative Cloud allows unrestricted access to all pro Photoshop tools, as well as access to Adobe Lightroom. Lightroom is a hybrid; it offers a companion cataloguing and organizing software that also has some post-processing capabilities. ("Post-processing" is the term that professionals use for a higher level of editing.)

Does it make sense to subscribe? Maybe, if you expect to do a fair amount of photo editing for professional presentation. Creative Cloud offers free updates with the subscription. And an extended subscription offers access to other Adobe products including, most critically for image-makers, the full version of Adobe Premiere, an industry-standard video-editing program. But what if you do limited video? Then the better option may be the package of Photoshop and Premiere Elements.

Photoshop's Competitors

For professionals, not a lot reaches to the level of Photoshop. Photoshop's biggest competitor is arguably Corel, a company that offers the Windows-only program PaintShop Pro. PaintShop Pro offers most of the capabilities of Adobe Elements without the option of RAW processing. In order to process RAW images, you can buy a package that includes Corel AfterShot. The two programs make a competitive alternative to Elements but the total cost is a little bit more—and it only runs on a PC.

Other competing products familiar to professional photographers include Serif's PhotoPlus (Affinity Photo for Macintosh) and ACDsee. The argument is one of price, platform, and preference, but the principles of photo editing for mass-media professionals remain the same.

Do you usually work on a Macintosh or PC laptop or desktop? You probably have photo-editing options already waiting for you. Windows Photo Gallery and Apple's iPhoto offer basic photo-cataloguing capabilities, although their processing abilities are limited compared with the big-league choices. Other well-known alternatives if you're looking for free options include Gimp, Picasa, and Fastone. These programs offer limited capabilities compared to their more expensive brethren, but some do offer RAW image processing and some post-processing abilities. Such options, while they are free and tempting to students, can be a bit of a hassle: advertising pop-ups can slow down the program and your computer in general. But why not download and try out one or more of them before spending money on a more sophisticated program? If a free option can satisfy your needs without slowing down your computer or killing your effectiveness, save your money! However, for a

Figure 4.6 Higher-level processing might include sizing for publication.

Credit: Larry Mayer

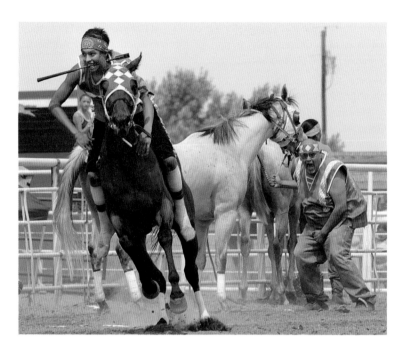

budding journalist planning on entering the field as a professional, paying for quality software is a good investment.

Your Tools

Beyond the Basics

We noted above that post-processing to professional photographers means a higher level of editing. Beyond the basic edits you can make with a smartphone, as we noted, what do professionals consider to be standard editing functions necessary for many pro-quality images? Below is a list in order of likelihood that you'll use them in mass-media photography.

Image Size

This tool allows you to change the dimensions of the image, whether the increments are in inches, centimeters, or pixels. A pixel is a picture element, or tiny portion of a picture. DPI and PPI refer to dots per inch and pixels per inch. This is called resolution. DPI measures how big pixels or dots are when printed. The image-size tool can change not only the image's size, but also its resolution for print or Web use, as larger file sizes are needed for print, and smaller for fast loading of online images. Some programs have a "Save for Web" feature that downsizes an image for Web use. For print, ability to size photographs properly is usually expected.

PPI and DPI affect the size of an image on a printed page. How to choose? Here are common standards:

- 72 ppi for the Web (also called *low-res*);
- 150–200 ppi for newspapers or newsletters;
- 250–300 ppi for magazines or high-quality brochures.

Most photographers whose work will become part of an online-only pdf (Portable Document Format) newsletter also submit low-res images to speed up download times. This projected color (that is, projected onto a computer screen) looks perfectly fine. But low-res images in printed documents (reflected color) may look muddy or pixelated (those blocky details).

Curves/Levels

These more sophisticated tools let you manipulate exposure, highlights (the lightest area of the photograph), shadows (the darkest area), and contrast using histograms, or graphs of the image's visual information. Curves and levels are the go-to tools for most visual journalists when it comes to adjusting exposure. Note that a histogram will offer you an idea of where the tones are distributed in an image, light to dark. Ideally a well-exposed image will have a few tones at the darkest side of the histogram (left edge), a few at the lightest, and most toward the middle. No law says you have to achieve a perfect bell curve of tones, but a histogram does give you an idea of your range, and a warning of clipping, that is, blocked-up areas of dark or light in which no detail is visible. A little clipping is all right, but too much indicates an image of unacceptable contrast or exposure.

Dodge/Burn

This tool was named to help the first photographers who migrated to Photoshop from a wet darkroom. They were used to adding or holding back light from an image by placing a piece of cardboard attached to a wire, or their hands, under an enlarger light. Today, the metaphor has no meaning for most Photoshop users, but tradition is a powerful thing. The tool lets you selectively lighten or darken small or large areas of an image by moving your cursor over it. You can change the size of the area and the intensity of the changes, from 1 to 100 percent lighter or darker. This is a fast fix when small areas of an image are over- or underexposed, and you'd only like to spot-fix.

Filters

The vast amount of filters available in photo-processing software can perform probably hundreds of actions to an image, whether it be adding or removing warmth, reducing noise (appearance of spots or splotches of color), sharpening, or adding blur. A few of these filters can be helpful,

Figure 4.7 Some higher-level processing includes techniques that migrated from the wet darkroom. The Dodge Tool can lighten a specific area of the image, such as the upper right side of this photo, while the Burn Tool can darken a specific area, such as the upper left side.

Credit: Larry Mayer

offering quick ways to fix color issues or sharpness issues in an image. But mass-media professionals generally avoid overuse of filters. In journalism, heavy filter manipulation can land you in a rough spot ethically. The rule here is this: don't add or remove anything from the image that your eye didn't see when you shot it. In other mass-media areas filters may be ethical, but may nevertheless look amateurish or gimmicky. Sure, you *can* twirl, crystallize, sheer, wave, emboss, or create a mezzotint, and a few dozen other things. But *should* you? Not usually, unless you're also the graphic artist. Choose a few simple filters that can make the job easier.

Masks/Layers

Masks and layers allow you to make exposure or color-balancing changes to a highlighted portion of an image. These tools can be helpful in color balancing or fixing the exposure of part of an image, while keeping another part separate from those changes.

Quick Selection/Lasso/Pen

These tools allow you to use different selection methods. It is wise to experiment with all the tools to see which one you find easiest to use, to select part of an image for changes using masks or layers.

Saturation/Warmth

This tool allows you to boost the intensity of the colors in an image to accurately represent what the eye sees. A little goes a long way. Do not go overboard using the saturation tool, as it will be obvious to professionals and editors looking at your work. The best way to add or remove warmth from an

image is by using color balance/selective color; however, this is a quicker way to make a fast fix.

Black and White/Grayscale

This allows you to convert an image to black and white. This tool uses the color information in the image to accurately reflect it into a grayscale format. This is a better way to convert color images to black and white rather than using saturation tools to take color out. Removing color information in this way compromises the accuracy of a black-and-white image, reducing contrast. We sometimes convert images into black and white for aesthetics, relying on the simple strength of contrasting gray tones. But also it is less expensive in print to publish black-and-white images.

Auto Tone/Auto Contrast/Auto Color

Why not just let the software fix your photos? In fact, the auto tools are helpful in quickly making adjustments to images. Your software will look at the image information and make changes based on histograms and embedded algorithms in its programming. Sometimes the changes are spot on. Other times you will end up with a complete mess. It can be helpful for beginners to try auto as a way to see what their photo-processing software *thinks* should be changed or altered in an image, and then make changes as they see fit using their own eye.

Vibrance

Like the saturation tool, adding or subtracting vibrance may be easily taken too far. But it can be used as a quick way to boost the impact of an image,

Figure 4.8 Auto tools are helpful in making quick adjustments to photographs.

Credit: Larry Mayer

especially when lighting conditions or other factors have taken away some contrast that the eye would see while shooting. Remember: a little goes a long way.

White/Black/Gray Points

One way to quickly set the color balance of an image is to use the white, black, and gray eyedroppers in the Levels or Curves pane (Photoshop). While not a fix-all, they can be a useful starting point to adjust the overall color cast of an image.

Other Tools: Beware

Image-processing software offers a lot of tools that can break ethical codes for visual journalists, depending on the job they want to do. As a journalist, adding or subtracting parts of a photo, over-saturating, or vignetting images to increase their visual impact beyond what the naked eye would see can easily land you in hot water. For public relations, perhaps the rules are less strict, but your public nevertheless will not accept your plan to add more hair to the CEO (he didn't like the shiny reflection) or to slip into your university view book's football crowd shot a minority student as a way to reflect more class diversity. (Yes, it's been tried. And yes, the staff got into trouble.) That power outlet on the wall behind your subject may be annoying. It's easy to remove it using Photoshop's Clone Stamp tool. But keep this in mind: even in a minor way, you are still misrepresenting reality, and that goes against everything a solid photojournalist stands for. Doing it once makes it easier

Figure 4.9 In higher-level processing it helps to build a workflow system.

Credit: Larry Mayer

the next time, and at some point your readers start to notice. If you're ever in doubt about the ethics of your photo-editing techniques, ask a professional photographer for an opinion. Most visual journalists are strongly against pushing the envelope when it comes to editing practices, and they'll tell you if you've gone too far. In fact, if you have to ask yourself, "Have I gone too far?" you probably have. Hit the undo button a few times and remember that when it comes to photo editing, simple is best.

In the advertising world currently no ethical rules set boundaries for photo manipulation, although laws against misrepresentation in advertising might constrain some photography. Still, we realize that advertising photographers are trying to create imaginary worlds that don't exist in reality. But that kind of highly technical and costly work usually relies on a team of professional photographers, not the average communicator who is expected only to take a reasonably competent picture now and then.

Workflow, Archiving, and Storage

The typical professional workflow for editing a photograph goes like this:

1. Download photographs.
2. Open editing software to organize your photos (Photo Mechanic, Bridge, or Lightroom).
3. Select the photographs to be edited.
4. Write a caption and add any information to make the image searchable.
5. Select an image, and open. The image will open in a photo-processing program such as Photoshop. (Note: alternatively you can make changes in organizing software such as Bridge and Lightroom.)
6. Once the photo has opened, rotate if necessary. Consider cropping. A tip: most mass-media photography will need at least a little cropping.
7. Adjust exposure and color balance.
8. Consider more advanced needs: red-eye fix, burn/dodge, saturation, vibrance, or more.
9. Sharpen the image using that filter. A good starting value would be 50 percent, Radius 1.0 pixels, and Threshold of zero (Photoshop).
10. Convert to black and white, if necessary.
11. Select "Image" and "Image Size" to size the photograph for your specific application. For print you will size it to the printed size. For email or Web use, you may want to downsize the resolution significantly to make is easier to share.

 Add caption info. In Photoshop you can do this from the toolbar: select "File" and "File Info."

Figure 4.10 Find a secure way to archive photographs.

Credit: Larry Mayer

12. Finally, save in the format you need. If you've made significant changes that you may wish to revisit later, save the image as a native file from that application (Photoshop uses a .psd extension.) Otherwise, you'll usually choose from these formats: .jpg or .png for the internet; .tif for print. (Most publishers nowadays also accept .jpg files.) You can name the files as well during the saving process, and choose a location.

Archiving and Storage

Too many photographers don't think about storage and back-up until their hard drive crashes. But you're not one of those. Photographers may choose from several options, physical and cloud-based. For physical storage, you can buy DVDs. It's also not a bad idea to pick up a one- or two-terabyte external hard drive and regularly move your work over. Store that drive in a location

away from your main computer which should be on a schedule for automatic backup.

More conveniently, however, many photographers choose cloud-based (remote-server) storage systems. These include Amazon Cloud Drive, Apple iCloud, Dropbox, Flickr, Google Photos, Microsoft OneDrive, and whatever new cloud service has launched since yesterday. Probably every communication professional who takes photos and videos needs to upload at least the most important choices to the cloud. We can't tell you which cloud service is best (that may change tomorrow), but we can give you a basis for choice. Consider:

1. How much storage you can get for free. Most services offer a few free gigabytes. The venerable professionals' choice of the past, Flickr, has upped its game to offer a free terabyte. But Google Photos offers an unlimited amount of space—well, sort of. See below.

2. Free features. Does the service offer automatic backup across platforms? Video backup? Backup of RAW files? Seamless integration to your platform choice? Cataloging and search function? Easy sharing with other users?

3. Pay features. You will have to pay for space above the free maximum. Some of the features you may need are not as robust in the free site.

4. Your ability to put up with data mining. Do you care about privacy on the cloud?

Google's announcement of its robust, and mostly free, photo cloud storage feature seemed exciting. It offered tools to sort and find the photos you want. But that feature comes with fine print: Google's search function relies on its much-vaunted search engines combing your photo metadata, the digital information your camera records when it takes the picture. It also combs your visual data using algorithms that are as secret as those behind Google regular searches. This is not necessarily sinister. It makes the ability to search your collection more robust. But it also can collect data for

Figure 4.11 Look for the image storage device or service that will fit your search requirements.

Credit: Larry Mayer

advertisers, with the option to target ads your way. In fact, Flickr (a Yahoo product) already does this, offering customized ads based on your photos.

This may or may not be a nuisance you wish to avoid. If it is, some services offer a promise they will not collect your metadata or personal information for commercial gain. Apple iCloud offers this. But as of now, it also is among the most expensive options for cloud storage. Serious photographers should carefully read the user agreements to see how their data can be mined, and if they don't like it, see if an opt-out policy is available.

What about Video?

Let's switch gears to something a little newer to the photojournalism industry, the art of recording, and editing video. Over the past decade or two, the technology needed to create and edit video has become much more widely available to the average journalist or other communication pro. While video-editing knowledge hasn't become a standard expectation across the industry as still photo editing certainly has, learning to use the software will enable you to produce professional video with high audio quality, and ability to cut your best video images together for better storytelling.

Newspapers, magazines, and other publications and internet sites are using video as a new medium to tell stories and add to visual packages online. Depending on where you work, you may be expected to know how to shoot and edit video, or at least be willing to learn.

Video Editing Software

As capture technology has blossomed (the wide availability of digital camcorders, DSLRs, and high-quality cell-phone video) so have the options available for editing software—the tools used to edit, process, and finish video projects. Many options are available in video-editing software, from the simple and straightforward to the complicated and sophisticated beyond the need of average communication professionals who are not video specialists.

As smartphones are more often becoming reasonable alternatives for fast videos, editing apps for this kind of video have grown in sophistication. Cute Cut for Apple, Andromedia Video Editor for Android, Video Edit, and others that will likely be available tomorrow can turn your ragged clips into reasonably polished work. These (mostly free) apps can insert photos, edit audio, make transitions, trim clips, and add music or commentary. On the fly with a smartphone, they'll at least smooth the ragged edges. But don't expect the kind of precision you get from the pro choices.

For more sophisticated work the most popular processing software for professional video editors, journalists or not, are Avid Media Composer,

Figure 4.12 A cell phone video or a high-quality production? Select the video-editing program that fits your needs.

Credit: Larry Mayer

Apple's Final Cut Pro, and Adobe's Premiere Pro. These are the highest grade, most professional options out there. Bear in mind that professional programs also require a large amount of processing power, so make sure your computer can handle these large files. Otherwise your computer will be prone to crashing mid-edit. (Recommended: at least 8 GB RAM; 16 recommended for Premiere Pro.)

Because each brand of camera often has its own file type, the best video-editing software accepts a large number of video file formats. Check your camera, but the sophisticated applications covered here support just about all possible video formats.

Avid Media Composer

This is a comprehensive program available by subscription, unless you wish to buy a perpetual license at a four-figure price. It can serve the most die-hard editors of video, but perhaps is more complicated than the general communications practitioner needs. We make note of it because it's a professionals' choice that may just be lurking in your office.

Avid Media Composer is designed to handle high volumes of media files and edit large, high-quality video projects. It is often used by TV stations and broadcast companies to put together visual packages. This program allows you to edit from your own work station or from anywhere using cloud technology.

Final Cut Pro

This is Apple's video-editing software that often comes installed for use by university students and budding professionals (or you can purchase it for several hundred dollars). It offers simple or advanced editing tools. You

can fairly easily upload multiple video, audio, and still image files, cut them together in multiple layers, and export them as one cohesive piece. Final Cut also allows in-depth editing tools for audio.

Final Cut may seem daunting at first. But with a little experimentation it can be simple as you discover the tools most useful for your needs. Numerous online tutorials are available (make sure they cover your version of the software) as well as help through Apple.

Adobe Premiere Pro

This is a more recent entry to the market, but keeps professionals in mind. Like Photoshop and Lightroom, it is available by subscription through Adobe's Creative Cloud. Premiere Pro offers a library of online tutorials to help you learn how to use their product, and, of course, more tutorials are available online. If you already have subscribed to an Adobe Creative Cloud suite for Photoshop and Lightroom, it may be worthwhile to upgrade, and get nearly the entire line of products from Illustrator to InDesign. You never know. They might come in handy.

What about something more basic?

The three pro-grade programs above can be daunting to the beginning communication professional who is not planning a career in videography. With a little time and perseverance, anyone can learn the tools they need to edit video at a professional standard. But the vast array of tools and functions can be intimidating to a first-time user.

Perhaps you'll want to choose a more basic and more inexpensive video editor. Quite a few are available for download, or even exist already on your computer. But keep one thing in mind: they do not necessarily process a large number of video file formats you may need. Common file formats like .mp4 or .mov are easily handled by nearly all video-editing programs. But proprietary formats such as Canon's MXF may not be supported. You may have to buy conversion software to handle these less common formats.

Adobe Premiere Elements

This is a relatively inexpensive (no subscription required) stripped-down version of the pro software. It accepts fewer file types, but still retains the basic editing tools needed to produce a simple video package, including layered timeline editing, audio editing, and multiple exporting options.

iMovie for Apple; Movie Maker for Windows

iMovie comes pre-installed on all Mac machines and offers tools for simple and effective video editing. If your machine doesn't already have

Figure 4.13 It's a good idea to consult the program tutorials when getting started with a new editing program.

Credit: Larry Mayer

iMovie installed, it is available from the Mac App Store. Inside iMovie you can browse your video library, cut clips, and edit them together to create simple but effective video projects.

Movie Maker for Windows is similar to iMovie. It offers all the tools that a beginning journalist needs to cut together videos with sound and transitions. Movie Maker is included with Windows 7 and later versions.

The Tools You Need

The vast amount of tools and functions available in even simple video-editing software can seem overwhelming. First-time users may open their new program and have no idea where to begin. A good way to begin is to rely on experts. Consult online manuals and view the company's tutorials. Here's a list of basic tools that are helpful for the average video-editing journalist.

Ingest/Import

This tool allows you to import files from a media card, your desktop, or other location, to be used within the editing program. These files are usually kept in a library to be easily accessed and cut for your use.

Edit in the Timeline

This tool allows you to drag and cut clips into the order you want them to be played. The timeline is the main area used for creating your video piece. All but the most basic programs will allow you to create multiple layers of video and audio, giving the final piece a more polished look.

Transitions

Transitions allow you to cut from clip to clip seamlessly. You can choose from many options, from the simple to the elaborate. For mass-media communicators in most cases, simple is best.

Crop

This tool allows you to crop a video clip to the dimensions you need. Use with care, as over-cropping can decrease the file size and diminish its resolution.

Color Correct

Just like still photos, sometimes a camera or phone can record video color information that isn't true to life. Color correction allows you to balance the colors in a clip to better reflect what the eye saw.

Export

This tool allows you to transform your video from its cut-together piece to a full-fledged seamless MPEG (Moving Picture Experts Group) or movie file ready to upload to any website or play using a laptop, a phone, or a tablet.

Titles/Lower Thirds

For news video, this allows you to place a name and title over the subject of a video. You may wish to use pre-set styles for these, or create your own.

Whether you're shooting on a sophisticated video camera, a DSLR, a simple camcorder, or a cell phone, these programs give you the opportunity to turn random clips into a seamless and storytelling video.

Figure 4.14 Good video editing will turn random clips into seamless and storytelling video.

Credit: Larry Mayer

Conclusion

Let's recap:

- Stay organized! Programs like Photo Mechanic, Bridge, and others provide a system to follow when ingesting and importing your photographs.

- The world of photo- and video-processing software is vast, but experiment with free trials, take a look at your budget and what kind of work you'll be doing, and decide what program(s) will work best for your individual needs.

- When editing photos, less is more! Ethical boundaries vary depending on your professional goal, but breaking them can land you in some seriously hot water.

- Be ready to learn to shoot and edit news video. Being able to make simple edits to video clips will give a video package a professional look.

- Learn how to shoot and edit photos and video on your cell phone. The chances that you'll be using it even in professional settings increase with every new and more sophisticated model. For news reporting, expect to make images from the field, and consider the many apps that allow you to make basic edits without a computer.

What Do You Think?

1. Photo-editing tools can eliminate facial flaws such as wrinkles, scars, or acne. In which professional situations would you want to do that? In which professional situations would you not want to do that?

2. While it's usually recommended that professional photographers avoid filters that heavily manipulate an image, in what situations would you possibly want to dramatically change a photograph?

3. In what situations would you prefer a black-and-white image instead of a color image, in addition to the reduced cost of printing in black and white?

What Can You Do?

Note: for current step-by-step instructions covering each brand of software, it's best to refer to the software company's website or other online tutorials. If you choose to consult how-to videos on YouTube or another crowd-sourced website, be sure that tutorials cover your version of the software. Tools and procedures can change substantially from version to version.

1. Become familiar with organizing software. Bring an intake of photos into a photo-organizing program such as Photo Mechanic, Adobe Bridge, or Lightroom. Try tools and options to help you organize your work.

2. Become familiar with image-editing software. After organizing, open one or more of your photos in image-editing software such as Photoshop. Gain experience by practicing the most commonly used tools. Try some unusual filters to gauge the effects.

3. Become familiar with video-editing software. Import a video into an editing-software program. Experiment with familiar tools such as timeline edits, transitions, and titles to produce a short video clip.

Beyond the Still

Early Cinema and the Fundamentals of Video Storytelling

Julie Jones

Introduction

Complexity is at play whenever someone picks up a camera to shoot a video story. On the one hand, to shoot a video story badly is very easy. Most cameras, even DSLRs, have auto functions that allow anyone to aim, hit the record button, and follow people at will. However, the variety of shots one captures in this shoot-and-piece-it-together-later mode of working rarely produces a good story. The irony, then, is that while it may seem easy to shoot video, to capture the right shots for storytelling is a harder skill to grasp.

Video storytelling is difficult because the end product drives the decisions in the field, and for photojournalists those decisions are often made in the moment and under real-world situations. Similar to still photojournalists, video photojournalists attend to the same technical considerations (e.g., exposure, focus, depth of field, and composition) as they seek moments that tell a story. Unlike the still photojournalist, though, the video journalist must be cognizant of how each shot could play out in an edited story. The skilled video photojournalist shoots in the field with the story's editing decisions prominent in his or her mind.

One way to think about this task is to analogize the effort of constructing a text story in the same manner. Imagine if a writer in the field needed to gather not only the facts and quotes of a story but also every word she or he would eventually need in order to later write the story. This is the task that video specialists take on every day whether they are aware of it or not. At the end of the day, the story is edited, and the order of that edit depends on what was captured in the field.

This chapter is designed to build a conceptual framework as a way to help students best understand the unique ways video, as a set of moving images, communicates a story. It emphasizes the concepts that video photographers in journalism or other areas of mass media need to keep front-of-mind when working in the field. To begin, we review the ways early filmmakers developed a visual language. The fundamental rules they developed more than a hundred years ago still underpin all media content built around moving images. Then, to bring this framework into a practical set of tools you can use, a set of *mantras* (memory jogs for essential types of shots) is introduced as an easy-to-remember way to keep a sequence of edits in mind.

Early Cinema: Seeking the Difference in Storytelling

Shortly after the turn of the last century, early cinema's first innovators faced a puzzle: how does this new tool for capturing moving images differ from other forms of photography and entertainment? Soviet filmmaker Lev Kuleshov (1974) explained this as the quest to understand the "filmness" of the new medium. The people who established early cinema worked out a number of now-common practices, creating distribution and production systems as well as storytelling conventions. Through their pursuit to understand the uniqueness of moving images as a communication tool, the storytellers of early cinema began to see that the meaning of a story originated more from the connection between shots than single shots in and of themselves. Over time the shots they filmed in the field were increasingly dependent on the narrative conventions they were developing at the editing stage.

The One-Shot Narrative Phase

The cinema industry in early years focused on innovating cameras, projectors, and exhibition systems. From this era two broad approaches emerged: staged shots of theater, sporting, and vaudeville acts, or locked-down views of people and life from city streets or country views. Two main commercial organizations popularized these content genres. Staged works were produced at Black Maria, Thomas Edison's film studio in New Jersey, and the seemingly real glimpses of life, known as *actualities*, were introduced by brothers Auguste and Louis Lumière in France.

Although the Edison and Lumière photographers are known for capturing different kinds of content, film historians have found similarities between the two. Actualities actually out-numbered fictional works in the Edison Company's offerings until longer stories began to be produced in about 1904. Similarly, the Lumière group took on fictional depictions, such as a series of films featuring Christ's 12 stations of the cross. There is also evidence that

both Edison and Lumière photographers attempted crude means of editing. For some actualities, the photographer stopped hand cranking the camera to wait for a more desirable scene (more people and activity) to unfold in front of the lens. In other cases, the film was cut to remove technically unacceptable foggy frames, a common result of stopping the hand crank in mid-shot.

Exhibitions and Showings

Once early cinema became a commercial endeavor, collections of short films were assembled in sequence for projection at the exhibitor's site. Although the exhibitors had ultimate control, production companies and filmmakers alike started to see the *order* of films as meaningful. Distribution companies marketed sets of films that "joined up" to tell a longer narrative. This tableau phase of storytelling often depended upon the audience's prior knowledge of the story, such as Lumière's series on the trial and crucifixion of Christ. When necessary, exhibitors hired lecturers to fill in gaps in a story for the audience, or used musicians to offer auditory cues to suggest meaning between the films.

On the filmmaker side, an early attempt at ordering shots to tell a story was advanced by British producer George Albert Smith. Smith filmed a scene of a man flirting with the woman inside a train car. The man eventually leans over to kiss the woman. Smith thought that the shot, when assembled between two shots of a train going into and out of a tunnel, would have a different meaning than if shown alone: it would suggest that the couple had snuck a kiss in the darkness of the tunnel. Editing, though, was still controlled by those who projected the film. The Warwick Trading Co. distributed Smith's *The Kiss in the Tunnel* (1899) with the suggestion that exhibitors "splice" the car scene between the two popular travel shots as Smith suggested.

Four years later American Edwin Porter parodied Smith's work in *What Happened in the Tunnel* (1903). This time, though, the film was made in one shot. Two women were travelling together. One was African American and, based on conventions of the day, would have been presumed to be the servant of the other. In Porter's film, the "tunnel" becomes a metaphor, represented as a filmmaker's technique of a fade to and from black. Porter used the fade to pull a narrative trick on the male character. As the scene fades out, the man appears to make his move. As it fades back in he discovers—along with the audience—that he has been kissing the servant character. He is subsequently angry at the suggested switch, and that delights both female characters. While the underlying racism and sexism of the scene doesn't match today's standards, the early use of this cinematic effect is what is significant for video students. Film historians call this type of editing, suggested by Smith and executed by Porter, *non-continuity narrative*. The editing disrupts the expected plot. Non-continuity storytelling acted as a

bridge between the one-shot narrative and to the third stage, the continuity form of storytelling.

Continuity of Action and Parallel Action

Whereas the *edit* is obvious to viewers in a non-continuity form, such as the fade to black or the jarring transition from outside to inside the train car, continuity editing minimizes the presence of a cut. Instead, action started in one shot and continued into another distracts the viewer from noticing the edit. In its earliest form, action in images often overlapped from one scene to the next. French director George Meliès' *A Trip to the Moon* (1902) uses a succession of shots to illustrate the launch and landing of a rocket from Earth to the moon. It includes the iconic shot during which a "Man in the Moon" face winces in pain as the spaceship hits his eye.

In this sequence, the craft lands on the moon twice: in a wide shot with the face of the moon reacting, and again in a wide shot on the moon itself. Overlapping action also appears in Smith's *Grandma's Reading Glass* (1900). A boy picks up his grandmother's magnifying glasses to examine objects in the room. In a wide shot he points to the bird cage and then wheels the magnifying glass to his eye. The next shot is a view of the birdcage through

Figure 5.1 Famous scene from Meliès *A Trip to the Moon* (1902), in which a spaceship hits the eye of the "Man in the Moon."

the lens of the glass. Similar two-shot sequences are repeated throughout the film as the character and his grandmother move to examine other objects.

In *Life of an American Fireman* (1903), Porter's shot of a hand pulling down a fire alarm sets up a sequence of firemen rushing out of their beds in response. In this stage of motion-picture development, then, multiple shots were captured in the field. They then were edited to represent a continuous flow of action, such as a rocket ship progressing to a landing on the moon, a boy's view of objects through a magnifying glass, and the movement that prompts firemen to action. This launched filmmaking to a more sophisticated level, from merely shooting one shot and then suggesting it connected with another, or using tricks, like a fade, to represent a jump in time. Continuity of action *condenses* the time it takes for an alarm to go off and the fire crew to arrive.

Not all storytelling experiments during this era became popular. In *The Big Swallow* (1901), James Williamson's camera remains steadfast as a man approaches the lens. The man comes closer and closer to the camera, opens his mouth, and, it appears, swallows the lens. The next shot shows the cameraman (and camera) in a dark, ominous location—presumably the man's stomach. Other techniques also seemed too jarring to gain acceptance as storytelling tools. For example, Porter's firefighter film begins with a picture-in-picture technique. A lone fireman sits in a darkened room while the viewer sees, in a shot inserted at the top corner, a woman tucking a small girl into bed. Presumably Porter was trying to imply that the man was imagining life at home, and longing to be with his family, but this technique did not become popular. While not every in-the-field experiment early film producers tried as a way to communicate a story visually grew into common practice, one did; continuity of action became a widespread convention. American filmmakers, in particular, increased both the number of shots and changes in camera perspective so that film editors could quicken the pace of apparent action.

In the last stage of early cinema's development, the continuity and discontinuity approaches to storytelling merged to form the technique of parallel action. By editing in parallel between two lines of action unfolding at the same time, but in different locations, filmmakers could, as film historian T. Gunning observed, literally suspend the outcome of each scene. The natural suspense created by dueling-yet-separate actions became a prominent feature of films popularized after about 1908. It is in this last stage that Gunning and other film historians believe that cinema began to grasp the uniqueness of the medium; through new techniques of story, shot, and editing, filmmakers could control the pace of action and give viewers an omnipresent picture of events across locations. Moving images, then, had spatial and temporal attributes more akin to novels, and not in the practices of still photography and theater that early cinema producers had tried first to mimic.

Controlling Space and Time Today

So what do these early discoveries mean for photographers shooting video today? Quite a bit, because the techniques still form a base for strong video. Early cinema's main storytelling lesson is that *editing* dictates the shots needed and gathered in the field. The structure of an edit can either reflect a continuity of action or disrupt the action's flow. How, though, do videographers keep in mind that edit expectation while they are capturing video clips of real-life moments? Taking the basic notions of cinematic language as a framework, the next section introduces a set of phrases as mental tools photojournalists can use in the wild—that is, in real-life situations where staging or setting up scenes is usually neither feasible nor ethical. These mental reminders, or mantras, are useful for anyone using video to tell a mass-media aimed story, whether that story airs on a local newscast, is published online, or is part of a longer form of video storytelling, such as a documentary.

Figure 5.2 Screen grabs from a video sequence of an acting group practicing for a medieval fair performance. The wide shot establishes the location and the relationship between the actors, e.g. the narrator (reading from the script) and the two warring sides in the play.

Credit: Julie Jones

Shooting for the Edit

It may seem that contemplating an entire edit while shooting a story is, at best, nearly overwhelming or, at worst, downright impossible. This mental task is especially daunting when you consider the amount of technical and

practical elements a videographer must also keep in mind as he or she captures what is happening in front of a lens.

To begin with, instead of thinking of the entire work overall, it is helpful to remember that a video story is actually a series of *sequences* that tell a larger story. For this discussion, a sequence is defined as two or more shots of an action. Sequences serve basic storytelling needs. They give the viewer a sense of presence, establish a story's location, and introduce characters. In this way, sequences help to answer questions viewers might have simmering in the back of their minds. In real life, when the meaning of a situation is unclear people use visual clues to answer questions. Video stories are no different. A new location or situation presented in a video also needs to include visual clues to explain what is happening.

As an example, contemplate the questions a person might have if he were suddenly dropped into a backyard where a medieval acting group is rehearsing a performance. The person will likely be asking himself: Where am I? Who are these people? What is going on? Good storytellers of any medium address these basic storytelling needs. For video storytellers, presenting a sequence of action to viewers helps to quickly answer these questions.

A videographer may repeatedly ask herself, "What does the viewer need to see next?" In regards to the medieval acting group, she can answer that question visually: this is where the action is happening (wide shot); this man is a key character (medium shot of the narrator); this is the script he is reading from (tighter shot over his shoulder); here are the people listening to him (shot of the actors). In cinematic language terms, each of these shots aids in the continuity of the sequence. When the action a videographer is capturing *repeats* itself naturally, the possibility of capturing *overlapping action* in the sequence is enhanced. In a play setting, of course, rehearsals give the photographer plenty of opportunities to get different shots.

But in the real world, repetitive action happens more than a casual observer may expect. Consider this scenario: a mountain rescue of stranded hikers is underway. First responders are scouting for the best rescue plan. From the command center, search-and-rescue teams gear up while helicopters circle around to survey the terrain around the trapped hikers. All of these actions offer the possibility of overlapping action, because all happen repeatedly. Every time a helicopter takes off or a new group heads up the mountain, the videographer has an opportunity to record different shots of that particular action. Overlapping action happens in less dramatic scenarios too. A person working at a computer will use the same hand to operate the mouse and often repeats smaller gestures, such as moving the mouse in the same manner over and over. Friends ordering food at a lunch bar will take some time scanning over the menu on the wall before making a decision. Noticing overlapping action is the first step to gathering the variety of shots needed to build a seamless edit.

Building Sequences in the Field: Mantras as Mental Reminders

The next challenge for the videographer is to understand which shots are needed to build continuity, and when that continuity should be disrupted. For this task, a series of mantras are helpful to cover a number of shots necessary to maintain—or disrupt—continuity in the edit.

The *first mantra* reminds the photographer to record *wide, medium, and tight* shots. Continuity editing is best served with a variety of shots that represent an action. In the mountain-rescue scenario, two wide shots of helicopters taking off is not the strongest option. Instead, each time a helicopter takes off is an invitation to capture a *different shot* rather than the ones already recorded. Shots from different focal lengths are stronger than a wide-to-wide edit because the scene then changes enough to keep the viewer engaged on the helicopter taking off, and so not notice the edit.

Edits are also less apparent to the viewer when the shots are from different perspectives. In order to get different views of an action, the *second mantra* reminds videographers to *shoot and move*. An edit between two shots is less noticeable when recorded from different camera perspectives—*even if* they are similar focal lengths.

Figure 5.3 shows two different sequences of a golfer practicing on the driving range. In the first sequence, the golfer appears to jump because the

Figure 5.3 In the first sequence, the background behind the golfer does not change in the two shots. This produces a jarring edit, the action of the golfer appearing to "jump." Shooting from different camera perspectives helps to smooth out the action of the edit in the second sequence, even though the two shots are similar in focal length (medium-wide to medium-wide).

Credit: Julie Jones

Figure 5.4 Different focal lengths and perspectives for a sequence of a golf swing. Shoot and move means not only moving to different camera locations, but also changing camera angles.

Credit: Julie Jones

sky behind him does not change between the two shots. Moving the camera also means changing perspective from low to high angles of view and, for a golf story, a shot from the level of the ball seems required.

The *third mantra* for video storytelling is based on a familiar idea played out in everyday life. Whenever someone or something acts, someone or something responds. Keeping the concept of *action–reaction* in mind helps the videographer build a sequence that occurs naturally. For example, a football team makes a touchdown, and the crowd cheers; a person clicks a computer mouse, and something appears on the screen; a golfer hits a ball, and the ball takes off. In cinematic terms, "action–reaction" is a bit of parallel action coming to life. Returning to the mountain rescue, a helicopter takes off, and the ground crew watches it.

Understanding parallel storytelling along with screen direction can help a videographer visually represent conflicts before they unfold. Consider the possibilities present during a protest march with a group of bystanders looking on. If the video journalist anticipates that the two sides may be (or already are) in conflict, shooting the protesters looking one way and the bystanders looking a different way distinguishes between the two groups. In cinematic terms, this is known as the *axis line* or the 180-degree rule. In principle, continuity across shots and consistency in camera direction

establishes that line. In reality, though, it is hard to fix an imaginary line in the real world and keep people (and things) on one side or the other of the "180." This is especially true for video journalists in the field because they, along with the subjects they are covering, are rarely stationary.

Screen direction is therefore better handled in the viewfinder rather than outside of it. Keeping track of screen direction in the viewfinder is as easy as remembering the *fourth mantra*: *the noses always know*. Even when events seem chaotic, at any moment the photographer can keep track of screen direction by noticing in the viewfinder the direction different groups' noses point.

Considering the battle scene of the medieval rehearsal, we can expect two natural sides. By shooting the actors from one side looking in one direction, and the other group looking in the opposite direction, the photographer can create visual clues so that the viewer can parse out *who* is on *what side*.

This is similar to the protest scenario. Anticipating a possible clash, the video journalist could start by framing the protesters as looking screen left and the

Figure 5.5 When two groups are in conflict with each other, maintaining screen direction helps to distinguish who is on each side. This principle also applies when people are talking to each other. Each side of a discussion should look at the other as the story is edited. Keeping track of where people's noses are pointing in the frame creates continuity.

Credit: Julie Jones

bystanders looking screen right. Keeping "the noses always know" mantra in mind, the videographer can use screen direct as a powerful tool to build continuity, or to disrupt it to better tell a story.

Sequences are building blocks. They are essential parts for the construction of the story but not the whole story itself. *Transitional* shots are needed whenever a story shifts in time or location. When these shots are not captured in the field, visual editors can use less compelling means of spatial and temporal control, such as dissolves or narrator tracks. One way to remember to capture transitional shots in the field is to memorize the *fifth mantra*: *cutaways*. Cutaways are shots that help *cut away* from an established sequence. A cutaway may be as simple as a wide shot that establishes a new location or as complex as a series of shots that moves the story forward. When used with corresponding natural sound, a cutaway can help the viewer understand that a new part of the story is about to unfold.

Reaction shots also offer an effective way to cut away from one sequence to the next. Returning to our medieval players, a videographer can capture a

Figure 5.6 Reaction shots are especially powerful tools to maintain continuity and transitions. People understand reactions because they are part of everyday life. Reaction shots can also help move the story forward in time or change of location. In this sequence, the woman's reaction helps the story move away from the narrator (dressed in red) to introduce the director into the scene (wearing a leather jacket).

Credit: Julie Jones

cutaway of someone listening to the narrator. This allows the videography to cut to another time, such as when the director gave the actor his notes on their performance.

In the story about a football game, the shot of a crowd cheering a touchdown can serve as a cutaway to events that happen later in the game, or even somewhere else—such as cheering fans in a bar. The reaction shot helps to pull away from one action and transition to a different place or later time in the story.

Conclusion

The five mantras are touchstone phrases a videographer can use in the field as a mental tool. Each mantra is a reminder to gather certain kinds of shots that will be used for sequences. The first two mantras, *wide, medium, tight* and *shoot and move*, prompt the photographer to shoot multiple shots from different perspectives of an action. By looking for *action–reaction* moments, the video journalist supplies a vital part of a story—whenever something happens, usually something or someone responds. *The noses know* reinforces the way screen direction can enhance continuity or visually set two sides of a story apart. This is particularly helpful when parallel action happens naturally in the field. Finally, capturing *cutaways* gives the story transitional simplicity, and considers the need for more drastic means of progressing the story forward, like postproduction transitions or overt narration.

This chapter has laid out the logic underpinning visual storytelling that was developed more than a century ago, during the age of early cinema. Film producers came to realize that the power of moving images was not in a single image itself, but in the connection between shots. This gave a sense of realism and presence to a story in a way unlike still photography or theater. To help videographers make use of these techniques in the field, the chapter offers a basic set of five easy-to-learn mantras. For more on how to use these techniques to produce powerful videos in the editing studio, consult Chapter 4.

What Do You Think?

1. Why do videographers use different types of shots to build sequences for storytelling? What do the different shots do?

2. Videographers use different camera angles and widths to build sequences. They might record multiple shots of repetitive action at different times. What problems could occur in editing a story with similar shots made at different times?

What Can You Do?

1. Look for the use of different shots and sequences in different forms of video:

 a. Watch a news video story, either on television or online. Note the different types of shots in the story and the way they are put together to create a sequence.

 b. Watch a segment of a documentary film. Note the different types of shots in the story and the way they are put together to create a sequence.

 c. Watch a segment of a fictional program, either a show on television or a cinematic film. Note the different types of shots in the story and the way they are put together to create a sequence.

 d. Compare your notes among the different forms. What types of shots are similar in the different forms? How are they used differently?

2. Identify an activity that you could break into a sequence of video shots. Have a partner do the activity while you record video of the different steps. Do you have the shots you would need to edit a sequence?

Photocommunication, the Internet, and Social Media

Walter P. Calahan and Keith Greenwood

Introduction

In the ever-expanding world of online media, the roles of the internet, social media, and photographic communication are forever linked. According to the Pew Research Center, 86 percent of Americans use the internet, and the various channels available through the internet provide a means to easily distribute content. Social media provide ways for a photographer to build an audience of viewers, to share work, and, potentially, to generate financial support for a photo or video project. Whether a high-school yearbook photographer or a world traveling *National Geographic* contributor, all practicing photographers must embrace social media as a means of reaching a wider audience that was just a dream to twentieth-century journalists.

But the world of social media is complex. Gone are the days of having only a website as a showcase for a photographer's portfolio that could be updated a couple of times a year, and fading is the dedicated blog that people visit every few days to learn about a photographer's recent work. Now photographers must bridge between multiple social media platforms that expand their visual reach around the world morning, noon, and night. Photographers must think like a 24-hour news cycle that once was the domain of cable news programming. They must drive the conversation, send up signal flares, and shout from the mountain top that they are here.

Adding to the complexity is the fact that social media generally are accessed differently than previous online forms. Viewers are not sitting in front of a computer monitor but are staying abreast with content on the go with mobile devices. Those devices and the different social media platforms accessed on them also have different parameters for how photography and video are

Figure 6.1 The majority of users today access social media by smartphones or other mobile devices.

Credit: Keith Greenwood

displayed. Photographers have to adapt to multiple changing standards as they share content through multiple channels.

Mastery of the image is not the only thing that counts in the social media world. Words matter, too, particularly keywords in the form of hashtags. The very social media we embrace empowers us through the use of tags that automatically send our content out to internet venues that have vast audiences.

There are some concerns related to social media for photocommunication. Social networks may lead people to a photographer's work who otherwise might not have seen it, but who shares the work and how they share it can change how the work is viewed and understood. And while positive conversations can be generated through social media, they also can be a source of negativity.

So how do we make sense of something that is different today than it will be tomorrow? We probably have no control over computer programmers, corporations who own social media outlets, or the people who use it, so we must embrace our role as perpetual students of this revolution. However,

whether sharing content for an organization or promoting our own work, some consistent ideas for photocommunication and social media are worth exploring.

What Are Social Media?

Social media are digital channels that allow users to create and share content and to build networks with other users. Social media reflect the evolution of online communication that began with websites in the 1990s. Those websites started out as digital channels where one communicator, whether organization or individual photographer, could distribute content to many viewers. In the social media world, the users are interacting and sharing stories, photographs, and video with one another.

Communication through websites was largely one-way, from the content creator to the site visitors. A person might find contact information or a form that would allow communication with the website's creator, but the communication occurred through a separate channel and was invisible to other visitors. The Web 2.0 evolution brought website users into the mix, providing options for visitors to add comments to content on the site. Visitors could provide support and encouragement to the content creators, or they could express disagreement and argue with the content creators or even with one another. The comments also could spark ideas for new work.

The introduction of easily accessible tools to create weblogs, or blogs, continued the evolution, simplifying the process for anyone to create a digital space for their own voice. Blogs allowed more individuals and organizations opportunities to spread their message to a larger audience and to engage in a dialog with viewers. Whether website or blog, the comments became part of the conversation along with the original content.

Websites and blogs still required people interested in the content to find it, though. Viewers interested in specific topics or communicators could search to find them, and they could save the locations in their browsers to easily return, but sharing something interesting found on a site involved emailing a link to other interested users or possibly adding it to one's own blog.

Social media changed that model. Instead of a user building webs of information sources, social media put the emphasis on webs of other users. Rather than searching for content from individuals or organizations who publish it, social media users find content that has been shared by other users they are connected to. Social media also provide people with a simple means to promote their own perspectives. "Hi, friends. Here are things I think are important or interesting! You should, too!"

Social media have changed information-seeking behavior. The Pew Research Center's 2016 survey determined that 62 percent of adults in the United States get their news on social media, and the majority of those users, 64 percent,

get news through just one social media channel rather than following several. Social media sharing has impact. The more friends who post or react to some information in social media, the more likely a person is going to take the time to look at it. We trust that our friends who have similar interests will share things that would interest us. Conversely, we also may disagree with some of our social media connections. (Just because you went to the same high school doesn't mean you have the same views.) We may identify the content those people share as false or simply not worth paying attention to. Our social media friends have taken over from anonymous editors to become our information gatekeepers.

But organizations are working to reclaim some share of the gatekeeper role. As social media use by individuals has spread, organizations also have adopted the channel as a way to reach an audience. News organizations use social media to spread word of breaking news or to promote stories in the newspaper or on a broadcast. Organizations also use social media as part of a strategic communication strategy to forge relationships with customers or other people interested in their products or services.

All these online communication channels are important for photocommunication. Whether individual photographer or communication organization, internet and social media channels have different demands and fulfill different functions for presenting photography and connecting with an audience. How they are combined reflects a photographer's goals and intended audience. The following discussion will focus on the perspective of an individual photographer, but some of the ideas also reflect concerns for photographers working within organizations, too.

The Starting Points: Websites

While not social media, establishing a website should not be overlooked. A website serves as the foundation of a photographer's online presence, providing visitors with a clear vision of a photographer's specialties. A photographer's website is a statement about the type of work she or he does, a portfolio of her or his best work, and information about how to contact her or him. It also can direct users to the photographer's social media profiles. Organizations have websites, too, of course, where news stories with photographs or video and galleries of photographs can be posted. Postings on social media can link users to more content on the website of a photographer or organization.

Many social media sites limit a photographer to posting a single image. The photographer's website can present stories consisting of multiple photographs along with galleries that showcase the range of a photographer's work. Photographers who work in multiple areas might create different galleries for each one. Photographers working in the news field might have separate galleries for news events and for sports.

Figure 6.2 A professional photographer's website should include a portfolio of best work, a statement regarding specialties, contact information, and links to social media.

Credit: Walter P. Calahan

Sidebar 6.1: Domain, or Not to Domain?

When setting up a website or blog, a photographer is staking out a place on the internet. Getting a website set up may be easy, but that does not mean that it will be easy for users to find it.

What domain name will best identify that digital place? It's a key decision for a photographer hoping to establish a domain.

Every website has a domain name that is part of its digital address, or uniform resource locator (URL). Websites set up through hosting services may have long URLs that incorporate the hosting company's domain name with some indication of the photographer's name. In the URL www.webhostingcompany. com/photographername/, the domain is webhostingcompany.com. The photographer's name is a directory on the company's web server. This is a pretty straightforward URL, but some can be more complicated.

On the other hand, if the photographer registers his or her own domain name for the website, that domain replaces the hosting company's name in the URL. Using the previous example, the domain could be as simple as www.photographername.com. A photographer who establishes multiple websites for different types of photography could register distinct domain names for each one.

Registering a domain name is fairly simple, as long as the one you want hasn't already been taken. If you move your website to a new hosting site the domain can stay the same. Several sites exist online to help register domain names, including some companies that also host websites.

Commercial photographers might have separate galleries for studio and location work, or for portraits and product photography. When the range of work is very different, though, some photographers create multiple websites. For example, a photographer who works primarily in news/editorial but supplements his or her income by photographing weddings might set up a separate website for each area. Likewise, someone working as a photographer for a public-relations firm might create a separate website for his or her artistic landscape photographs.

Setting up a website can be a simple process, especially if it is done through a company that offers template website forms. All a photographer has to do is pay a monthly subscription and fill content into the template. Photographers also can build their websites from scratch using tools that help to write the code. This approach will have a larger learning curve than the ready-to-use templates but provides greater ability to customize the look and feel of the website, helping it to stand out from everyone else's.

An additional advantage to using companies that provide templates is that it can simplify the process of adding keywords that help search engines catalog the site. A key to effectiveness of any website is that it must play nicely with search-engine tools. Website code must include lines that welcome search engines and tell them what they want to know, so that when an art director Googles "photographer Peoria" they find you. Website have downsides. The galleries often are not updated frequently. Viewers will not visit repeatedly unless new content is available, but a collection of a photographer's *best* work would not significantly change on a regular basis. For more frequent updates about ongoing work, some photographers turn to weblogs, known more commonly as blogs.

Starting a Conversation: Blogs

Blogs provide a tool for photographers to easily share their thoughts and latest work. If websites are collections of a photographer's best work, blogs are the "Hey, look what I did" updates, whether something from the latest assignment or an ongoing personal project. Photographic updates can be simple—a small gallery from an assignment or some interesting photography from a weekend trip. Blogs also are a means for a photographer to share opinions about the photographic world. Photographers can share links to and write about other online articles. The key is to publish content that is the best possible, and write about efforts in creating the photographs.

Like websites, blogs can be created easily using one of several online platforms. Companies provide space and templates for your blog along with tools and plug-ins for customizing content (such as embedding social media feeds), tracking viewer behavior or to notify followers when new content is added. The choice of blog site provider is largely one of templates, tools, and space.

An added feature of a blog compared to a website is the ability for viewers to more easily communicate with the photographer. Blogs offer options for people to add comments about content that has been posted. If a creator decides to allow comments on a blog, he or she should go through a screening process before allowing remarks to appear. A professional wants to maintain as much control as possible of online presence. Reviewing comments allows the creator to eliminate irrelevant comments or negative remarks directed at other users. The photographer may want to reply to comments. Replies should project the same professionalism in comments as in the rest of the website or blog. This includes making responses as positive as possible, and proofreading for spelling and grammar errors.

The blog can be an entry to a photographer's website. Photographs posted to the blog can link to a larger gallery of website images, as regular blog visitors may be more often willing to click over to a website to check for new material. That works both ways: a blog should be linked from the website so people who find a collection of best work can easily be directed to the ongoing work on the blog.

Like websites, though, a blog must be fed. Without new content uploaded often, people will soon start to ignore a blog. Another hurdle: people must actively seek out a blog. This is where other social media come into play.

Making Connections: Social Media

Social media are important tools for individual photographers as well as organizations. For individuals, social media can greatly expand the reach of communication by taking advantage of a network of users. A photographer might share a photograph on a social media site. That photographer's friends

or followers on social media might "like" or comment on the photograph. That becomes visible to others in their social network. In this way, a photographer's message can be seen by people well outside a narrow social media network.

Organizations also find social media important, especially when posts come from individuals within the organization. A study of Twitter usage in Canada indicated that users retweeted stories more often when the initial messages came from actual journalists rather than from a news organization's general account. Twitter users feel personal engagement with other users. The implication is that photographers can use social media to form connections with other users, regardless of whether they are posting their own work or promoting an organization's publications.

Not all social media platforms are the same or equally as popular, of course. The 2016 Pew Research Center survey mentioned earlier found that 68 percent of adults in the United States, including those who do not use the internet in general, are Facebook users, compared to 28 percent who use Instagram, 26 percent who use Pinterest, 25 percent who are on LinkedIn, and 21 percent who use Twitter. Photographers need to consider the characteristics of platform and audience to select the best social media channel for their communication needs.

Facebook

Think of Facebook as a blog located where everyone else is located. Social media users across all categories of age, education, and income log on to Facebook, meaning that it is there that a photographer can find the broadest range of potential viewers. Like websites that can be focused on specific types of photography, Facebook provides opportunities for photographers to establish different pages. A photographer can set up a personal page to share photographs, comments, and daily activities with people within his or her social connections, and can still set up a separate page dedicated solely to professional photography work. Unlike websites, Facebook gives the photographer more control over viewers of those pages. The personal page can be limited to viewing only by friends and family, while the professional page can be open to the public. Professionals may keep posts about what they ate for lunch, the party they attended, or their political beliefs to their personal page, while keeping the focus of the photography page on photography.

A photography Facebook page should have much of the same information that a photographer's website would have. A visitor to the page should be able to find out a photographer's specialty, location, and contact information. The page should link to the photographer's website, and the website should link to the photographer's Facebook page.

Facebook uses algorithms to analyze the types of pages and posts that users engage with, and responds by showing users more items that perhaps will suit their interests.

This means that engaging with other users and pages on Facebook will improve the chances of a photographer's page being suggested to users who have similar interests. Photographers should post regularly and consistently, but it's not necessary to post multiple times a day to promote their work. Facebook does allow a user to create albums of photographs, but posts related to photography most often involve a single image with a short, informative caption. Similar to blog posts, the image and text could be from a recent assignment or work on an ongoing project. Photographers working for an organization might post a photograph from a local event with a link to more work on the organization's website. Older images from a photographer's archive also could attract interest. For instance, "Throwback Thursday," a recent trend of posting old pictures on that day, provides an opportunity for a photographer to post older work with a connection to a current theme. Users who are interested in the throwback image might scroll through other posts on the photographer's page. If they like what they see, and "like" the photographer's page, the photographer's social network is widened.

Facebook photographs help to establish a photographer's identity or brand, particularly through profile and cover pictures. A photographer's Facebook page should have a quality portrait that reflects a professional appearance for a potential client or subject. If the focus of the page is wedding photography, the photographer should dress as she would at a wedding. A photojournalist working in the field may not always wear business clothes, but the profile photo should project a professional image that conveys friendliness and trust.

The other key image on Facebook is the cover photo. A photographer's audience needs to see an image that grabs them and instantly tells them what kind of work the photographer does. People who arrive at the page of a news photographer who works at capturing spot news for a local newspaper should not see a pretty flower photo as a cover image. The content on the Facebook home page needs to support the content and tone of a photographer's website home page. Mismatched information leads to confused audiences who don't help spread the word about a photographer.

One more way that photographers can use Facebook to create awareness of their work is to recognize and promote the work of others. Photographers who post about a company that was easy to work with for acquiring lighting equipment, musicians they photograph, or caterers who provide food for events build goodwill with those people and promote them to other users, and if those people "like" or comment on the post, people in their social network will be drawn to the photographer's page. Not all Facebook posts have to be about a photographer's own work. Photographers might also post about new directions or issues in photography, upcoming gallery openings, or even other photographers. All posts should be designed to boost a photographer's credibility with an audience.

Instagram

If ever there was a social media app specifically friendly to photographers, it is Instagram. Where Facebook provides a location for people to find information about a professional's photography, Instagram focuses primarily on sharing photographs and video. With the ubiquitous use of smartphones with built-in cameras and internet access, it seems that Instagram, or something like it, had to be invented. As noted, about 28 percent of all Americans use Instagram. Unlike Facebook, though, users tend to be younger, and more women than men use it, according to the Pew Research Center.

Instagram is owned by Facebook. Like Facebook it uses algorithms to analyze the kinds of photographs and video a user is most interested in seeing. For photographers, that means that, as with Facebook, interacting with users and encouraging them to "like" and comment on photographs helps raise the visibility of a photographer's work on the site. A popular way to make photographs more visible is to include familiar hashtags with captions. Hashtags are keywords that begin with a # symbol and link the photographs to topics, making it easier for Instagram users to find them. The hashtag #tbt is used to denote images related to Throwback Thursday. Locations can also be connected to other Instagram photographs, making it easier for users to find images made near them or around an event. (Note: adding a location to images can raise privacy issues. Photographers should avoid tagging a location in an Instagram image that invades someone's privacy.)

Like Facebook, Instagram relies on single images and videos. It is best suited to showcasing new work and spur-of-the-moment images, but more photographers are experimenting with Instagram to present ongoing projects. Photographers can turn to Instagram to present multiple-images projects in real time, as the photos are being made.[1]

Figure 6.3 Instagram's ability to quickly share photos is an attraction to serious photographers who hope to reach a larger audience.

Credit: Keith Greenwood

The Instagram app can be used as a stand-alone camera and editing tool or solely as a postproduction and upload tool. Compared to camera apps in both Android and iOS, however, Instagram's app is limited. Many specialty camera apps have more powerful shooting modes and shooting tools. But Instagram's app does provide editing tools to crop photographs and to adjust features like brightness, contrast, and color balance. Instagram also features setting combinations as filters that can be applied with one tap. Some filters can be useful for professional mass media, such as an easy conversion from color to black and white. Other filters may significantly alter the image. Photographers working in journalism need to remember the ethics of their craft: filters should not be applied to change the message of the image.

Regular cameras can be used with Instagram. Photographs can be transferred from the camera to a computer and uploaded to a user's Instagram site. The Instagram app also offers edit and upload options for cameras with smartphone or tablet connections. Instagram also offers easy sharing across other social media platforms, allowing a photographer to link images on Instagram to accounts on sites like Facebook, Twitter, Tumblr, Flickr, and Swarm. Instagram's power has pushed cell-phone manufacturers to improve the quality of their built-in cameras. The future will only see better and better smartphone camera quality to match public demand. One cultural effect of apps like Instagram has been emergence of the "selfie." But it is a form of self-expression that should be of limited use for any serious photographer. Yes, the public wants to know who you are, so a selfie from an event from time to time is fine, but mostly the public wants to see the photographs you make of the event.

Twitter

Twitter features a short message blast to an audience. It's different from Facebook or Instagram in that users are restricted to a 140-character message, called a tweet. Photographs or video can be attached and do not count in the 140-character limit, but that limit does determine what a creator can say about a photograph. While Facebook offers a stable location for photography, Twitter offers a platform for the spur of the moment. Tweets are short bursts that let followers know what is happening, the photographs of it, and what the creator thinks about it.

Twitter is a great tool to drive people to other internet locations. A photographer who covers the local championship football team victory and has put a gallery up on Facebook or an organization's website could send a tweet about the gallery with a link to the gallery. A photographer also could send a tweet from Instagram to promote the work. Photographers also use Twitter to promote their work. They can tweet about the opening of an exhibition containing their work, a workshop they are teaching, or a publication by them in the media. Newspapers and magazines love to have

their journalists tweet a story—it drives more viewers to the publication's website.

As with other social media, tweets need hashtags. They help users to find content related to their interests. Photographers using Twitter can also gain more attention by interacting with other users. Replying to and retweeting posts from others can increase visibility for a photographer among the original poster's followers. Retweeted posts of course should be relevant to the photographer's audience. Retweeting everything that shows up in a feed will overshadow the photographer's own tweets. And remember to keep the focus on professional work. Photographers who want to tweet about politics, their lunch experience, or other aspects of personal life should establish a separate account.

Snapchat

Snapchat is a newer social media channel than Facebook, Instagram, and Twitter. It features a streaming service of moments that seem to recall the man behind the curtain in the old movie *Wizard of Oz*. A photographer can use this storytelling tool to educate followers about *how* the photography is done, but not *what* is created. The makers of Snapchat want users to think of its messaging as being a "conversation," rather than an information-collecting "transaction." Another comparison is perhaps a temporary Instagram, where photos and videos (from 1 to 10 seconds in length) are posted, but disappear as followers view them. A photographer can't create a gallery of images over time as in Facebook, Instagram, or Twitter, but will offer fleeting interactions, as the visual moments come and go in real time.

Why then should a photographer use Snapchat if the photographs and videos will disappear? Isn't the goal to create a permanent record of a photographer's talents? Using Snapchat requires turning one's sight to a different perspective, to see the brief post as part of the creator's larger social networking system. A photographer using Instagram does not need to duplicate the work in Snapchat. The power of Snapchat is in the ephemeral. This is the place for photographers to post images and videos of behind-the-scenes moments leading up to the creation of a photograph or video that will permanently appear on a website or another social media channel. A photographer waiting to cover a political rally can use Snapchat to show what's going on while she waits for the candidate to arrive. The images made at the rally itself might appear on a news organization's website, the photographer's social media channels, or both. Meanwhile, Snapchat can also be a tool to show how the photographer set up unusual lighting for a shoot, while directing people to Instagram or Facebook to see the results. Snapchat is a tool with the specific purpose of directing users to other locations of a photographer's work. It also is a better place to post a photographer's selfies.

Pinterest

Pinterest may not be the first social media forum a photographic professional considers, but it has an advantage other sites do not: the power of people who share a photographer's interests. Imagine being a wildlife photographer who also enjoys fly fishing. A lot of people love wildlife and fly fishing. Imagine getting them to spread the word about a photographer's amazing photographs of fly fishing and the surrounding nature she or he encounters. Or imagine a landscape photographer who photographs the amazing designs of landscape architects, and sees everyone on Pinterest sharing the images. You name the topic, and there are people with a passion for it. Your photography can travel to more eyes when Pinterest members share it.

Pinterest also can be a source for inspiration. A photographer can use a Pinterest board to save interesting and inspiring photos or to find ones pinned by other users. The images are worth coming back to for specific photograph ideas.

LinkedIn

At first glance LinkedIn appears to be a résumé location for job-seekers. It is that and more. A freelance photographer is always a job-seeker, and LinkedIn (or similar sites) provide a location for a photographer's credentials with a business-oriented look and feel. LinkedIn's real advantage, however, is the power to network. A commercial photographer who provides photographs for annual reports might use LinkedIn as a tool to research companies' internal communications departments and build a social network of professionals who need to hire photographers. Don't forget: those professionals might also use LinkedIn to search for nearby photographers who can provide the work they need. Having a LinkedIn presence with accurate keywords related to photographic specialties makes it possible for communication professionals to find an appropriate photographer. As with other social media, a LinkedIn profile also can include links to a photographer's website, blog, and other social media accounts.

Google+

Google+ is Google's social media answer to Facebook.

The core feature of Google+ is "Circles." This empowers the user to link to friends, family, and co-workers in different circles of connection so that information can be shared differently. What a user wants family members to know isn't necessarily broadcast to friends and professional colleagues. Posts also can be organized into "streams" that filter posts among circles. The feature may be helpful to a photographer organizing groups of viewers for a variety of photographic content.

Figure 6.4 The majority of users access social media on their smartphone or other device, in the United States and around the world. Tokyo, Japan.

Credit: Ross F. Collins

Like some other social media sites, Google+ allows sorting and cataloguing posts. The "Collections" feature on Google+ is similar to Pinterest, and the "What's hot" stream resembles Twitter's "Trending Topics." Google+ also provides a built-in photo editor to adjust images after posting.

The analytical tools of Google+ helps photographers to see how people are interacting with posts. The tool provides photographers with another means of maintaining their presence in the complex world of social media.

YouTube and Vimeo

In addition to sites like Facebook and Twitter, YouTube and Vimeo are the places to be seen for photographers who work with video. Each site provides free access to a location for uploading video and fee-based options to upgrade to a higher level of service. Paid accounts offer perks like additional storage space, the ability to present videos without advertising, and analytic tools to track viewers' activities.

Both YouTube and Vimeo restrict some content, prohibiting pornography, harassing videos, and other inappropriate material. The services expect users to comply with copyright rules. A photographer cannot post video content that contains copyrighted music or video clips without permission of the copyright owner. The services also may require certain types of users, such

as businesses, to subscribe to a paid account plan. This could be a tricky area for independent photographers. Uploading a documentary video about a local issue may not be considered commercial content, but uploading a video promoting a photographer's video shooting and editing skills could be considered promotion. Photographers should check the guidelines to make sure that content complies.

As with other social media channels, the choice of service to stream video must take into account the intended audience. For a nuts-and-bolts photographer who wishes to promote videos demonstrating problem-solving techniques, such as mounting cameras to moving cars, trucks, and airplanes, YouTube might be the best venue for the work. Documentary video projects may be better presented in Vimeo.

Following Others on Social Media

So far we have approached internet and social media from the perspective of distributing a photographer's work. Photographers also can benefit from social media by following others. Following other photographers on social media provides a ready source of examples and comparisons. Photographers historically have learned from the work of others. Seeing examples of how another photographer has used lighting or found a unique camera angle to show a familiar subject in a new way can be inspirational and instructive.

Following others on social media also helps create an environment for a photographer to gain notice for his or her work. Liking, retweeting, and commenting on the work of other photographers may get noticed. Those photographers may return the favor, broadening the range of exposure work receives. From a business perspective, independent photographers also want to pay attention to the social media of clients. A photographer who photographs a local celebrity golf tournament should make sure that the golf course and the local professionals who play there follow her or him on social media. The photographer's social media posts may be shared or retweeted expanding the original post through their networks. The snowball effect to get a photographer's name out can be amazing.

The Small Screen

So far this chapter has touched on characteristics of internet and social media channels to help determine a photographer's choice of which to use and how to use them. Just as the focus of these different channels vary, so do the ways that content is presented and how the users access it. Websites and blogs may be viewed more often on computer screens, but social media are often viewed on the go through mobile devices like tablets and smartphones. The screen size, and the way that content is presented within a site, raises some

considerations for photographers in selecting the content to share and how it is formatted.

Computer screens can display large images. That's a plus for a photographer's website portfolio or blog. Smaller images that might be used for navigation or to give an overall sense of a gallery can be opened as larger images measuring 1000 pixels or more wide. The screen size allows photographers to present large images that display a lot of space. Think of a photograph of a golf tournament that shows a golfer walking down the fairway with crowds of spectators on either side. That image includes a lot of space and could be easily viewed as a large image on a computer screen, but on a smaller screen individual areas of the photograph would not be distinct.

Photographs displayed on smaller screens, or in smaller spaces within other content on websites, communicate better when the camera is closer to the subject. Even though the image dimensions may be large in terms of pixels, the photograph is being displayed in a smaller space. Instead of photographs that contain a lot of area, like the golf-course example, photographs selected for smaller screens should focus more tightly on the main subject. An image of the golfer teeing off or lining up a putt would work better on the smaller screen.

Just like different devices have different screen sizes and resolutions, different social media channels have varying parameters for image sizes. As photographers choose and edit their work for display through different channels, they should be mindful of the purpose of the image and how it will be displayed. The differences can be noticed in just a few social media sites.

Facebook, for example, has differing image sizes depending on the role the photograph fulfills on the site. Profile photographs display at 170 pixels square. The content of the photograph will be best readable if the subject fills the frame. Overall, though, Facebook leans to horizontal photographs. Cover images are displayed at 820 pixels by 312 pixels. Strongly vertical photographs of a skyscraper would not work well as cover photographs, but strongly horizontal, almost panoramic, photographs would be good choices. Facebook displays other photographs approximately 1200 pixels wide and a little more than 600 pixels high.

Twitter profile photographs occupy more space on the screen at 400 pixels square. Cover photographs on Twitter accounts are still strongly horizontal though at 1500 pixels wide by 500 pixels high. Images that are shared through Twitter also are horizontal in format. At 440 pixels by 220 pixels they cover less space than the profile picture.

Instagram users have one of the smallest profile photograph sizes among social media sites. Instagram profile photographs also are formatted to be square images but only 150 pixels in width and height. The main photographs in Instagram display at 1080 pixels wide, but the vertical dimension varies. In Instagram's first years photographs were displayed in a square format, but

Sidebar 6.2: Not All Pixels Are the Same

Computer, tablet, and smartphone screens are typically measured in two ways: physical screen size and the number of pixels the screen can display. Physical size is obvious. An inch is an inch (or 2.54cm), and a laptop screen is many inches larger than a smartphone screen. But pixels (short for picture elements) can vary in size. If small, more can be displayed in the same amount of space.

At the time of this writing, a popular laptop computer with a 15-inch screen (38.1cm) measured diagonally has a screen resolution of 2880 pixels by 1800 pixels. A popular smartphone screen measures 4.7 inches (12cm) diagonally and, when held vertically, has a screen resolution of 750 pixels by 1334 pixels. At first glance the difference seems obvious. The smartphone screen is much smaller than the laptop screen and would display fewer pixels. However, the ratio of pixels to screen size on the laptop is 220 pixels/inch, while the ratio on the smartphone is about 326 pixels per inch. The smartphone displays more pixels in a smaller physical space.

the site now also displays horizontal and vertical images. The site still displays square images in a user's feed at 1080 pixels in width and height. Horizontal images are displayed with a height of 566 pixels, while vertical images are displayed with a height of 1350.

Video site YouTube, on the other hand, features some of the largest image sizes. A YouTube user's profile image at 800 pixels square. The cover image for a YouTube channel is still horizontal, displayed at 2560 pixels wide by 1440 pixels high. A custom image made as a thumbnail for a video maintains a similar ratio but at a smaller size, 1280 pixels wide by 720 pixels high.

The variety of channels available to photographers is a benefit. Through websites, blogs, and social media channels, a photographer can present photographs that fit with the roles the different channels best fulfill. The same variety also presents challenges for photographers. How users typically access those channels has implications for the composition of photographs, and the varying image sizes mean photographers cannot easily take a "one size fits all" approach to image selection and editing. Photographers must either format images in a manner that will accommodate differences in presentation among social media sites, or they must make the effort to individually tailor their photographs to specific channels.

Keep in mind that social media will continue to evolve. The dimensions listed above provide a guideline to different social media sites, but as the sites and user-technology change, image dimensions on the different sites are likely to change as well. As sites change and new sites are introduced, keep track of how photographs are displayed on each one.

Protecting Your Work. Respecting the Work of Others

Social media are built on users sharing content with one another. Different sites and apps make it easy for a user to click on photographs and video and to share them with others. Many organizations have buttons on their pages to encourage viewers to share content on social media.

That same ease of sharing content also makes it easy for it to be misused. Photographs can be easily saved and shared in contexts that do not match the original intent of the work. There is little a photographer can do to prevent an individual or organization from sharing his or her work, but there are some techniques photographers can employ to limit the options for misuse or to signal to users what acceptable uses might be.

One technique photographers can use to protect work is to include a symbol or text as part of the images themselves. Known as a watermark, these more or less transparent symbols are part of the visible content of the image. They make it clear whose work the photograph is and limit the ability for someone else to use or share the photograph out of context or for commercial

purposes without contacting the photographer. Watermarks can be added in computer photo-editing software, but smartphone apps also exist that will insert a watermark into images before they are posted from mobile devices to social media.

Photographers can decide to make their work available for others to use, opting either not to enforce their ownership rights or to explicitly allow some uses through a mechanism such as Creative Commons. Creative Commons actually is an organization. Its website says it exists to enable "sharing and reuse" of creative work. By connecting a Creative Commons license to an image, a photograph can signal to others that reuse is acceptable under certain conditions. One option is to require that anyone using the image must give credit to the photographer who created it. Other options allow individuals or organizations to distribute or even modify the work as long as they agree to the same terms for any work they create using the photograph. Or a photographer may restrict the license to noncommercial use, requiring anyone who wants to profit from using the image to contact the photographer. For other options and the mechanics of how Creative Commons works, visit the Creative Commons website (creativecommons.org).

Licensing through Creative Commons or other sources or watermarking images are not guarantees that photographs and video will not be misused. There is a risk in making photographs available to the public through these digital channels, but it's also a necessary practice in twenty-first-century media communication. One thing photographers do have control over is respecting the work of others. Like any social media user, photographers would be expected to like and comment on images and, perhaps, share other photographers' work in their own social media sites. Make sure credit is given to the photographer who created the work. Include links to their sites with the photographs, and respect any restrictions they might have placed on their work. By respecting the work of others, photographers signal how they expect their own work to be used.

Conclusion

Whether working independently or for a mass-media organization, publishing photographs and video through internet and social media channels is imperative to professional success. It can feel downright overwhelming, though, if you start with the belief you need to be in all places, all at once, all the time. You don't need to be. The key to successfully using social media is to work among the platforms and tools that seem most useful for your own work. Over time your proficiency will grow. Don't expect to be an instant expert. Grow into it. The best place to start is to have a website that showcases your work as an online portfolio. Add one or two social media venues, and as your comfort level grows, reach out to other tools and include

links to them on the home page of the website. As you add a new form of social media, update the links on your website.

As a professional all your posts should be about your work, your assignments, the people you have helped, the new services you offer, the new technology, or photographic style you are embracing. Keep it respectful, even when people leave negative comments. In these public arenas, maintaining the utmost professional demeanor is crucial.

Also, don't forget your audience: people can give you helpful feedback for your work, and how they wish to see it. Engage on social media and reply to comments. Reach out to learn about where your audience would like to see your work.

Social media outlets may come and go with the public's whim. Just as some great newspapers have become victim to economic pressures of the internet, we may too see the rise and fall of today's social media. The key is not to put all your eggs in one basket, but to embrace all that helps us communicate to a wider audience, as well as retain the interests of people who view our work.

What Do You Think?

1. Think about how you typically use social media. What does the content of your social media feeds say about you?

2. Now put yourself in the position of an editor or someone hiring a photographer. Does your social media feed reflect a professional approach? Are you someone you would want to hire?

3. What do you think about image licensing and social media? Should photographers have some means to control how work is shared, or is any sharing good exposure for a photographer?

4. From the description of social media channels in this chapter and from your own experience, what is missing in social media that would benefit photographers?

What Can You Do?

1. Identify one or more photographers whose work you like. You might find them through sites of news organizations or agencies, or you might even reverse search using a photograph and Google's image search functions.

 a. Does the photographer have a website and/or blog? What kinds of content does the photographer present? Does it appear to have been recently updated?

 b. What social media channels is the photographer on? Is the photographer active, posting a lot to social media? Or does the photographer rarely post new images?

 c. How does the content of the photographer's website or blog compare to that on social media? Does it look like the photographer is thinking strategically about how to use each outlet?

2. Investigate web hosting and blog sites. Could you easily set up a site to present your photography and video?

3. Create a possible domain name for your website or blog. Find a domain registry site and determine whether the domain is available.

4. Take an inventory of your social media use. What channels are you not on that would be beneficial for a photographer?

Note

1 Matt Black is one example. As a photographer, Black has focused on issues of poverty in America's poorest communities. For his *Geography of Poverty* project, Black presented his photographs on Instagram, using the app's mapping feature to track his journey through more than 70 United States cities where more than 20 percent of the residents fall below the poverty line.

Law and Ethics for Today's Photocommunication

Denise McGill and Keith Greenwood

Introduction

An unprecedented abundance of images is available to us nowadays. As citizens of the world, we have never with greater ease been able to take photographs and video, and to publish them virtually to a potential audience of millions.[1] The laws and ethics that govern these images are complicated by an ever-evolving mix of technology. Today we must consider such innovations as unmanned aerial vehicles, computer manipulation, and data towers, as well as the difficulty of tracing an image to its true source. Fortunes have been made, and lives have been destroyed, by certain images or videos gone viral. Possibilities and perils are great and over time both will likely only increase.

It's our mandate to be responsible citizens on the internet, as well as responsible professionals in our media careers. That means being aware of laws that govern not only when and where photographs can be made, but also how they can be used. It also means understanding ethical principles that govern when photographs should be made or used, even if the laws say it's OK to do so. The way forward is sometimes complex. The answers vary depending on who is making or using the photograph and for what purpose.

This chapter outlines some of the major points of law and ethics related to media professionals who communicate visually using photos and videos. (The chapter is written from the perspective of practices in the United States, although some of these may apply to many countries in which democracy and free press are considered basic rights.)

Figure 7.1 Photographers and videographers in the United States generally have the right to photograph in public places without seeking permission.

Credit: T. J. Thomson

The Law: Where Do I Have a Right to Take a Photo? Whose Photo Can I Take?

In the United States, *if someone is seen or an event occurs in public view, it generally can be photographed*. A good general rule is to ask whether the person who might be photographed has an *"expectation of privacy."* When people appear in public they have no expectation of privacy. They can be seen, and photographed, by anyone else in the area. This legal right applies to children as well as adults, and applies to any photographer, whether or not he or she is a media professional. People may not wish to be photographed in public and may even demand that you not take their picture (or try to make you delete it if you do). But legally you have the right to photograph people and events that can be viewed in public spaces.

While U.S. photographers do enjoy broad rights, there are *exceptions*. The biggest relates to the concept of *private property*. People have an expectation of privacy with respect to their own property. For example, if Joe is in his home bathtub with his rubber ducky, he has an expectation of privacy. It would be a violation of Joe's privacy for Becky to photograph him through

the window, even if she's standing in a public street. (In the United States these restrictions are called Peeping Tom laws.)

Technological advances for photographers, particularly after the introduction of affordable unmanned aerial vehicles (UAVs) (often called drones), have added a new dimension to the issues concerning photographs on private property. Drone technology allows a photographer to stand on public property, but fly the UAV over neighboring properties that might be out of public view. But the same general rule for photography of private property applies to UAV use: if the subject has an expectation of privacy, it is probably illegal to use the technology as a way to get photographs. UAV use is also governed by Federal Aviation Administration (FAA) rules. Private use may be allowed, but commercial UAV use, such as by a news or other professional communication outlet, requires a licensed operator.[2]

A second exception to the right of citizens to photograph is based on considerations of *public safety*. During an emergency such as a fire or flood, law-enforcement officials can reasonably restrict where citizens stand, even on public property, so that officials can work unimpeded. However, photographers can legally take photos and interview people as long as they stand outside that line. Officers can't legally stop anyone from taking photos; they can only restrict your location.

So far, we have discussed the expectation of privacy. Photographers need to remember that other considerations may affect their right to take photographs. For example, if Becky goes onto Citizen Joe's property to take photos without permission, she runs the risk of a *trespassing* charge. On the other hand, if the owner of private property has given the photographer permission to be there, the photographer can freely make pictures. This applies not only to outdoor spaces, like yards and farms, but also to businesses. Shopping malls, for example, are typically privately owned, and

Figure 7.2 Photographers can't legally cross police barriers, even if they are in a public place.

Credit: T. J. Thomson

mass-media photographers should get permission from mall management before making photographs. With that permission, however, shoppers in the mall would not have an expectation of privacy and can be photographed. In other private locations, such as a concert venue, photography may be limited by the property owner, the performer, or both. For example, photographers may be restricted to working for the first three songs or from the press box only.

In most cases public property is free of limits to photographers. A common exception is the courtroom. In some jurisdictions, laws may allow courtroom photography in general, but may provide options for a judge or lawyers to deny access to photographers. Other exceptions include, but are not limited to, school buildings and university sports arenas.

Regardless of where the law allows a person to photograph, how authorities interact with photographers can determine whether photographers can actually take pictures. The relationship between police officers and photographers in the United States has changed dramatically since the terrorist attacks of September 11, 2001. America's Department of Homeland Security lists observation or surveillance of likely terrorist targets high on its list of *suspicious activity*. Websites and bulletins encourage citizens to contact law enforcement if they see someone photographing a monument that could be vulnerable to terrorist attack.[3] This may include bridges, airports, or power plants. But journalists, artists, and tourists may have legitimate reasons for making photographs of those locations, creating potential conflict. In addition, officials sometimes will attempt to restrict photography in areas where it is normally allowed, such as on a public train platform. Although legal, photography can be and has been limited by well-meaning individuals who err on the side of security concerns.

Relationships between police officers and photographers have also been challenged by today's ability for citizens to easily post online video of officers' conduct. In several cases, thousands of viewers have denounced police behavior based on a short video clip of an officer's actions. These incidents have led some lawmakers to support police who try to restrict photography at the scene. Lawyers have seen a sharp rise in arrests of photographers on charges such as "interfering with an investigation" and "failure to obey" a police officer. But free-speech advocates argue that these arrests go far beyond a need to protect public safety and are often unconstitutional. In fact, for the most part, such charges are eventually dropped as the arrests will not hold up in court. Some states actually have tried to pass laws restricting photography and videography of police officers. While these are usually challenged in the courts, it's important to know the current laws and practices in your state—and to realize you may be arrested for taking pictures. Professional photographers know that even if charges are dropped later, the arrest has the practical effect of denying their right to photograph a breaking news story.

Knowing the law does not guarantee a photographer will come out on top in a confrontation with police, at least at the time of the confrontation. What should you do? What should you risk to get a photograph? Many attorneys will advise you to obey officers at the scene, but make a formal complaint to the police later. For independent photographers especially, this may be good counsel. Photographers working for news organizations likely have the advantage of a company attorney at their disposal. Regardless of whether the officer is right, or whether resources to fight arrest are readily available, one thing is assured: an arrested photographer is not making photographs.

The Law: When Can a Photograph Be Published?

News and Editorial Photography

In the United States, the contents of photographs are protected by the *First Amendment* and are treated like words, graphics, and other content. Because of this protection, if an event or a person is of *general interest to the public*, then a news publication may generally print or post the photo without the subject's permission. Anyone on public property, or readily visible from public property as discussed above, is fair game as a photographic subject for news and information purposes.

Likewise, we recall that photographs with news value may legally be published if a property owner has given a photographer permission to photograph on private property. In the shopping-mall example, a news organization may publish photographs of holiday shopper crowds without their consent as long as the photographer has permission to photograph on the property.

Let's consider another case. Suppose Joe works for Cold Cola. If Joe goes to the city park on the first day of summer and drinks a cold, refreshing Super Soda, he doesn't have an expectation of privacy. If he's drinking Super Soda and Becky the journalist takes his photograph, Becky and her editors can publish that photograph in the newspaper or its website with or without Joe's approval. Joe wakes up tomorrow to see his photo on the publication's website. He might not look forward to the next day's conversation with his boss, but Joe likely has no legal recourse. However, be sure to read the sidebar about *false light*.

Strategic and Commercial Photography

News organizations have great flexibility to publish video and photographs because the subject is, in their judgment, a matter of public interest, and the organization is not profiting specifically from that image. In advertising and public relations, however, photographs often are used to convey the

Sidebar 7.1: Are the Rules the Same Everywhere?

The rules and ethical standards that govern the practice of media photography in one country may not be the same elsewhere. In countries outside your own, different laws may govern whether you may take or publish photographs without permission whether it be through the mass media or even on social media.

Different rules may give police broader discretion to prohibit photography at a news scene. To be a journalist you may even be required to have a license or other credential. Being a guest in another country does not allow you to ignore the laws and practices of your hosts. Quite the opposite. When traveling overseas, be sure you know and respect others' laws, customs, and codes of ethics. Use common sense. Be a responsible citizen and a responsible media professional.

In media use, photographs usually do not stand alone. They are accompanied by captions (also called *cutlines* in journalism jargon) that identify the subject, the location, or the activity. It is important to make sure the caption accurately reflects the activity depicted in the photograph. Suppose FirstNewsFirst.com covers a story about underage drinking. A photographer gets photos of young people drinking beer outside TrippyQuik store. The story runs with the photo, but the caption neglects to mention that the drinkers are 23 years old and they are drinking outside during a weekend festival in a zone licensed for open containers of alcohol. Viewers might assume that the people in the photo are minors and they bought the alcohol at TrippyQuik. Such a characterization potentially presents the parties in a *false light*, possibly harming their reputations. A person who is presented photographically in a false light has legal recourse to sue the photographer or others in an organization that published the picture.

Photographers should write down correct information at the time the picture is taken, and then make sure that information is associated with the photograph when it is distributed. The same caution applies to video stories that run footage of people walking down the street while a newscaster reports on the latest menacing trend.

commercial message of a particular organization or business, or otherwise enrich the organization in some way. It's assumed that images show the subject in the best light. It's the photographer's job to convey that message. Strategic and commercial photography may feature products and services for businesses, non-profit organizations, and government agencies. Examples of strategic communication include product catalogs, public-service announcements, corporate annual reports, music videos, magazine ads, company newsletters, recruiting brochures, e-commerce sites, charity websites, fundraising videos, and promotional materials of all kinds.

Bridal portraits, fashion, and event photography are not strictly strategic communication, but they generally follow the same rules. The client is paying for the images, and the client wants to be shown in the most favorable light.

Let's return to Joe, the Cold Cola employee, who is at the park drinking Super Soda. This time Pablo the commercial photographer takes Joe's picture for a Super Soda advertisement. When Joe saw the photograph on a *news organization's* website he had no recourse. But if Joe wakes up the next day and sees his picture on a *Super Soda billboard*, he may sue Pablo and the Super Soda company. Joe must give his permission before Super Soda can use that photo in its advertising campaign.

Video and photos without a clear news value are governed by somewhat different rules from journalism. Photographers can still take photos anywhere, but the law goes further to protect the subjects. Photographs of people used in strategic communication typically serve a commercial interest, rather than the public interest (e.g., news) discussed above. The organization publishing the photograph gains benefit from the use of the image. Courts have ruled that a *right to privacy* allows Joe to control how his likeness is used for commercial purposes. This means that legally a photograph could be used in a *news context* without the subject's explicit permission, but if that photograph is used in an *advertisement* or some other product for sale (like

Figure 7.3 In strategic communication, subjects are depicted in the most flattering way to emphasize the client's message.

Credit: Dan Koeck/North Dakota State University

the cover of a book), the publisher should obtain written permission from the subject.

Actually, if Super Soda hires Pablo to take advertising photos, it's standard practice for Pablo to set up a photo shoot with willing participants, preferably actors. Super Soda pays them a fee, and in exchange they sign a contract agreeing to appear in advertisements. It is important to have any agreement in writing. Standard *model releases* are available online for independent photographers, but it's likely that Super Soda has its own release.

It's Not Just the Photographer Who Is Responsible

In professional media organizations, several people may select photographs for publication and determine how they will be used. In news organizations, a photo editor may select an image, and a copy editor may decide how to present the photograph and accompanying text. In strategic or commercial communication, the same functions may be performed by a communication or art director. Those who select and present photographs also need to know the legal parameters regarding their use.

Thinking back to the Super Soda ad, suppose Alicia is art director for Super Soda's advertising campaign. She should be sure to file signed model releases.

The Law after Photography: Who Owns the Photos and Video? Who Gets Paid, and Who Pays?

The law also extends to questions of image as property, covering both ownership and right of usage. Considerations of copyright form the largest sector of media law today. *Copyright* is a legal term that refers to the ownership of originally created works, including photographs and videos. Regarding ownership, laws are the same for all types of photos and video: the creator of the content owns the images unless the creator gives up the copyright or the images are very old. Photographs, film, or video that are not copyrighted are considered to be in the *public domain*.

Ideally, the owner of the content licenses it to users, much like musicians license their music. It is hoped that the more it's used, the more the artist gets paid. To make a living, photographers need to know how to manage their copyrights. On the other hand, those who publish images must understand how to obtain legal licenses.

Independent Contractors

An independent contractor, sometimes called a *freelancer*, works for herself. (By the way, there is nothing "free" about owning your own business!)

Sidebar 7.3: Model Releases

A model release should include:

1. The names of the parties involved.

2. How the images will be used. It might be any use, or it might be for a specific publication.

3. What the model will get in exchange. It might be nothing, it might be money, it might be prints. Clarify who will provide compensation: the photographer or the publication? Does the model have the right to see images before they are published? Does the model have the right to veto use of particular images?

4. How to get hold of parties later. Suppose a photographer takes a great photo and another client wants to use it. The original photographer will need to reach the model, and get a new release for the new purpose. When taking group photos or video projects with lots of subjects, a professional photographer often writes down a description of the model on the release, so that it is possible to later match the release to the subject.

Independent contractors may work for a variety of clients, including news and strategic outlets.

Let's look at Becky the photojournalist. Suppose FirstNewsFirst.com hires Becky to photograph a college football game. The contract stipulates that the news organization pays her a fee and that she submits a dozen images that run on its website. Since Becky created the images, she still owns the copyright to them. FirstNewsFirst.com has paid only a fee to publish the images. Next week, the star quarterback from the game wins the Heisman Trophy. Publications across the country want a recent photo of him. Since Becky still owns the images she can charge a fee each time her photos are republished.

Independent contractors should make sure agreements are clear about photo and video ownership and usage. Contracts should spell out:

1. what the photographer will deliver and when;

2. what usage of the work is allowed: a six-month license for 12-photo gallery on a news site, a cover photo for *Time* magazine, or unlimited Super Soda ad campaigns for the next three years, and is social media use allowed?

Figure 7.4 Students, like any other photographers, have rights to their work. They can assign some rights to others, but this doesn't mean that they assign rights for any reason.

Credit: T. J. Thomson

3. what compensation the photographer will receive and when. (no. 2 determines no. 3);

4. who is to blame if something goes wrong.

Photographers should be familiar with all elements of a contract, especially when it's written by an organization's attorneys and not by the photographer. In recent years, publishers increasingly want photographers to create what are called *works for hire*. This specifies that the photographer may take the photos, but the publisher owns the images. Agreeing to this kind of contract means a photographer possibly is giving away potential income. If Becky's agreement with FirstNewsFirst.com stipulated that the company owned the photographs she delivered, FirstNewsFirst.com would earn all the money for republication of the images, while Becky receives nothing.

Another issue of concern in photography contracts is the *indemnity clause*. It spells out what happens if something goes wrong after the image is published. Note such clauses are often attractive for a media company, but may be unfair to the photographer.

Case Study: Maxwell Jackson

Photographer sued by corporation after he asks for compensation for his image: how social media got a college photographer into trouble, and then got him out.

In October 2012, Maxwell Jackson, then a student at Florida Atlantic University, took photographs of The Color Run event and posted them to Facebook. The company organizes 5K fun runs that spray color on participants as they run. In this case, however, the fun event turned into a social media minefield.

Jackson received a request from a manager at The Color Run asking to use his images on its Facebook album. In return Jackson would receive credit, a link back to his images, and good exposure. He readily agreed. In fact, he changed his Facebook status to say he was an employee of The Color Run.

In summer 2013 Jackson spotted his images on an advertising display in a major shopping mall. He also discovered The Color Run was using his images in advertisements for the sporting-goods chain Sports Authority, for the Coca-Cola Co., on The Color Run's main website, and for promotions in publications across the globe.

Jackson wrote The Color Run, requesting "$100,000 US deposited into my business bank account," a designation as the "Official Photography Sponsor of The Color Run (Internationally) for the remainder of its existence," placement of his photography business logo on The Color Run website, and clear photo credits on any images used in the future. In response, The Color Run sued Jackson for illegal use of its trademark. Its attorneys said Jackson was its employee, and so the company owned

the copyrights to all the images. The CEO of The Color Run wrote he "would rather spend $500,000 on lawyers than be extorted by [Jackson]."

Jackson turned to social media for sympathy. Complaints about The Color Run soared. After significant pressure online, The Color Run settled the suit for an undisclosed amount.

This case between a student photographer and a corporation spotlights the importance for mass-media photographers, as well as those who use their work, to understand legal and ethical considerations applicable to photography and video for mass-media use. *Legal lessons learned from Maxwell Jackson and The Color Run*:

- Photographers and media managers should beware of oral deals regarding copyrights. Agreements must be in writing.
- When a photographer gives a company (or a person) permission to use a photo, there are legal limits to that usage unless the creator clearly states otherwise.
- Those who procure images from a photographer must understand exactly what is being promised. Commitments must be fulfilled and limits understood regarding how images can be used.
- Posting a photo on Facebook in exchange for a photo credit is possible, but it does not mean that a photographer is an employee, nor it does not mean the user can publish the photos for any usage, and indefinitely.
- Large companies have money to pay for photos, but they have even more money to pay for lawyers to deny the money a photographer may deserve.

When the Employer Owns the Copyright

An exception to the *creative ownership rule* sometimes occurs when the photographer is hired as agency or publication staff. As an employer, the organization pays the photographer a salary and benefits and provides the photographic equipment and the tools necessary to create images and ready them for publication. For a news organization, that also means arranging assignments to cover events. For an advertising or public-relations agency or corporate communication department, that also means managing scheduling and arrangements for photo shoots. In these cases, the organization owns the copyright to any images the photographer makes as part of the job. Arrangements can take many forms. If an organization retains you to take pictures, you need to understand your copyrights and those of the organization.

Editors and Art Directors

Editors, art directors, and others who may select photographs for publication are responsible for knowing who owns the copyright and making sure that

proper permissions are obtained before publication. Images that appear on a photographer's website or on social media are not in the public domain just because they have been put on the internet. The same goes for images that appear on websites or social media accounts of photographic agencies or other organizations.

To verify ownership, photographs can be registered through the U.S. Copyright Office (copyright.gov). A nominal fee is assessed. While this registration is not required to preserve ownership of an image, in a usage dispute it simplifies the process of proving ownership. However, because registration is not required, there may be no apparent indications accompanying an image in regards to its copyright protection. The safest course is simply to avoid publication without securing permission for use. Note that even *photographs an organization has previously published should be verified for copyright permission*. The original agreement may not cover reuse.

Here's a case that reflects that possibility. Alicia, art director at Gamma Grocery, needs photographs for an annual stockholders' report. She sees some photographs she loves on commercial photographer Pablo's portfolio website and emails Pablo. They agree on a price for the images to be used in the annual report and sign a contract. Pablo delivers the image files. Alicia delivers a check.

Months later, Pablo is shopping at Gamma Grocery and sees his photographs on large banners throughout the store. It turns out Gamma hired a new graphic designer, Franklin. Franklin was told to make some posters, and someone handed him a flash drive with some photos on it. Unfortunately, Franklin lost his job when Pablo sent him and the grocery store a "cease and desist" letter. Neither Franklin nor anyone else on the project thought to check the copyright permissions. Just because you find files physically in your possession doesn't mean it's OK to use them.

Exceptions to Copyright Law

Exceptions allow publishers to use images without seeking permission. One exception is *fair use*. The U.S. Copyright Office defines fair use as "permitting the unlicensed use of copyright-protected works in certain circumstances." Activities that may qualify as fair use include news reporting and criticism. If an artist paints a mural in the lobby of City Hall, news organizations could publish a photograph of the mural as part of its dedication coverage. They also could publish an image of the mural as part of an art critic's critique of the work. The organizations would not be allowed to use the photograph to make and sell posters of the mural, however, without the permission of the artist.

Another exception is that an image may be in the *public domain*, meaning it is no longer subject to ownership restrictions. Age is one consideration. Under current United States copyright law, all photographs or film created before 1923 are in the public domain. Those created after may be in the public domain in some circumstances. Photographs created by the U.S. government may also

be in the public domain. For example, photographers for the Farm Security Administration in the 1930s made thousands of photographs of American life. Those photographers were working for a government program supported by taxpayer money. All FSA (Farm Security Administration) photographs are in the public domain. For the same reason, photographs and video made as part of NASA (National Aeronautics and Space Administration) programs are in the public domain. Photos taken by US military personnel in the course of their official duties are in the public domain, unless the photos have been classified for containing sensitive information. The final reason a photograph might be in the public domain is that a photographer has waived ownership of the image, making it available for anyone to use without restriction.

Figure 7.5 Carl Mydans' photo of Civilian Conservation Corps boys at work, Prince George's County, Maryland, was created in 1935 as part of the FSA photography project. All photographs from this government-sponsored project are in the public domain, and available from the Library of Congress.

Credit: Library of Congress

Related to this, internet websites such as *Creative Commons* offer photographs for which photographers have *waived rights for non-commercial use*, or even for all uses. It bears repeating, however, that potential users should always verify ownership and permissions associated with a photograph made by someone else.

Law versus Ethics

While laws determine what photographers and editors are *allowed* to do, ethical principles determine what photographers and editors *should* do. Sometimes law and ethics align. It might be both illegal and unethical to peek into someone's house and take a photograph. Other times law and ethics dictate different actions. It may be legal to make or publish a photograph, but it may not be ethical to do so. Ethical standards depend on motives behind the situation.

Ethics standards evolve, and we seem to be in a state of transition right now. It's important to keep abreast of changes in social climate and public opinion. For instance, citizens are becoming more sophisticated regarding how their own likenesses are published. Cell phones and social media make it easier than ever to post a person's photos online without his or her knowledge. Millions of people can view them, perhaps within hours, and overnight the subject of those photos can see his or her life changed. As a result, some people guard their privacy more than in the past. As a journalist, I attest that average people on the street ask me to *not* publish their photograph more than they did ten years ago.[4] The law may give me permission to publish, but ethical principles may spur me to respect their wishes to not publish the image.

But we also see the flip side in this online world. More and more people are accustomed to living their daily lives online through social media posts. Reality television and viral media have made stars of common people, even in sometimes non-flattering situations. The *Humans of New York* photography blog by Brandon Stanton had in the region of 18 million followers in 2017. Stanton's website and best-selling books rely on street photography of people not always in the best of circumstances.

Another societal change is the growing debate over body image and the apparent size of models in advertising and magazine features. Laws and ethical standards are changing for live fashion models and for the level of photo manipulation regarding the appearance of those models. Ethical standards will change as they continue to address the unrealistic manipulation of fashion images.

Ethical principles guide photographers as they make images, and also set parameters for how they edit those images. At the heart of both law and ethics, though, is this professional principle: offer truthful and accurate images.

Many professional organizations have developed codes of ethics. The codes vary in language but have some similarities in principle. Part of the National Press Photographers Association (NPPA) Code of Ethics says photographers should "be accurate and comprehensive in the representation of subjects," "resist being manipulated" by subjects, and not intentionally seek to "alter or influence events." The American Society of Media Photographers (ASMP) Code of Ethics suggests its members should "respect the privacy and property rights of one's subjects," to not use deceit in obtaining releases, and to "represent a client's best interests."

While not specifically focused on photography, the Society of Professional Journalists (SPJ) Code of Ethics does caution journalists not to misrepresent and to show compassion for the subjects of news coverage. The Radio Television Digital News Association (RTDNA) Code of Ethics begins by stating that "[j]ournalism's obligation is to the public" before outlining guidelines for truthful and accurate reporting.

Responsible and accurate communication is not limited to journalism organizations. The Institute for Advertising Ethics develops and maintains the ethical code adopted by ad agencies and members of the American Advertising Federation (AAF). The code basically follows the rules of the Federal Trade Commission (FTC). Many of those concerns are about deceiving the public. For instance, an advertisement shouldn't be disguised to look like a news story.

Principles also are identified in the Public Relations Society of America (PRSA) Code of Ethics, which also guides members to "preserve the free flow of unprejudiced information."

Sources:

www.aaf.org/_PDF/AAF%20Website%20
Content/513_Ethics/IAE_Principles_Practices.
pdf

http://adage.com/article/news/advertisers-
agencies-ethics-code-review/149464/

Ethics while Taking Photos: How Do I Treat Subjects? What Do I Control on the Scene?

News and Editorial Photography

The sweeping power and legal rights of the American press to photograph news requires responsible actions guided by high ethical standards. News organizations expect photographers to abide by applicable laws and also to work ethically to make true and honest photographs and videos.

In the United States, ethical standards are often established by professional organizations. Members are committed to upholding an organization's code of ethics, and non-members can use them for guidance as well. Codes of professional news organizations generally reflect media-industry standards.

The National Press Photographers Association has developed the most widely used code of ethics for photojournalists. An important tenant of the NPPA code indicates that a photographer's "first loyalty is to the *public trust*." That means the photographer's first responsibility is *not to her employer nor to the subjects of photographs*, but to the people who will see the photographs. Photographers should do their best to give viewers an unbiased view of the day's events.

Providing an unbiased view asks photographers to take *candid* photographs without disturbing or influencing the scene at an event. Candid means the photographers record events as they happen. They do not ask subjects to pose or "pretend" for the camera, or to repeat an action if they missed getting it the first time.

Remember Joe at the park on the first day of summer? Suppose Joe is playing with his dog, and Fido makes a remarkable aerial catch. Becky is taking photographs of Joe and Fido. If she misses the photograph, according to the ethical code she can't ask Joe and Fido to do it again for the camera.

News photographers do not move objects around but photograph the scene as it occurred. If there's an ugly trash can in the background of Becky's frame, she doesn't move it. Instead, she moves herself around to get a different angle without the can. Furthermore, she doesn't remove the trash can in Photoshop afterwards.

When moving to select camera angles, photographers must remember this admonition: do not misrepresent the scene. In Becky's case, changing positions to avoid including the can does not change Joe's activities. But a photographer's camera angle can change a viewer's perception of an event. At a political rally, Becky can use a camera angle that shows a lot of people in the crowd, making the candidate look popular, or few people, making the candidate look unsupported. The photojournalist is obligated to select the

Figures 7.6.1 and 7.6.2 The photographer has removed the seagull from the second photo. While Photoshop makes this easy, it's not considered ethical in photojournalism to remove or move any object naturally found in a scene, even if the change would make a better photo.

Credit: T. J. Thomson

camera angle that most accurately communicates what happened at the event.

Sometimes a photographer can influence a scene just by being present. People may act up, hoping the photographer will take their picture or record video of their actions. In this case the subjects are not acting as they would without knowing the camera was present, so the photographs are not truly candid and do not reflect the events as they happened.

Codes of ethics direct journalists to treat subjects with respect but also to balance that with the commitment to the public trust. When Becky photographed Cold Cola employee Joe drinking Super Soda, she would normally approach Joe to ask for his identification for the caption. This is Joe's chance to request that she not publish the photo because it could hurt his job. Becky has the legal right to run the photo, but she and her editors may

choose to run a different photo that conveys a similar message but doesn't cause harm to Joe. It's not the journalists' job to protect Joe from his choices, but they're not out to get him either.

Suppose that while Becky is at the park she also records video of Mayor Bigshot demanding free sodas in exchange for political favors. The mayor tells her not to post the video. But in this case Becky and her editors may decide that the public interest is more important than the wishes of the subject.

Sometimes the daily news includes scenes of tragedy. In those instances, a photographer may be faced with victims, emotional relatives, and bystanders. As in previous examples, a photographer needs to balance the public's right to know with ethical issues of good taste. It takes determination and sensitivity to know when to raise the camera and when to give victims their privacy.

News gathering in these instances is a two-step process. The photographer decides what photos to take. Then the photographer with her editors decide which photos actually end up in the news. When in doubt, photographers should document what they see. Later they can decide with their editors what will end up before the public's eye.

It is imperative that journalists appear *neutral and unbiased*. Therefore, they should not accept gifts from their photo subjects. Nor should photographers pay their subjects, as this may give the appearance of bribery. Being neutral means photographers don't wear logos of a team while documenting a sports event. Finally, journalists don't participate in the events they are covering. A photographer who participates in a civil-rights demonstration is not an unbiased observer of that event.

Editors, Buyers, and Curators

Photographers are not the only ones bound by ethical principles. Editors, art directors, and content managers act as gatekeepers for their publications. As such, they are responsible for the images that appear and for upholding the credibility of the publication. Many editors work with images collected from various sources, including employees, stock and wire services, and independent photographers. These *gatekeepers should verify the reliability of the source* before publishing an image to ensure that the content in their publication was taken in an ethical manner. It may take work to determine the original source of the image and get good IDs for captions.

Some editors and content managers also rely on *user-generated content*. This material comes directly from citizens who contribute their photos and video, or editors may find it on social media. But most citizen photographers do not know the principles of journalism. The editor is responsible for due diligence to make sure the images or video are real, not staged for the camera or altered by a computer.

When a private citizen sends an image to a publication or shares it on social media, that person may still have the right to control its use. Editors should lawfully acquire rights to this content, the same as images from professional sources. Does the owner expect recompense? Can the editor share the content with other publications? Can the photographs be shared on social media? Legal and ethical guidelines require editors to deal professionally with all those who create photographs and video.

User-generated content provides other ethical issues for content managers. When a photograph or video goes viral, there is likely a huge impact on the subject of the piece. Good editors will take this into consideration and weigh the merits of running the piece. "Everyone else is running it" is not necessarily a compelling reason to post a controversial video. This is where accuracy is important. Take the extra effort to get correct names and provide context.

Furthermore, there are issues about the subject matter that gets published. Most publications have standards for decency. In the age of print journalism, newspapers called it "the breakfast test." If a photo seemed too disturbing to look at while the reader ate breakfast, then it didn't run on the front page. These days many sites have a warning that shows up before the viewer can watch graphic content, hear curse words, see nudity, or listen to a 9-1-1 tape.

Strategic and Commercial Photography

The American Society of Media Photographers (ASMP) is the main organization for non-journalism photographers. Their code of ethics says members are committed to *"represent a client's best interests."* No one expects them to give an unbiased view of events. In fact, they are paid to convey their client's message.

In advertising and public relations, the photographer often will control everything in the scene, even if photos look "natural." Suppose State University makes a recruiting brochure. A photograph in the brochure may look like a candid image of students enjoying campus life, but the photographer exerts a lot of control over how the image is made. The photographer will choose clothing and props to avoid unwanted logos and will position student actors into a pleasing composition. Commercial photographers working for advertising agencies or corporate publications also manage the scenes they are photographing.

Photographers in strategic communication settings also have greater leeway to interact with subjects. A photojournalist covering a college football game for the local newspaper would not ethically be allowed to turn around and encourage the fans to jump and cheer to make a better photograph. That would be influencing the scene. A photographer working for the university's promotions office, though, could encourage the fans to jump and cheer.

Photographers working in strategic communication are not, however, *obligated* to set up scenes. They *may* incorporate the same techniques as

Figure 7.7 This university public-relations office photo appears to be candid, but in fact was carefully set up.

Credit: Dan Koeck/North Dakota State University

news and editorial photographers. For example, Anita's church is holding its annual fundraiser, and she volunteers to take photos of the evening. She uses journalism-style techniques, not interrupting guests and capturing them candidly as they enjoy the event. But when the church publishes the photographs on its website, it's still public relations.

Greater latitude to control the photographic environment does not, on the other hand, mean that photographers in strategic communication should act however they want. The American Society of Media Photographers membership comes from all areas of photography, including those related to strategic communication. The organization's code of ethics mandates respect for subjects of photographs and includes repeated entreaties to put agreements in writing. For advertising and public relations, this means signing and filing a written agreement with subjects. For almost any content for public distribution that is not journalism, the photo subject should sign a model release to avoid later legal questions.

Special Considerations

Children and minors often make great subjects, but ethical mass-media photographers have permission from a parent or guardian to photograph

them. A parent always has control over how his or her child's image is used. On a journalism assignment, ethical considerations ask you to approach a nearby adult to find out if he or she is the child's parent or guardian. Explain the purpose of the photography and secure permission to make and publish photographs. One technique is to ask a parent or guardian to write down their name and the child's name. While a model release may not be necessary in a news situation, having the names in the parents' handwriting is confirmation that the photographs were not made without the parents' knowledge. The same goes for social media and posting online.

Portraits represent another special case in which the news photographer is allowed to interact with subjects and control the situation. Regardless of use, the ethical photographer's goal is to make an image that communicates the subject in a respectful way. That means in portraiture it is acceptable for the photographer to manipulate lighting and backgrounds and to direct the subject's pose and expression. Remember the ethical admonition: respect the subject.

Ethics after Taking Photos: When May I Manipulate Photos for Distribution?

Ethical guidelines apply not only while making photographs or recording video. Professional photographers rarely consider their photographs and video ready to publish or share directly from the camera. Camera sensors and film do not usually capture scenes exactly the way our eyes see them and so require adjustment in brightness, contrast, or color balance. Still photographs may require some cropping, and video requires editing to build a story. These manipulations are necessary, but ethics should still guide the process.

News and Editorial Photography

The NPPA Code of Ethics states: "Editing should *maintain the integrity of the photographic images' content and context*. Do not manipulate images or add or alter sound in any way that can mislead viewers or misrepresent subjects." The accepted journalism standard is based on principles developed during the days of the wet darkroom. Today ethical photojournalists agree that a photograph can be manipulated digitally in ways similar to techniques that could be done in a darkroom. That means photographs, or parts of photographs, can be lightened or darkened to compensate for the limitations of the camera so that the image more accurately reflects the way the scene appeared in front of the photographer. Darkening the background in a photograph is considered acceptable in some cases, but not if it obliterates details. White balance may be adjusted to make the photograph appear

closer to what the eye saw because the eye usually corrects color casts of artificial light. But overcorrecting color cast, such as to create a sunset when such dramatic light was not actually present, is *not* ethically acceptable in journalism. Dust spots left by the camera can be removed, but deleting dirt or objects from the actual scene is *not* ethically acceptable in news photography.

Cropping means resizing a photograph to a specific area and deleting the content outside that area. It is ethically acceptable when the *crops do not change the message* of the photograph. Images are often cropped to improve composition. Photojournalists working in a hurry in the field sometimes later need to crop to produce a center of interest more closely reflecting the rule of thirds, or to enhance a leading line. That's OK. Cropping can also eliminate a distracting element along the edge of a photograph, such as a sign partially captured in the frame. But photographs should not be cropped to change the scene to such an extreme degree that people or objects significant to the meaning of the image are deleted. Such cropping removes context, and so may misrepresent the scene. (Remember the earlier example: the photographer can't actually move an object. But he or she can change positions so the object is not part of the photograph.)

Combining parts of multiple photographs to make one image is also not ethically acceptable in news. By combining parts of two or more different images, the photographer creates a scene that did not exist. It's a serious ethical lapse, but it's tempting: in news photography, the practice has often resulted in a photographer losing his or her job. A *Los Angeles Times* photographer was fired in 2003 after combining two photographs he made in Iraq showing a soldier and civilians. Another resigned from the *Toledo* (Ohio) *Blade* after an investigation revealed he had digitally manipulated several photographs, including adding a basketball to an image made during a game. Unethical changes to a photograph also include over-enhancing elements for dramatic effect, such as adding extra smoke to a photograph of a house fire.

A Note about Video Journalism

Like photography, video files often are adjusted for color and brightness. In addition, video files must be trimmed and moved to build a story. It's important that news editors use these editing tools in a way that maintains an honest story. Clips don't have to be in chronological order, and they are almost always condensed to fit a time limit, but they should not lie. Video journalists should not use clips from different events in a way that suggests they come from a single event. As it is unethical for print journalists to crop photographs to misrepresent the scene, it is unethical for video journalists to edit clips so tightly that words or actions are taken out of context. News video should not be edited so that the subject appears to say or do something not intended.

Figures 7.8.1 and 7.8.2 Combining multiple photos into one also is not ethically acceptable in photojournalism—even if adding the moon would make this photo more dramatic.

Credit: T. J. Thomson

Ethical editing choices for video invariably include audio. Video for news and editorial purposes should only use audio that was actually collected on the scene at the time of shooting. It is unethical for news videographers to add audio from other sources—such as adding stock bird sounds to a nature story.

Strategic and Commercial Photography

Photographers, art directors, and others working in strategic and commercial photography have greater flexibility to manipulate photography to present the best image for the client. It is acceptable in advertising, for example, to combine parts of different photographs, or to make dramatic adjustments

to color balance or lighting. It may be acceptable for a sports marketing representative to add a basketball to a photograph to advertise an upcoming season, or for an art director working on a fire-alarm advertisement to add extra smoke to a photograph of a house fire.

That does not mean that photographers have no limits to acceptable manipulation in photography for strategic purposes. The admonition to not misrepresent still applies. As an example, digitally adding people of color to a scene to make an organization appear more diverse misrepresents reality. Legal limits may also apply to photo manipulation. Advertising photography can be manipulated but must still reflect a truthful account of a product. A photographer can't digitally add or enhance features that a consumer would not receive when using the product.

Conclusion

This chapter has reviewed the legal and ethical environment for professionals who will communicate visually in a variety of contexts through mass media. Laws determine what photographers, and those who select and publish images, are *allowed* to do, while ethical guidelines determine what they *should* do (or not). Laws and ethical guidelines do evolve. New technologies or events change public awareness. New laws may directly or indirectly affect how photographers work. As societal norms and expectations change, professional ethical guidelines may change as well.

What Do You Think?

1. Legally, people have no expectations of privacy in public places, yet people sometimes do not want their photograph to be taken when they are out in public. What rights should people have to control when their photograph is taken?

2. There is a tension between the desire of a creator to control use of his or her work and the desire of others to use it. How much control should a creator have over the use of a photograph or video? How long should the ownership last before it becomes public domain?

3. Ethical guidelines suggest avoiding misrepresentation in photographs, but the intended use of the photograph has a great deal of impact on how that goal is achieved, such as limiting news photographers from asking subjects to repeat an action. Should different uses of photography be subject to different standards? Should news photographers have more freedom to interact with their subjects? Should strategic/commercial photographers have less freedom to control the making of photographs?

4. The widespread adoption of smartphones means more and more people are making and sharing photographs and video. What should editors or content managers in news organizations do to make sure the content is accurate before using it? What about those working in strategic communication?

What Can You Do?

1. Go to the website of the United States Copyright Office (copyright. gov). What steps are required to register a photograph or video? When can a photograph be published under the conditions of fair use?

2. Look up the codes of ethics of professional organizations related to photocommunication. What similarities do you see among the different codes? What do you think accounts for differences in the codes?

3. The next time you are in a class or attending a meeting, look for different camera angles you could use to photograph a speaker. Look for positions that would include a lot of people, making the speaker seem popular. Then look for positions that would show few people, making it appear as though there was little interest in the presentation.

Notes

1 Photography in this chapter always means still photography or video photography unless otherwise noted. Published means printed in a publication, broadcast on television, distributed online, or other distribution.

2 Laws and attitudes about UAVs vary *widely* from country to country, and are quickly evolving in the U.S. At the time of writing, drones with cameras are mistrusted by the public and hated by most government agencies. Any media professional that employs UAVs should do proper research about licensing and use.

3 www.dhs.gov/see-something-say-something/what-suspicious-activity.

4 Denise McGill is the author speaking in this case.

CHAPTER 8

Pix for All

How Photography Grew from Elite Profession to Everyday Obsession

Ross F. Collins

Introduction

Photography seems to be almost by definition a practice driven by technology. From the organic process based on chemicals to the digital process based on bytes, each technological advance in turn made its predecessor obsolete. Each new camera sought to record light in a way different from the one before it.

To tell the story of the medium, then, has fallen naturally to those who chose to lay down a timeline based on inventions. The early photo historians of the 19th century who wrote in the decades after 1839 were usually photographic inventors as well as chroniclers. They preferred to have their own inventions showcased, and so earlier photo history has often become a story of rivalry: daguerreotypists versus calotypists, dry platers versus roll filmers, SLR

Fig. 11.

Figure 8.1 An early view camera based on a wooden frame and flexible bellows focus mechanism.

PHOTOGRAPHIC BELLOWS CAMERA.

analogers versus digital smartphoners. Beaumont Newhall, unquestionably the 20th century's most influential historian of photography, chose to extend this technical story. Photography was foremost about technology's march.

But the history of photography straddles many disciplines, just as it accommodates many tastes. Art historians saw in photography a different historical debate. In this view, the story of photography reflects a different rivalry, that of fine art and industrial commercialism. From this approach, photography spent the last nearly two centuries as either a threat to, or an affirmation of, fine art.

But what histories of photography often downplay or ignore is the story of photography as an activity wrapped into the everyday experience of average people. In this view, technology and art speak only insofar as they influence the needs of the average person, be they snapshooters in New York or Instagrammers in Tokyo. From this perspective, photography has been not only about new gadgets or pictorial philosophies. It has also been about the growing domination of the machine-produced visual image in society. That began with a unique metal image and has ended, at least so far, with a multitude of images on screens. Photographs and videos today are taken by pretty much everybody, and pretty much all the time. They document, remember, and communicate.

Social historians call everyday snapshot photography the vernacular. The vernacular has grown throughout history. It has risen from nearly undetectable to almost ubiquitous. It has become a driver that influences daily decisions of professional mass-media practitioners. Now that everyone takes pictures, and technically pretty good ones, everyone is expected to—not just the photojournalists, not only the commercial photographers, although these professionals still are a big part of the photographic conversation. But today the reporters, the public-relations practitioners, and, on the street, the crowdsourcers have joined the pros in making mass media what we see today. We can trace these new photographers historically to the rise of the vernacular.

The Great Glory and Fatal Flaw of Daguerreotypes

We study Louis-Jacques-Mandé Daguerre as the inventor of photography, just as we remember Tim Berners-Lee as the inventor of the internet.

That is, neither Berners-Lee nor Daguerre really invented those technologies. What they did do was make the technology feasible and, so, wildly popular. Berners-Lee invented the World Wide Web, the digital road that gave the internet to the masses. Daguerre invented the photograph on a metal plate, and in promising not to patent it, gave photography to the masses.

Figure 8.2.1 Louis-Jacques-Mandé Daguerre, who popularized (but did not actually invent) photography.

Figure 8.2.2 Tim Berners-Lee, who popularized (but did not actually invent) the internet.

Figure 8.3 The world's first photographic image, captured in an eight-hour exposure.

Daguerre, an artist, made his famous announcement in January 1839, in Paris. But he hadn't worked alone to perfect his photographic process. Daguerre had originally teamed with scientist Nicéphore Niépce, who had been working on a process to "fix an image," as it was called, on a copper plate using an etching process. Niépce's eight-hour exposures remained at best a curiosity, but he is still credited with creating the world's first surviving photographic image, dating from about 1826.

Photography was a technical process whose time had come at the beginning of this industrial age, and other inventors demanded credit for being first. Hippolyte Bayard argued for a decade that he and not Daguerre had invented practical photography. Historians have found Bayard's plea credible. But the three French pioneers shared a single problem of process: all produced unique images impossible to duplicate outside of the engraver's studio.

William Henry Fox Talbot worked differently, and independently. The British scientist was caught off guard by Daguerre's 1839 announcement, and hastened to assert his own claim. It became clear that not only had Daguerre not been first, he had not been first by several years. Fox Talbot's first photos dated from 1835, and his process was well along by 1839. It became clear by mid-year, however, that Fox Talbot's process was not at all like Daguerre's. The British scientist used paper instead of metal, coated with a silver solution that turned dark on exposure to sunlight. This produced a negative image that seemed less than useful—but Fox Talbot solved that problem. He pressed the negative against a second sensitized sheet to produce a positive, called a calotype.

Fox Talbot today is not the near-household name of Daguerre for two apparent reasons. One, Fox Talbot refused to give away his patents, stunting growth of his process outside of England. Meanwhile, Daguerre declared his

Figure 8.4.1 William Henry Fox Talbot, whose negative/positive process grew to become the standard of photography used from early days to the beginning of digital imaging.

process "free to the world," that is, the world outside Britain and its colonies. There a license was required, perhaps as a vestige of rivalry between London and Paris that dated from the Battle of Waterloo 25 years before.

Just a few weeks after Daguerre announced his photographic process, American Samuel F. B. Morse, of telegraph fame, paid him a visit. He offered to show Daguerre his new invention if Daguerre would demonstrate his photographic process. The French artist complied. Morse wrote, "the exquisite minuteness of the delineation cannot be conceived. No painting or engraving ever approached it." Morse's observation explained the second reason why Fox Talbot is not as famous today. Fox Talbot did not know how to eliminate transfer of shadows through the paper fibers on to his final positive image. His calotypes had a luminous softness, and not the uncompromising detail of a daguerreotype. In an age that valued artistic realism, detail was the goal, the more, the better. Steely clarity seemed to bring the metal-plate photograph closer to the person portrayed, almost as if part of the subject transferred. "It is not merely the likeness which is precious in such cases," wrote poet Elizabeth Barrett Browning, "but the association, and the sense of nearness involved in the thing … the facet of the very shadow of the person lying there fixed for ever!" Artists, seeing their efforts of centuries to paint more and more realistically overtaken by a machine, did not so quickly appreciate the magic. "From now on, painting is dead," lamented artist Paul Delaroche in one of the century's more famous overstatements. Actually, painting was just beginning its revolution away from realism, but who could have predicted that in the 1840s? Photography seemed such a

Figure 8.4.2 Charles Baudelaire by Étienne Carjat. Ambrotype taken in about 1862.

threat to artists, illustrators, and engravers that some of the most prominent of the age, such as French poet Charles Baudelaire, called it no less than a corruption of art. But Baudelaire did condescend to have his picture taken.

And so did pretty much everybody else, and quickly, too. Morse's report published in the *New York Observer* brought the daguerreotype to the United States in 1840, and the very idea of a photograph to the larger public. It may have been disreputable among fine artists, but among everyday folk, photography immediately became the rage of fashion. Everyone who was anyone, and a lot who were not, hoped to sit for an inexpensive photographic portrait. Mathew Brady's New York daguerreotype studio opened in 1844 to a mob of image-chasers. Millions of daguerreotypes paved the United States and continental Europe. The popular but technically difficult photographic process established the dominance of photography as a commercial industry for trained professionals: you will love this photo of your relatives or yourself, or of a famous person, and we will supply it to you for a modest price. Photography may have been a science and an art to some people, but to other people it was a way to preserve and remember their own personal world and the world around them. Memories otherwise so fleeting could be kept for practically an eternity. And they were so detailed! While color was still nearly a century off, hand-tinted daguerreotypes gave children ruddy cheeks and colored clothing.

But despite its cultural ubiquity, the inherent limitations of daguerreotypes spelled their demise, and fairly quickly. People now familiar with the technology not only wanted pictures; they wanted copies of pictures they

Figure 8.5 A hand-tinted daguerreotype from about 1850.

could share. This was the one thing that daguerreotypists could not supply. The metal plate was unique, obtained only after a mildly tedious requirement to sit still for a minute or so in bright sunlight with fixed expression. If you wanted a second shot, you sat for a second time. It cost more. It was still tedious. And it was hard enough to keep children still for the first one.

Photography for the masses turned back to photography from the scientists for a way to get around the expensive uniqueness of the daguerreotypes. The solution was already there: Fox Talbot's calotype. What people dismissed then about the gauzy calotype was its distant, almost aloof quality, as if subjects were sitting in fog. Looking back at the calotype from a century and a half of typical high-contrast realism, some will argue that they really prefer the softness of a calotype portrait. Particularly related to acne and wrinkles. But commercial success of the 1840s demanded detail, as Fox Talbot knew; his process had seen little growth. The problem was the paper negative. The solution might be a different substrate for light-sensitive silver-based chemicals. Something such as glass, if only it weren't so slippery.

The Growth of Limitless Reproduction

British sculptor Frederick Scott Archer today may be even less remembered than Fox Talbot. But he ought not to be. From a modest, short, and health-challenged life he gave just one thing to the photographic vernacular: limitless reproduction of a picture. Archer announced the collodion glass

Figure 8.6 A daguerreotype of Abraham Lincoln, made in 1848, just as the daguerreotype era was coming to an end.

plate process in 1851, *colle* being French for glue, and, so, sticky. The wet chemical potion applied to a glass plate held the light-sensitive silver salts in suspension during an exposure. After development and drying, the glass plate negative could be pressed against sensitized paper as in Fox Talbot's process, but the image now was nearly as sharp as glass.

Daguerre had died the year before so did not see the quick demise of his metal plates in favor of the reproducibility of glass negatives. But Fox Talbot was still alive, and still keen to protect his patents. He was not able to extend that control to the new collodion process, however. Archer perhaps more than Fox Talbot is the father of modern photography, but he did not patent his invention. The wet-plate process, and a similar ambrotype direct positive process, grew to dominate commercial photography, taking the world one step closer to pictures for everyone by establishing a basic requirement of most modern photography: the ability to make copies.

The new photographic process could respond to a cultural need for personal memories as well as a growing commercial industry marketing photographic depictions of other places and cultures. It also lowered photography's technical barrier, just a little bit, to admit a few hobbyists. Advanced amateurs with means began to pick up cameras for family and home. Photo albums began to appear in the 1850s depicting not only commercially produced portraits, but also everyday family scenes of pets frolicking, children playing, grandparents doting. Perhaps they were slightly blurry and violated

Figure 8.7 An 1876 engraving illustrates development of a collodion-based image. In reality the process had to be carried out in a darkroom.

Fig. 25.

WASHING THE DEVELOPED IMAGE.

professional standards of posing and lighting. But they were memories of the everyday made more and more by people who were not trying to become commercial photographers.

The professionals, and perhaps a few advanced amateurs, also responded to the more light-sensitive (but also more awkward) wet-plate process by pulling portable darkrooms across the United States and throughout the world. A few intrepid daguerreotypists recorded places and events, but by relying on the faster exposure times of wet plates, Roger Fenton was able in 1854 to record for the first time scenes of war battlefields in the Crimea. Mathew Brady poured the wealth he had acquired during his daguerreotype studio days into an ambitious plan to document the U.S. Civil War. He died penniless, but his photographers captured what no one had ever seen photographed: death on the battlefield. Other photographers prowled the world to record for the first time how other people lived across culture and geography.

Revolution of the Vernacular

Growth of the wet-plate process helped to bring photography to a larger audience. But its reach was still limited, as it could not piggyback on commercial mass media. Photographs for most of the nineteenth century could not be directly published. They instead were copied by engravers, in artistic renderings that in effect were drawings of photos. While the Civil War photographs of Brady's team could now reach a growing audience of mass-

Figure 8.8 Roger Fenton's portable darkroom, 1855.

media consumers, they could only reach readers as facsimiles. The halftone printing process of the 1880s changed that. But it was just a start. That decade proved to be a watershed for vernacular photography.

Photography by this time had grown to enormous commercial success and widespread acceptance as a medium for artists. By 1870 in New York City alone more than 300 photo studios produced *carte-de-visites* (3¾ by 2¼ inches) and cabinet cards (4 by 5½ inches) for people's albums, featuring celebrities in particular. Stereograph photos brought the world to people's living rooms.

As a participatory medium for the average person, however, photography remained out of reach. The collodion process was complicated and not a little bit hazardous. The cameras were expensive and bulky. And as a communications medium, engravings, not photographs, continued to be the news standard.

Then just a year into the 1880s, the medium's high barriers to entry fell like a house of cards. Probably everyone has heard of Kodak, the company founded by George Eastman. Many presume it was Eastman's roll film camera that in 1888 put picture-taking into the hands of everybody. That's not quite true. Dry plates had replaced the cumbersome collodion process by 1881. The

plates were more sensitive and the cameras were less bulky. No more need for a portable darkroom. You could record an image in a fraction of a second— no tripod necessary. A larger group of more casual hobbyists discovered that photography was accessible. In fact, a very large group. The industrial revolution gave many average people more money to spend as cameras became cheaper. The growth of free weekends away from work gave people more opportunity to pursue hobbies, while the development of family and public schooling for children gave people more childhood achievements worth recording. But photography's growth at this time did not end with just the kids in the home.

Figure 8.9.1 Everyone was encouraged to photograph, although it is a stretch to expect children would use the more sophisticated camera in the ad to the right (from a 1901 *Collier's* magazine).

People responded to an easier picture-taking process by recording everything they could point their lenses at. *The New York Times* as early as 1884 wrote with (satirical) alarm about the burgeoning group of urban snapshooters. "Camera lunatics" had become a "national scourge," mobbing the city streets to point cameras at unsuspecting passers-by. The consternation of the newspaper regarding the new street photographers seemed to rest on the presumption that photography ought to occur only when both photographer and subject agreed to cooperate. That was a practical necessity when cameras were cumbersome and shutter speeds were slow. But the possibility of instantaneous images changed the relationship between photographer and subject. People could now just take pictures, no need to bother or fuss, to introduce or to request consent. The mob of

Figure 8.9.2 The London humor magazine *Punch* satirized the new hordes of amateur photographers in an 1890 sketch.

amateurs could take to the streets for an afternoon photo ramble and snap at whatever might move into their waiting viewfinder.

The smaller group of serious amateurs who were working toward finding acceptance of their medium as a fine art reacted as many others who didn't like the ethics of the new street-based camera bugs. Grabbed pictures from a new wave of amateurs were vulgar, obtained by actions crass and disrespectful. Cities proposed to outlaw the people bold enough to photograph strangers going about their business, under the assumption that even on the public streets people had the right to some measure of privacy. Amateur photo clubs published guidelines regarding ethical street photography. Artists grew to disdain the machine-aged realism, and turned to a soft-focus style of painterly work that came to be called pictorialism. For some critics, photography in the hands of the masses could signal no less than the decay of civilization—not the first or the last time the high-brows would fret over photography's increasing democratization.

But if the expanding interest in street photography might be offensive to some elites, to other serious amateurs it might be a way to show what few of those elites even knew existed. In the 1870s John Thomson first sought to take street photography into the underside of the city. His *Street Life of London* used the camera to document the brutality of the industrial revolution on a new urban working class. Jacob Riis working a few years later in New York City did not even call himself a photographer—at least not in the way the artists or commercial photographers of the nineteenth century had defined the medium. Riis rose from the street-snapshot tradition to practice his own version of photography with a social mission. He moved around the city's squalid immigrant tenements in an attempt to document the grim consequences of poverty. He did not ask permission. In fact, he did not even ask for very much light. Instead, he brought his own flash powder, an explosive mixture that he sifted into a frying pan and touched with a match. The blinding flash illuminated his subjects, and probably stunned and temporarily blinded them as well, while Riis beat a quick retreat into the gloom.

Riis learned his street smarts as a police reporter for *The New York Sun*. An 1888 *Sun* profile of his work, "Flashes from the Slums," described his approach, mentioning the "ghostly tripod, some weird and uncanny movements, the blinding flash ... the patter of retreating footsteps." Riis brought the newly popular vernacular photography from the streets and turned it into part of a growing journalistic effort to draw attention to the problems of society. In that he became one of the first true documentary photographers, and one of the first real photojournalists. But given his tactics, he also could be called the first paparazzi.

The number of everyday people with cameras that grew at the beginning of the decade still was limited by the process required to produce a photo. People could now fairly easily take a picture. But they couldn't see that picture. For that they needed to know how to turn the latent image into an

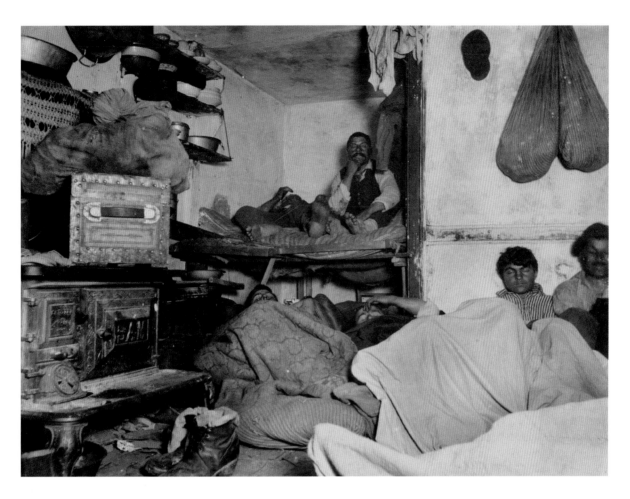

actual print in a darkroom, a service generally not at the time commercially available. To do that at home required money and skill, and so photography still was not easily accessible to the larger group of casual picture-takers who just wanted a camera on hand for whatever photo-worthy moments might ensue. Commercial photographers, on the other hand, could handle the darkroom work. But usually they could not be there for spontaneous records of family or chance events. Then toward the end of the decade a new invention swept away all the surviving barriers to universal photography: George Eastman unveiled the Kodak.

It is hard to overestimate the significance of Kodak in the growth of vernacular photography. Eastman's 25-ounce Kodak No. 1 of 1888 not only was tough and portable enough for fuss-free use everywhere, but it also required no technical skill beyond ability to push a shutter button. The Kodak arrived by mail already loaded with film on a flexible roll instead of sensitized plates. People snapped 100 frames of whatever they wanted, and then returned the camera to the company for processing. Finished pictures

Figure 8.10 The New York tenements of Jacob Riis.

Figure 8.11 An early advertisement for
the Kodak Brownie box camera.

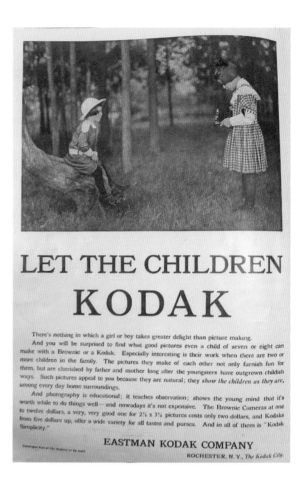

and a fresh roll already in the camera arrived as easily as they would from a commercial photographer, the difference being, of course, that they were shot by the user at any time, from anywhere. Eastman emphasized that his company was setting a new standard for amateur photography. "Anybody," Kodak announced in an 1888 advertisement, "man, woman or child, who has sufficient intelligence to point a box straight and press a button" could make a picture.

Within a few months the originally odd-shaped round images were converted to familiar rectangles. Within a few years a nationwide photo-finishing industry assumed control of processing. For the next century "The Great Yellow Father" with its familiar yellow boxes grew to supply cameras and supplies to generations of middle-class people, from retirees to young children—the cheap Brownie was originally marketed for kids. "The Kodak," observed photo historian Robert Hirsch, "initiated a new dialogue between viewer and subject, continuing photography's ability to level hierarchy, and creating a sense of visual democracy." It became a verb, to "Kodak everything," snapping wildly without concern for lighting or composition, just to see what

would come out. Film was cheap, after all, compared to clunky plates. In one of photography's more famous droll remarks, playwright George Bernard Shaw mused, "The photographer is like the cod which produces a million in order that one may reach maturity."

Eastman gave photography to the masses, but the masses gave to the medium as well. Serious photographers who had established principles of quality saw little to salvage among a teaming multitude of amateurs who lopped off heads, tilted horizons, blurred subjects, placed people directly in the center squinting against the sun into the camera, and offered compositions that resembled the helter-skelter ransacking of a burglarized bedroom. It's likely few Kodakers took time to study principles of art, but if art didn't come to them, their practice of defying convention did grow to become part of fine art. The Dada movement after World War I, or even the surrealists, began to paint as the common people photographed. The group f/64 in the 1930s rebelled against pictorialism, advocating sharp angles and unmanipulated "straight" photography that influenced black-and-white photographers for half a century.

Professionalization of Photojournalism

The emerging profession of documentary photojournalists grew to seriously challenge nineteenth-century photographic conventions as practitioners tried to record daily life during the Great Depression of the 1930s. Photojournalists such as Weegee in New York (Arthur Fellig) worked the streets. His harshly lit and artlessly posed images resembled casual snaps that seemed to make more convincing an illusion of authenticity. The snapshooting masses, for all their amateurism, were presumed to be more honest. "For the audience to believe it is seeing the photograph subject directly," observed photo historian Anne Tucker, "the photography must understate its authorship." After World War II photographers such as Robert Frank and Lee Friedlander took to the streets of a troubled, violent, and racist society with gritty, blurred, seemingly careless images that suggested influence of the vernacular. Their social landscape photography, as we call it today, showed clear influence of the casual, ephemeral, humble snapshot.

Despite its influence on artists and photojournalists, vernacular photography as it grew during the Kodak era seemed to take a turn away from its beginnings in the early 1880s. Now that everyone probably had a camera and took pictures, the pictures they took drifted away from original interest in street photography. The "streets" became mostly those of the family vacation, and then usually familiar clichés of famous buildings or monuments. The special events became mostly events of interest to families. Milestones like baptisms, recitals, birthdays, graduations, or celebrations were worth photographing for the family album. Things that had no significance to the photographer or friends and relatives generally found little favor. It was hard

for most casual snapshooters to see a point in going beyond the conventional. After all, except for albums and (perhaps) boring slide shows of last summer's vacation, no one cared to see random street snaps. The casual amateur with his Kodak who tried to venture into purposeful street photography would invariably face this question: "Do you know that person?" This suggested a need to defend the point of taking pictures for anything but the usual family and travel records.

The family album gave personal photography a purpose, and so became established as early as the mid-1800s. When it later was possible for everybody to take pictures at a whim, the medium became democratized, but the purpose for the casual amateur had not changed. The album was still the same album, repository, and archive of family history. Kodak early on sensed that this was why people were going to buy a lot of its film and cameras. Throughout a century of advertising, Kodak promoted the camera as a personal memory-making and saving device.

Figure 8.12 Kodak emphasized in its early advertising the importance of a family camera as a memory-saving device.

Family rituals, travels, and personal experiences were appropriate subjects for the average gal or guy. Birthdays, proms, babies in the bath were "Kodak Moments." Familiar tourist scenes were "Kodak Picture Points." The image, as photo critic Susan Sontag wrote, was more authentic than the reality, "pretty as a picture." Kodak's advertisements suggesting the limits of casual photography seemed persuasive. Critics and historians tended to ignore vernacular photography because, as it seemed, it was so many trite eggs from the cod. But not everyone. Writing in a 1974 *Aperture*, art photographer Lisette Model suggested that the snapshot came closest to photographic truth. "We are so overwhelmed by culture and by imitation culture," she wrote, "that it is a relief to see something which is done directly, without any intention of good or bad, done only because one wants to do it."

Still, the problem of everyday snaps was purpose. Photography in the twentieth century diverged into genres based on the reason for taking a picture. For scientists it was research. For police it was investigation. For artists it was self-expression. For commercial studios it was profit. For photojournalists it was mass communication. For the rest of us it was ... well, it was memories, of course, as a picture seems nearly by definition to be a record of the past. But there was really nothing else for the casual snapshot to do. Camera clubs grew following the 1880s revolution that empowered the amateur. By the 1930s the clubs blanketed the United States and Europe. Their purpose was education and competition, with competition particularly emphasized. Clubs grew to compete regionally, and nationally. Picture competitions gave amateur photographs something to do, as club members were less likely than family and friends to ask, "Do you know that person?"

But beyond the club contests and family archives casual snapshooters seldom ventured into more professional realms. Photojournalism did seem to be a possible avenue for amateurs. While commercial, scientific, technical, and art photography had become well established as separate disciplines long before Kodak, photojournalism as a distinct genre grew later, alongside the amateur revolution. Photojournalism history, comparatively speaking, is short—the word itself doesn't seem to have been invented until after World War II. War photographers existed, of course, since the 1850s. But the modern idea of "covering a story" with pictures began with social documentary photographers like Riis and sociologist Lewis Hine, also "amateurs" who used photography as a tool to argue societal reform.

The Kodak revolution came at the same time as the explosion of commercial mass media. Newspapers and magazines by 1900 had built empires that reached nearly every reader in the Western world. Twinned with this was the recent invention of the halftone, a process that finally made it possible to bypass the engravers and publish photographs directly. The idea of constructing a storytelling package of pictures, captions, and limited text had developed in Germany by 1900. In the United States it blossomed into magazines such as, most famously, *Life*, established in 1936.

Figure 8.13 *Life* magazine cover.

Professional photographers hired by the United States Farm Security Administration (FSA) traveled America's back roads to document the misery and family upheavals of the Great Depression. In Europe, ordinary workers themselves were encouraged to record their challenges during this difficult era. The mass media would seem to offer the masses a new place to show their pictures beyond albums and camera-club salons. But that did not happen.

Photojournalism's growing professionalization served to limit outsider access in response to growing demands for a higher ethical standard. Following World War I, journalism's critics called for new codes of fairness and objectivity. Editors sought to exert greater control over a photograph's typically uncertain meaning by requiring explanatory captions. The rise of journalism programs at universities reflected efforts to bring a greater level of professionalism to the craft. Photojournalists were expected to produce work based on standards as set by publishers and editors, the gatekeepers

of the mass media. Explicit requirements regarding composition, exposure, cropping, captions, and darkroom manipulation grew as the profession emerged into a professional subset of journalism. The bar grew high for the non-photojournalists, even reporters, who hoped to submit pictures for print.

As Hirsch noted, commercial, editorial, and political dynamics brought specificity to the often ambiguous meaning behind a photograph. "A multiple reading of a news photograph was not considered desirable," even if the photographers themselves did not agree with an editor's interpretation. Powerful photo magazines such as *Life* actually pulled most control away from photographers themselves as the editors chose pictures and prepared picture packages reflecting the magazine's editorial needs. Some of the biggest names in war and documentary photography, notably Robert Capa and Henri Cartier-Bresson, established Magnum Photos agency in 1947. It was a symbol of protest against the big media of the time that insisted on taking control of the image away from those who produced it. But the pros and their agencies showed little interest in opening their gates to amateur photography. The stream of pictures produced by the box camera-wielding public was effectively barred from mass media in all but those few cases of the talented amateur (who probably was hoping to become a professional), the contest winner (who usually had to surrender all copyright control to the publication), and the lucky shooter who happened to be at the right place at the right time. Mass-media photography had become a nearly closed profession.

The argument for professional status suggested, reasonably, that untrained snapshooters, one, just did not produce images of a quality sufficient for publication, two, just did not understand news values, and, three, just couldn't be trusted for veracity. By the 1980s few professional shooters for mass media did not have a degree in photojournalism, journalism, or a related field. Amateur work was not only rejected, it was ridiculed, the "Instamatic" brigaders named for the popular series of small snapshot cameras produced by Kodak beginning in the 1960s. The wall between the plain folk with a camera and the professionals with a, well, super-duper camera had grown thick.

Fall of the Gatekeeping Wall

Then the medium of photography faced its greatest technological revolution since daguerreotypes: the rise of digital, and the wane of analog. The replacement of film and chemical processing with computerization and Photoshop processing. By the new millennium few photographers, professional or amateur, still shot film. The Great Yellow Father in 2004 quit selling the cameras that defined amateur photography for a century. In 2012 Kodak filed for bankruptcy, although survived in a form no longer of interest to amateurs.

Roll film was cheap, relatively speaking. But it was expensive compared to digital photography. Each digital image was essentially free. It became feasible to shoot 500 images of your kid's birthday party. A thousand images of Disneyland—on the first day. Why not? Be playful! Snap around. If photos of the 1880s had become just so many codfish eggs, then photos of the 2000s had become grains of sand on the Sahara. In 1993, at the twilight of analog photography, an estimated 17.2 billion pictures were taken in the United States in one year. In 2015 about that many were taken in two weeks.

The first digital cameras took pictures, period. The only real difference within the camera was that the film was replaced by a digital sensor. This allowed users to see the photo immediately after it was taken. It also allowed the viewer to upload the photo onto a computer, if desired. But increasingly digital photographers did not desire to upload their snapshots. They stayed in the camera, and the camera stayed with the photographer, doubling as a portable album to show family and friends on a whim. No longer was it necessary to drag out the family photo book over the holidays, or to bribe neighbors with dinner in order to show the family vacation slides. Photos became instant memories. And because they were free, and immediately accessible, the memories that weren't as good as the maker might have hoped could be instantly deleted. Research regarding digital photography showed that, one, people took a lot more pictures, and, two, they deleted a lot of them. When pictures were no longer a physical object, but just an ephemeral JPEG file, throwing away the bad ones became a lot easier.

Digital photography offered greater freedom to everyday amateurs by eliminating the middle person, the photo finisher. Cameras became more sophisticated. They took better pictures to begin with, and offered on-the-fly

Figure 8.14 An early digital camera from Kodak, about 1994.

tweaks to mimic professional techniques such as cropping or toning. Most photographs today never end up on paper. In fact, most of them never end up being viewed at all. If you've taken 500 pics of that birthday, well, no one wants to see all those. The creator doesn't even want to sort through them on a computer. Most digital photos are ephemeral.

But not all. An irony of a digital photograph is that, on the one hand, it is only a string of ones and zeros, having no materiality. It could be gone forever in an instant. And yet some photos gain a worldwide permanence far beyond the camera that made them. They will be there forever, whatever "there" means in cyberspace. And that ability defines a true revolution of digital photography for the amateur: a convergence of photography with communications media.

In analog days the only way to show a picture to a lot of people was through hard-copy mass media. You could try to get a newspaper to publish it (through a gatekeeper's high bar). Perhaps you could mail prints to your relatives. But how many people would really see your picture? A handful. Perhaps the single most significant development since the beginning of photography was the invention of the smartphone camera. Cameras on phones date back to 2001, but in 2004 they took off. In 2007 Apple introduced the iPhone.

Its explosive worldwide popularity helped to assure that a digital camera was always at hand, Kodak's Instamatic for the twenty-first century. If George Eastman was first to bring photography to nearly everyone, perhaps Steve Jobs was first to bring "phonography" to nearly everyone.

The smartphone, among other things, was a camera, portable album, and portal to the world. Photographs could be shared instantly; social media offered one way to make a personal picture reach a larger audience. The average user of the social media site Facebook by 2014 had 200 friends. But that was not the only place to share a photo, and for many snapshooters it was not even the principal place. The grandfather of photo-sharing sites was Flickr, launched in 2004, the same year the convergence of phones and photography took off. Its users in 2015 posted 41 photos a second. But that only seems like a lot if you consider it in isolation. It lagged far behind Instagram, approximately 300 million users posting 810 images a second; Facebook, in the region of 1.39 billion users posting 4,501 images a second; Whatsapp, about 700 million users posting 8,102 images a second; or Snapchat, in the region of 200 million users posting 8,796 images a second.

The 2015 pinnacle of Snapchat, at least in image sharing, symbolized what photography had become for casual amateurs. Throughout most of its history, photography was a story of the past. It was an expectation made in the present of a memory to be valued in the future. As Eastman explained it through his original Kodak manual, his camera was a photographic notebook that "enables the fortunate possessor to go back by the light of his own fireside to scenes which would otherwise fade from memory and be lost." But the confluence of photograph and communication in real time

Figure 8.15 An early iPhone 2G.

changed the very meaning of snapshots. By 2015 vernacular photographs were not so much about memories as they were about present moments communicated visually. The communicator's word was an image, a digitally produced photographic statement as fleeting as a telephone conversation. The photograph as tangible evidence of what has been is no longer usually the point. Instead it is a description of what is now. "The value of individual pictures decreases while the general significance of visual communication increases," observed new media critic José van Dijck. "Taking, sending and receiving photographs is a real-time experience and, like spoken words, image exchanges are not meant to be archived." Because there are just so many of them, "these photographs gain value as 'moments,' while losing value as mementoes."

Some smartphone photographers now visually blogged their day with uploads from breakfast to bedtime. You could share on the Web, in email attachments, or YouTube. The torrent of pics mostly were tepid in quality, but that actually could be a plus. Unposed, unretouched images and videos of ragged focus and framing could suggest authenticity, believability. The power of the photo still remained as it always had, having an appearance of honest realism. Visual immediacy is a convincing carrier of truth, and nothing could top the feeling of genuine communication like a smartphone.

If the life of an amateur photo had shifted away from family archive and toward mass communication, then its presumption of a private moment accessible to few also was called into question. Amateur snapshots moved closer to the definition of mass-media photography—to photojournalism. The rise of the internet to supplement, and more and more surpass, the power of legacy media for the first time in the history of visual images handed more power to the people. Control of mass-media imagery began to slip away from gatekeepers, as amateurs were everywhere, and so were their camera phones. People could not only photograph events, but they could instantly share them with the world. Increasingly since 2004 it has been the amateur photographers who have broken the news in photos and videos uploaded to Twitter, YouTube, or any number of less famous news and social media sites.

The power of what loosely has been called citizen journalism exploded into political controversy in 2004, in the Iraqi prison of Abu Ghraib. Soldier-photographers apparently for their personal amusement posed prisoners in humiliating scenes suggesting torture, and emailed the snaps to friends and relatives.

The resulting redistribution of these amateur photographs throughout the internet became an international subject for debate regarding not only the apparent brutality of the interrogations themselves, but also the meaning of the uncaptioned photos. President George W. Bush publicly apologized, explaining that the photos did not reflect the true nature of American character. But the amateur-produced Abu Ghraib photos for many became a symbol of injustice that seemed as powerful as the documentary photos of child labor taken by Lewis Hine almost exactly one century earlier. It is

Figure 8.16 Soldier-photographer Sgt. Ivan Frederick recorded this 2004 torture scene in Abu Ghraib Prison, igniting criticism of American military and its treatment of prisoners.

hard to imagine how a professional mass-media photographer could have recorded such scenes. The few instances in the decades of photojournalism's preeminence do include scandals such as My Lai, the Vietnam War massacre captured on film by a soldier. But surreptitiously photographing an event, processing the photos, and transmitting them past the gatekeepers into a world of print media was often an impossible challenge. Today it's easy.

Breaking news has become almost the expected realm of amateur photography. Citizen journalists were first on the scene for the Saddam Hussein execution of 2006, Mumbai terrorist attacks of 2008, Iran riots of 2009. and, of course, the recent wars in Afghanistan, Iraq, and Syria. As veteran war photographer Don McCullin acknowledged in a 2015 interview, "because photographers don't want to go to Syria anymore—wisely—all of the pictures coming out of there are being done on phones." Most legacy media not only has allowed more photos by citizen journalists, but actually has invited the horde to join in. Gatekeepers have become curators, as traditional media solicit amateur pictures. And if that is not free enough, websites expressly set up for amateurs offer reach beyond what even photojournalists could have imagined through much of the last century.

Conclusion

The plain folk's photography finally has found a place beyond the album page or the club salon, but that unsettles some photojournalism professionals. It is not only the fact that anyone can now take photo and video of reasonable technical quality, even reporters who had been generally shut out in traditional newsrooms. It is not only the realization that photojournalism seems to be slipping toward the status of a boutique career open to fewer

and fewer, though the fact that only half as many photojournalists were working in 2015 as a quarter century before does suggest that this may be the case. The problem is also the status of the profession of visual journalism itself. Anyone can take a picture—but can anyone take a picture that tells a story? Not so often. Much of the citizen-produced photography today is based on spot news, an image of the moment. Photojournalists consider that to be a small part of their work. The challenge, and the one that still usually requires professionals, is to document the ongoing stories with sensitivity to composition, lighting, subject, fairness, and context. Weaknesses of folk-art photo reportage include hidden bias and difficulty in tracking the creator and circumstances. Images may reach the internet not only from earnest citizens but also from shady propagandists of fake news; provenance is often impossible to vet. It is the credibility of professional journalism's ethical codes that photojournalists still retain. Digital technologies have converged to finally give reach and power to the vernacular after nearly two centuries of professional dominance. But standards still matter.

What Do You Think?

1. The invention of faster cameras made it possible by the 1880s for hobbyists and professionals alike to photograph anyone, anywhere. But from the beginning the practice was controversial. Do you think we can ethically defend a right to take photos of people in public without asking for permission?

2. Some visual critics have argued that amateurs who do not carefully compose, light, and expose photos using elaborate equipment and planning actually record the most honest and fair depictions of society. Do you think that's true? Why or why not?

3. Some photo critics think everyday photography today is no longer a record of the past, but a conversation in the present. Has photography for you become most often part of a digital conversation with friends, or do you mostly photograph as a way to preserve memories for later?

What Can You Do?

1. Photograph one scene from several viewpoints. How would a pictorial photographer record it? A straight photographer? A street photographer? A photojournalist? A casual snapshooter?

2. If you have access to a film camera, buy a color print film (it's easier to find a processor), and give it a try. If not, pretend your digital camera is limited to just one roll, 24 images. Go out on a photo shoot. How does your approach to taking a picture change when you only have two dozen images available, and no way to delete once each image is recorded?

CHAPTER 9

Epilogue: My Story

What Photocommunicators Do Today

Judy Griesedieck

Minneapolis/St. Paul, Minnesota
judygpix.com

What is your current position?

I'm currently a freelance photojournalist in the Twin Cities area (Minneapolis-St. Paul, Minn).

Why did you decide to become a photographer, and what background did you bring to your profession?

Looking back, I always had a camera in my hands as a child, so I had the desire to document events even back then. It didn't occur to me that I would be able to make a living doing something I loved so much. Taking photos just seemed to be a hobby. I got a Pentax camera for high-school graduation, and soon found myself taking photos all the time. I didn't do any photo internships because I was really "out of the loop" of the photojournalism world, majoring in English literature and psychology in college. Eventually, I got a part-time job working as a photographer for a professional soccer team, the Washington, Diplomats, but I didn't earn much. The experience was invaluable, but I was also working at another full-time job to pay the rent, so I had some long days, at times printing photos in a makeshift darkroom in my bathroom until 2 a.m.

Eventually, I heard about a job at a newspaper in Hartford (not the *Courant*), applied and got a job, but the newspaper folded two weeks after I got there. At that point I was committed to becoming a photographer, so I created a portfolio. Unfortunately, it was not a very good portfolio due to my lack

Figure 9.1 Judy Griesedieck on a book assignment at the Great Wall of China.

Credit: Judy Griesedieck

of experience. But luckily I didn't realize that at the time, so I soldiered on, driving around the East Coast in my barely functioning car, applying for any newspaper job I could find. One editor looked at my portfolio and bluntly told me I should "go home and have a good cry, and then find another profession because I had no talent." Tough words to hear, but I refused to give up. I called *The New York Times* and a wonderful editor for the Connecticut section gave me a few assignments, which boosted my confidence. Eventually, the *Hartford Courant* had an opening as a lab tech, working in the darkroom, a foot in the door, so I was thrilled to get that job.

What does a typical workday look like for you?

As a freelancer, I don't think there is a typical workday. At least not in the way there was when I worked for three newspapers (after the *Hartford*

Courant I worked at the *San Jose Mercury News* (now *The Mercury News*) and the Minneapolis *Star Tribune*). Freelance assignments are often last minute, especially if I'm shooting a news event. I covered many of the Black Lives Matter marches last year, and those were always "spur-of-the-moment" situations. For example, I am currently waiting to hear about a story that might occur tomorrow between a Somali man who immigrated to the United States five years ago. His wife and children, who are attempting to reunite with him, were delayed by the travel ban. I'm leaving the day wide open for whatever might occur. There are other types of assignments that I know I'm doing a few weeks in advance, but that's not the norm. I also work on my own projects when I have a slow period. It's nice to have a story idea I can pursue over a longer period of time.

What do you like most about your profession? Least?

What I love most is finding myself in amazing situations and meeting fascinating people and learning about their lives. There are times when I pinch myself and say, "I can't believe I'm being paid to do this job," like when I went to Vietnam with a medical student as part of a project, or riding along with a snow-plow driver during a blizzard. I love the fact that I get the opportunity to insert myself into other people's lives and come out of those experiences having learned something meaningful. That makes me a better photographer and, it is hoped, a more insightful person. I also love the opportunity I have now to shoot video or even just gather audio for my own projects. Audio adds an extra dimension to a still photo, and some projects just cry out for video.

What I like least about my profession, as a freelancer, is the business aspect, trying to sell myself as the best person for an assignment, updating my website (which I admit I haven't had time to do lately), making new contacts, and selling story ideas. Life was much easier as a newspaper photographer, where I knew all the editors and they knew me, and understood my strengths, so I was able to establish credibility after I was there for a year or so. As a freelancer, I have to constantly establish credibility with new editors.

What is the biggest challenge you face in your work?

Probably the lack of input I have into which photos get used. Sometimes I don't see a publication for months, sometimes never. That's difficult for me after having so much give and take, so much discussion every day with reporters and editors at the newspaper. I miss collaborating with reporters every day and also miss having a good photo editor to work with. Sometimes photographers can get too close to their own work, and can't be objective about their photos. That's where a really great photo editor can step in and help critique their work. I like constructive criticism, and believe it's important to becoming a better photographer. I do a lot of work for Minnesota Public Radio website, and luckily I do have an editor there I really respect.

What advice or concerns do you have for students who may want to become photographers?

When I first got into the profession of photojournalism, all I had to do was shoot good photos. Now students should have additional skills in video and audio, and be familiar with multimedia, because websites are quickly becoming the method the majority of people use to get their news. Readers once reliably picked up their newspaper with their coffee every morning, and read every section, saw every photo. Now readers sit down at their laptops or tablets and read the news much more selectively. Getting their attention requires a variety of new skills I've gradually learned from working in newspapers for years, skills that are required to get hired these days. Social media presence is also vital, but luckily younger people have grown up with the internet, Facebook, Twitter, Snapchat, etc.

One major concern I have is the downsizing of news organizations lately. So many photographers are being laid off, so trying to have a good plan B is smart. I think it's going to be much more difficult for photographers to work for a longer period of time on an important story. The short attention span of readers and editors is worrisome. I wonder if photojournalists in the future will learn the skills of good storytelling with such constant deadlines, the immediacy required to get photos out there on the web before your competitors, and then quickly moving on to the next story.

What advice or warnings do you have for students who may not become professional photographers, but as communication professionals may sometimes need to take pictures or video?

I'm sure that's already happening at most publications—reporters and other communications experts now asked to gather audio or take photos. My advice would be to learn the basics of those skills as soon as possible, and take them seriously. It's difficult to do too many things at once, so take the time to concentrate on each element of the job equally, which will mean taking photos, then the video, or vice versa. Don't try to do both at once, especially if there's also an interview. Treat people with respect. Don't just show up and start taking photos. Take some time to get to know the person, explain what you hope to accomplish. Be an observer and a listener as well as a photographer or videographer and, most of all, be a human being, not just a person with a camera. It takes a subject time to relax, and your results will be better if you're patient. And tell the truth. With all the fake news out there on Facebook and other sites, it's more important than ever to be honest, forthright, and adamant about getting the details correct.

How do you predict that the practice of professional photography will evolve in the next decade?

Well, that's a really difficult question to answer. I never would have predicted how much the profession would have changed with the advent of digital photography, with the invention of the internet, and the way people would

consume news—that it would be so difficult to separate real news from "fake" news, or that the media would be so disrespected. Unfortunately, it's too easy to alter photos, to change audio, and there are too many ways to be unethical. My hope is that photographers will fight for truth and continue to tell stories that help others understand the human condition, now more than ever, and will continue to be persistent in the face of adversity.

Advances in software like Photoshop and the web could make that more difficult—has already done so. The race to get things first often means getting things wrong. That will probably get worse in the future. Photographers have to dig in and make sure their work is truthful, even under the pressure of constant deadlines. Having time to absorb what's happening on a daily assignment, to step back and evaluate its meaning, to ask crucial questions that could add to the quality of a photographer's work, will become a luxury, not an everyday occurrence.

John Kim

Chicago, Illinois
johnkimrectangles.net

What is your current position?

Since 2012, I have worked as a staff photographer for the *Chicago Tribune*. From 2004 to 2012, I worked at the *Chicago Sun-Times*, and from 1999 to 2004, was at the *Oakland* (CA) *Tribune*.

Why did you decide to become a photographer, and what background did you bring to your profession?

I graduated with an advertising degree from the University of Illinois Department of Communications, having floated around in civil engineering for the first two years of college. I worked all four years at my college newspaper, the *Daily Illini*, as a reporter, and found my way to the paper's photography department my junior year. Realizing I did not want to become a copywriter and did not have the degree to work as an engineer, I decided on journalism. With a basic, humble portfolio of about 18 pictures, I was accepted as an intern at the *Kenosha* (Wis.) *News* after graduation. And so began my first of 20 years (so far) in daily newspaper journalism.

What does a typical workday look like for you?

Depending on the day of the week, I call/email the assignment desk an hour before my shift begins. Or, I will already have an email with my first photo assignment. It can be anything from a press conference, to an interview/ portrait of someone, to breaking news, to a sporting event, or anything else that is considered news. We do anywhere from one to three assignments a day. I photograph/video an assignment, and depending on if I need to go somewhere next or how fast they need the stuff, I will try to edit/send the

Figure 9.2 John Kim, *Chicago Tribune.*

Credit: Nancy Stone

pictures/edited video from my laptop, either on location, or at a coffee shop, or drive to the office and file from there.

What do you like most about your profession? Least?

What I like most about my work is the chance to meet new people almost every day. I often meet people on the best day, or worst day, of their lives. Raw emotions of fear, bliss, anger, grief—I am shown by strangers what it is like to be human, and it puts my own life in perspective, sometimes.

What is the biggest challenge you face in your work?

The biggest challenge I face at work is creativity in objectively telling the story. Most important is our ability to describe visually what is taking place. Anyone can take a picture of a protester walking down a street holding a sign. How do I make that picture different/better so the reader of the newspaper will want to know more about the picture and also want to read the story that often goes next to/above the story itself?

What advice or concerns do you have for students who may want to become photographers?

Decide what kind of photography you want to do. Do you want to work as a daily journalism photographer? Do you want to only do long-term documentary work? Do you want to photograph fashion? Do you want to photograph inanimate objects most of the time? There are many facets of "photography," but it takes a certain kind of masochism and drive to want to work as a daily news photographer.

Also, have skills. The more you know about computers/smartphone technology/editing software/coding/etc., the better your chance of getting hired in doing full-time work—anywhere, but especially at a daily news publication.

Know video (at least for now). Seven out of ten photo assignments I do also have a video component (meaning I film, edit, upload). Sometimes, video is all the assignment desk wants, for whatever reason.

What advice or warnings do you have for students who may not become professional photographers, but as communication professionals may sometimes need to take pictures or video?

Know the basics of how to do photography. When at an event, look for big, look for small, look for details, look for something out of the ordinary, given the situation. You can do all the kinds of pictures with an iPhone that one normally does with a DSLR.

However, if you are working in a communications field, have ethics. Especially now, and going forward—we need to tell truths, not half-truths, or "alternative facts." If you take a picture or video—do not mislead, do not make up things to make your content prettier, or more palatable, or less crappy. Tell it like it is. Don't be a jerk and lie. You do not deserve to have any job in any communications field if you think lying is okay.

How do you predict the practice of professional photography will evolve in the next decade?

The practice of photography will evolve with technology and how people consume visuals. The practice of photojournalism will become a rarer field of work, as there really are not many jobs left in daily newspaper/wire photojournalism. That is why it is important to have several skills related to photography: video production/postproduction, sound editing, computer software, coding/technology, ability to stay up to date on related technology and an efficient workflow.

Melissa Lyttle

Los Angeles
melissalyttle.com

What is your current position?

I'm an independent visual journalist based in Los Angeles, and president of the National Press Photographers Association (NPPA) (2017).

Why did you decide to become a photographer, and what background did you bring to your profession?

I thought I wanted to be a veterinarian. I was taking a lot of upper-level math and science classes and needed an elective one semester my sophomore year of college. So I took a B&W darkroom class because it fit my schedule, and it derailed those plans immediately and changed everything—including how I saw the world.

Figure 9.3 Melissa Lyttle, independent visual journalist.

Credit: Melissa Lyttle

What does a typical workday look like for you?

As a freelance photographer, if I had to guess, only about 20 percent of my time is actually spent making pictures. Most of my time is spent in front of the computer: researching ideas for issues I want to photograph, or fellowships and grants I'm interested in applying for, tweaking my website, updating my blog, Instagram, and Twitter (marketing!), and putting together promotional materials to introduce my work to and attract editors.

What do you like most about your profession? Least?

What I like most is that I feel like I'm constantly learning and growing, both creatively and as a human being. I'm able to pursue topics I'm interested in, and find ways to tell stories creatively. I'm also always getting to meet new people and see new things, because a camera is almost like a passport into any situation. What I like least is that the rates haven't changed much in the editorial world in the last 20 years and it's getting harder and harder to eke out a living as a professional photographer. With the proliferation of images online, and the fact that everyone fancies themselves a photographer these days (with that camera, aka an iPhone, in their pocket), it's really forced me to dig deeper into things to separate myself from the pack.

What is the biggest challenge you face in your work?

Getting people to fund work is one of the biggest challenges. Most editors will assign things in your area when it comes down as an idea from their staff writers or editors, but they don't want to pay for something a photographer conceives of until that work is complete, which makes it tough for a

photographer to make a living. Most of us end up self-funding work in hopes of making a little of it back by selling that work someday. It's a risky business model, for sure.

What advice or concerns do you have for students who may want to become photographers?

My advice is simple: study the past, but create your own future. Learn about the history of photography, ethics in journalism, and media law, and be inspired by the work of those who've come before you, as well as your contemporaries. Figure out why you like an image. But then be interested in other things. It's all those outside interests that are going to inform the images you make. It's the ideas that are going to separate you and carry your work. The worst thing in the world is to see a talented young photographer with no passion, and no interests outside of photography.

I would also say this: it's not the gear that makes you good. A camera is just a tool. It's a box that lets in light. Great photography is about moment, light, composition, and mood—not what you shot it with.

What advice or warnings do you have for students who may not become professional photographers, but as communication professionals may sometimes need to take pictures or video?

There is no such thing as objectivity. We're not robots devoid of feeling and thoughts. Instead strive to be fair and truthful when reporting a story. The same goes for photography and video. Everything you do behind the camera, from how you frame a scene to how you light it to the angle you choose to shoot something from says something about you and reflects upon subject.

How do you predict that the practice of professional photography will evolve in the next decade?

The obvious answer is that technology is going to continue to evolve, and get faster, smaller, and more interesting. Embrace change. If not it'll leave you in the dust.

Uwe H. Martin

Hamburg, Germany
uwehmartin.de

What is your current position?

I am an independent visual storyteller, slow journalist, and educator. I am a member of the collective Bombay Flying Club (www.bombayfc.com), an audio-visual house specializing in web documentaries, and a cofounder of Riff Reporter (www.riff-development.de), a new ecosystem for independent journalism. I work nearly exclusively on my own long-term projects that combine photography with documentary film, text, and sound. These

Figure 9.4 Uwe H. Martin, visual storyteller

Credit: Uwe H. Martin

projects build bridges from traditional journalistic publications in magazines and newspapers, over linear web-documentaries (such as *Texas Blues*) and an interactive app, to spatial installations at art institutions.

Besides my own visual projects I have established a strong identity as an educator at several universities, journalism schools and workshops around the world, as a mentor to young journalists and photographers and as a speaker on topics such as transmedia storytelling, slow journalism and fragmented narratives.

Why did you decide to become a photographer, and what background did you bring to your profession?

I have always been interested in politics, societies, nature, and diverse cultures. So after high school I traveled for a few years in Asia. In between my trips, each lasting about half a year, I worked in a bunch of different jobs, from construction to assembly lines, from dancing in a theater to promoting stupid shit, from selling cameras to working as a chef and waiter in heavy-metal clubs and fine dining. This combination of travel and odd jobs became my informal education. I learned how to navigate in foreign cultures and talk to people in all walks of life, from academics and artists to construction workers, fishers, and farmers. I began using photography just like every other tourist does, but eventually realized that I could convey what I experienced on the ground better through pictures than words. So I did an internship with Bernd Arnold, one of the most interesting photographers in Germany. Later I studied photojournalism in Hanover and, with a Fulbright grant, at the University of Missouri School of Journalism. Since the beginning of my formal education, it was clear to me that I want to tell complex global stories about climate change, nature, food, and social justice. In order to achieve this I had to go beyond the constraints of traditional editorial assignment journalism. So I slowed down to really understand a story and its complexities. I try to create an arc of different publications, from magazines to fractured narratives in art installations, where the audience spends hours constructing their own narratives from the material.

What does a typical workday look like for you?

There are really no typical workdays. Rather I fill a few typical roles.

On the road: I travel between three and six months per year for our own projects. I research, photograph, film, interview, and write. Mostly I am doing all this alone. As it doesn't make sense to try to shoot video and pictures at the same time, I often concentrate parts of the day to one specific task. To get the quality I strive for in photography as well as video, and especially to really understand the story, I work very slowly and stay an extended period of time. For each chapter of our "LandRush" project (www.landrushproject.com), for example, we spend a minimum of two months on the ground, and we often return as the story develops. And we stay in a constant cycle of research, production, and publication.

In the office: When not traveling I mainly work on postproduction, research, or financing of our projects. This includes editing pictures and films for grants, magazines, web documentaries, our iPad app, and multichannel installations for our exhibitions. I write texts for magazines and newspapers, but much more often for grants. I spend a lot of time reading books and articles on a broad range of topics. I have given up on trying to implement a regular daily routine, except to take at least one hour off for a walk with my wife, where we discuss our project, politics, etc., or just let go and think.

Teaching: I teach a bunch of very intense multimedia storytelling workshops at many different journalism schools, programs, and universities around the world. Workshop days are long, starting at 9 a.m. and often ending at about midnight.

What do you like most about your profession? Least?

I love that I constantly learn new things, meet amazing people, and am allowed to be a permanent student of life. It is inspiring to stretch beyond the realm of journalism and into the context of art. I am very grateful that I am able to concentrate on my own projects. So since 2011 I haven't worked a single day on things I didn't care for. (Except paying taxes, etc.) I love teaching and helping students to develop their own voice. I do not like all the complaining among journalists about how bad the journalism field is. There are so many possibilities to do great and important work. It is just a changing landscape. What makes it difficult at times are the traditional roles in magazines that give too much power to writers compared to photographers. This is even the case when the photographer researches a story for month, and the writer only comes in at the end. Still, the writer is the one who determines the direction of the story. This works well if you have a writer who respects the photographer's expertise and collaborates in a team. If the writer is too arrogant and ignorant, though, it hurts the story and leads to mediocre publications.

What is the biggest challenge you face in your work?

Having enough time to work on my most important ideas. There are so many distractions that want immediate attention. So making time for my

important long-term ideas often means working long hours. This eats away valuable time for family, friends, and private life. And often leaves me exhausted.

What advice or concerns do you have for students who may want to become photographers?

You really have to want it. Nobody is waiting for you. There are thousands of talented people out there. If you are not ready to push it harder than your peers, you probably will not rise to the top, most likely not even to a self-directed position. You will probably not make a fortune anyway, and it will take years to get into a somewhat stable position financially.

Today taking great pictures is no longer enough, but just the starting point. You need skills in other areas as well. Be a great storyteller, know how to shoot video, and understand how it is different from photography. Become an expert in one field of interest, be a great business person, client oriented. Dive or fly drones. You don't need to be all of this at once, though. Being a jack-of-all-trades mostly leads to mediocre results in most areas.

If you do film, photography, and text, you need to triple your time on the ground, plus the time in post-production. You can do this by working in a team, or invest the time yourself by taking on different roles. But never fall for the illusion and dreams of the bean counters on your client's side: that you can do it all in the same short amount of time. This will lead to a pile of garbage, and your brand and business will suffer.

You have to create your own market and destiny. Security, even in a regular staff photography position, is a myth. Not many staff jobs are left, and the ones that are, are often more insecure than being an independent photographer. Keep your cost of living down. Don't buy the newest cameras all the time. They are often only liabilities. Better to save the money and fill your "kiss my butt" bank account. This is a bank account that gives you freedom to say "no" to ridiculous offers or jobs that don't advance your career. It is your insurance if you fall ill, or just need time off. Depending on your situation there should always be enough money to live at least six months or a year. Make it a priority to fill this first.

The most important question is: What do you have to say? What are your questions, your concerns, your topics? Concentrate on them and build your identity, brand, and business around them. If you do this, this is still a dream job.

What advice or warnings do you have for students who may not become professional photographers, but as communication professionals may sometimes need to take pictures or video?

Photography (be it still or moving images) is a language. Almost everyone today knows it to some extent, just like reading and writing. But this doesn't mean everyone is a writer, nor a photographer. To write an article for *The New York Times* or a book, you'd better ask someone who really has the skill. And

Shakespeares are rare. Same is true for photography. If it is just to document something to the extent of "this is what it looked like, and I was there" you can do it yourself. If you want to communicate an idea, though, open up a meaningful discussion, or add an interesting thought or question, either work with a professional or invest a few years really learning the language of photography, its many forms and hidden traps.

How do you predict the practice of professional photography will evolve in the next decade?

If I knew I would be a millionaire. Photography in all its forms changes so fast and will continue changing fast. I believe that the only thing that stays is that people like to experience great stories. They liked them in the caves, in Athens and Rome, from traveling bards and hakawatis, books and magazines, to the epic films of Bollywood and video games. So studying and investing in storytelling is probably a good idea. The medium is only a means to tell the stories.

When it comes to professional journalistic photography, I could imagine two major things in the near future: the Instagram-influencer revolution continues (not necessarily on Instagram); an analogue revolution (not on analog film) of storytelling begins. Photography is becoming an event, and photographers tell their stories directly to the audience. Viewers pay to meet the photographer, to get something real and tangible. So it might go back to the traveling bards and hakawatis, to the bookstores, community centers and market places. Because in times when war is waged on facts, personal experience and direct access to a witness becomes all the more important.

Doug Menuez

Red Hook, New York
menuez.com

What is your current position?

I'm a freelance documentary photographer with my own company. I take commissions from advertising, corporate, and magazine clients as well as producing long-term documentary projects. I also have a company developing content from my approximately 1.5 million image archive, such as documentary films, books, exhibitions, and education programs.

Why did you decide to become a photographer, and what background did you bring to your profession?

I was a photographer from the age of 10 when my father gave me a 35mm camera. Built a darkroom at 12 and was getting paid to shoot portraits for family friends and news for local papers. I apprenticed in a studio at 15 and went to art school after high school, and then switched to photojournalism and was full time on newspapers by 23. I was always obsessed and in love with photography, so it was a natural progression.

Figure 9.5 Doug Menuez works on location in the Congo with famed anthropologist Jane Goodall.

Credit: Doug Menuez

What does a typical workday look like for you?

Every day is different depending whether I'm on the road shooting with a crew or at home where I have a studio for printmaking, editing, and production. A lot of time is spent researching, invoicing, and producing projects. Shoot days are widely varied and can be anywhere in the world, and can be complicated with crews of 10 to up to 60 people. Lots of travel time in between.

What do you like most about your profession? Least?

Being able to use my talent and skills to create an image that can connect with viewers in some meaningful way. Building a business out of what I do for love.

What is the biggest challenge you face in your work?

Right now the destruction of the business model I grew up with and that allowed me to provide security and a home for my family, put my kid through college, and produce projects that benefited worthy causes. That was based on copyright. Plus the competition from all the billions of brilliant young photographers who are fighting to create their own path but were now raised in the digital age where the value of images has dropped to almost nothing due to the loss of trade practices built on respect for copyright—a concept that came from our founding fathers in the Constitution.

What advice or concerns do you have for students who may want to become photographers?

First, figure out what you have to say and what you see that no one else does. Figure out what gives you absolute joy and hone that like a laser. Then learn basic business skills and develop a plan for generating income from

your photography. Find your niche. And remember that whoever wants it the most can have it. Despite all the obstacles, if you are willing to sacrifice (sometimes everything you have) you can make it as a photographer. You have to really want it.

What advice or warnings do you have for students who may not become professional photographers, but as communication professionals may sometimes need to take pictures or video?

This is kind of hard to answer. Having fought all my life to make a living from my photography, it's just alien to imagine it as a sometimes thing. Having said that, my advice would be to learn as much as you can, even if it's rare that you do it, so your images will be as accomplished as possible. The biggest problem today is the something like a billion images a day being uploaded to social media, and 99.9 percent of it is really, really bad imagery. The net result is probably a dumbing down of our visual literacy, a kind of societal lowering of comprehension. The upside is that anything decent really stands out. So if you can really learn to shoot well, you will better serve your viewers with images that more effectively communicate the information.

How do you predict that the practice of professional photography will evolve in the next decade?

On the one hand, I predict the pendulum swinging back to those with an original eye, with something to say, who create powerful images. They will again have the leverage we once had to build fair-trade practices that generate decent income. On the other hand, technology is developing so fast, such as Google Glass, that it's hard not to see further disruption and a shift away from how we perceive and use photography today. We kind of joke that now with iPhones/camera phones everyone is a photographer. And you can see on Instagram new users actually starting to improve with composition and lighting. The learning curve is getting flat. So maybe everyone really will be a photographer, although I still think there will be a gap for those who truly have an eye and bring images that grab your heart.

Eric Seals

Detroit, Michigan
ericseals.com

What is your current position?

I'm a photo and video journalist at the *Detroit Free Press*.

Why did you decide to become a photographer, and what background did you bring to your profession?

I wanted to see, experience, and feel the news going on in front of my eyes. I wanted to be that witness, to show and tell others what is happening in front of them and how I see it.

Figure 9.6 Eric Seals photographs a track-and-field competition at the 2016 Summer Olympics, Rio de Janeiro.

Credit: Dan Powers

The background I brought to my profession has first been an intense curiosity about people, how they live, what they do, and how it affects others. My education at the University of Missouri was also a great background of learning and training to help take me to the many places, assignments and experiences that I've had in 24 years as a photojournalist.

What does a typical workday look like for you?

I usually will get one or two assignments a day at the *Detroit Free Press*. My paper has had a great track record for decades of loving and respecting the power of the visuals. Our gatekeepers (picture editors and director of photography) make sure that we get plenty of time to work on daily assignments and video stories and not feel rushed about it.

I do video storytelling and documentaries as well for the *Free Press*, so depending on what story I'm working on I'm often freed up to just concentrate on shooting, interviewing, and/or editing my stories for days or weeks at a time.

What do you like most about your profession? Least?

Being curious is what I love. Having that awesome opportunity to be paid to be curious about people in my community or around the world and tell their stories is the most special thing about being a photo and video journalist.

I also love the freedom to be able to find my own stories, the amount of time I'm given to work on them, the dialogue and constructive criticism from colleagues in photo, and the collaborative effort with other journalists at my paper.

What I like least? Right now, and I hope it won't last long, it is the uncertainty going on in the newspaper world, not just at my paper but papers in general around the U.S.

What is the biggest challenge you face in your work?

The biggest challenge right now for me is trying to find a deep and good social issue story to sink my teeth into while still also working on short video stories and the other world I live in as a photojournalist, and my love for that as well. The balancing act going in and out of both worlds can be wobbly at times, but working at the *Free Press* where I get that time to dive into a deep story is just fantastic.

What advice or concerns do you have for students who may want to become photographers?

My advice for students who want to become photographers is to *embrace video*, know it, and do it well from the short day-turn videos to longer pieces. In this job market, just being a photojournalist who can make good storytelling pictures or picture stories, writing good captions and being a good journalist overall doesn't cut it anymore. The powers that be are looking for good people that can do it all.

The other thing I'd mention to students is to be careful what you put on your social media posts. As simple as this may read, you need to ask yourself, "Would my mom and dad be happy with this picture or post I'm about to make?" If it's not good enough for your parents, then consider that it's not good enough for the newspapers you want to work for. When looking to hire for a job or even an internship, editors are looking at those posts mainly because they want to protect the integrity and professionalism of their newspaper and the journalism that it does.

Many papers have social media ethics policies and even though you might have a private Facebook, Twitter, or Instagram page not affiliated with your newspaper you just need to be very careful.

What advice or warnings do you have for students who may not become professional photographers, but as communication professionals may sometimes need to take pictures or video?

My advice is don't think of video, photography, or photojournalism as an afterthought. Visuals are so important for newspapers, especially for online.

There are so many demands put on reporters these days between writing, tweeting, short video clips, and sometimes taking pictures with their iPhones. Balancing all this out in real time can be a hair-pulling struggle. I know because I've seen it first hand at my newspaper.

When it comes to shooting a quick picture at an event, just learning the simple basics of composition, exposure, and filling the frame with the subject can be helpful. I'd encourage those people in a position like that to go to their photo staff and ask for help. Nine times out of ten other photojournalists would be more than willing to offer tips or shooting advice because often having a reporter out on an assignment (depending on what that assignment is) can free them up to spend time on another assignment that requires more time to make good storytelling pictures.

How do you predict that the practice of professional photography will evolve in the next decade?

Over the next decade I see the strengthening of the story and the story having more dominance on our readers over the fluff, quick hits, and click-bait pictures, headlines, and overall product that newspapers have been doing for the past few years.

I hope that we'll see more readers seeking meaning in the stories they see, the pictures or videos they look at. I'm hoping newspapers will see the great importance to tell more stories that have impact on their readers and that will keep them coming back for more of that kind of good journalism.

And if we go to this trend, then the visual burden and responsibility of more impactful stories will fall on us. We will need to be more in tune with issues going on in our community, and we must have a great command on how to shoot and weave a story to capture and hold on to the attention of our readers.

Erin Sutherland

Washington, D.C.
erincarly.com

What is your current position?

My official title is "Videographer/Editor," but I work as a videographer, editor, still photographer, graphic designer, and occasional media instructor for the International Brotherhood of Electrical Workers (IBEW) in Washington, D.C.

Why did you decide to become a photographer, and what background did you bring to your profession?

I think I've always been a photographer. As a kid, I was driven by a desire to remember. Then as a graphic design student in college, I was driven by a desire for others to be informed about the world around them, so we would never forget. An internship at NBC News in New York City started out as a promise to learn news graphics but instead turned into a photo-researcher position where my eyes were opened to world events as they were happening on the AP wire. I knew then it was too late to change my major but hoped by pursuing photojournalism on the side I could someday make the leap. I

Figure 9.7 Erin Sutherland photographing in Iceland.

Credit: Scott Sutherland

spent five years working as a designer and moonlighting as a photographer with this knowledge that I was in the wrong field, trapped by a degree, rent, and a lack of experience.

The conscious decision to pursue photography as a viable profession—and not just a side-project dream—first hit me while attending a lecture in honor of Margaret Bourke-White's birthday, and then solidified at the Missouri Photo Workshop in 2008. I left both with the feeling of "this is what I am to do with my life." That year I applied to photojournalism graduate programs and began my new life as a photographer.

The background I bring to my current profession as a Jill-of-all-trades is the product of years of experience in a variety of industries and interests. Before I was a graphic design student, I was a writing major. As a designer, I worked in news, architecture, and advertising. In a previous life, I was a singer/songwriter, recording and producing my own music. Moving into visual journalism felt like a natural next step—combining photography and design with writing and sound editing. My work is truly a sum of all these parts. Without every step I took in the past, I wouldn't be where I am today.

What does a typical workday look like for you?

My job doesn't really have a "typical" workday. On days when I am in the office I could be editing a video project that we shot in the field, shooting messages

(stand-ups) with our union's president, taking staff portraits, photographing hearings on Capitol Hill, editing photos for our monthly newspaper and website, or creating graphics for sharing on social media about issues related to union life. I work with a producer who works on the logistics for our story projects, so often we have meetings about where to go next and what's coming up in our travels.

Days when we are on the road to shoot a story or project follow a general pattern, although the subject matter makes each shoot a new challenge. We often have a meeting with our local contacts when we arrive to make sure that our scheduled work is still on track as many projects involve coordination between a company and the union. For each story we shoot, we conduct on-camera interviews, gather scenic shots of the city/worksite, and try to capture our union members at work. Our shooting locations vary wildly— construction sites, offices, TV stations, national and state parks, manufacturing plants, solar fields, and more—so every project is a new adventure. We also often work at our union's conferences and our every-five-years convention, which vary in nature and change up our workdays even more.

What do you like most about your profession? Least?

I consider myself extraordinarily lucky to have found work where I get to be an in-the-field photographer for an organization I truly believe in, without the job instability in the news industry. I love that every day is different, and by the time I get "itchy" spending too much time in the office, it's time to go on the road for a story. I love that I get to travel around the country, meeting our members, and telling their stories about their work and how the union makes their lives better. But I also love that I don't travel every week. Being on the road can be difficult on your family, and I am grateful to have a supportive husband who handles the care of our young daughter and dog when I'm traveling.

What is the biggest challenge you face in your work?

One of the biggest challenges is fighting the "rut." Because I don't work in journalism directly, I feel isolated from many of my colleagues doing the same kinds of projects. I find the power of collaboration and community to be key in keeping skills sharp and ideas fresh. And now that I've been working in the same position for nearly five years, I'm feeling the need for a fresh look at the way I shoot and tell stories. Many of the workshops and conferences out there are geared towards those in the news industry, even though there are so many of us who have left for corporate communications yet still do the same work we did as journalists.

What advice or concerns do you have for students who may want to become photographers?

The best advice given to me was this (paraphrased, but true): "If you can picture yourself doing something else in life, do it. But if the desire to be a photojournalist burns in your heart and there's nothing else you could ever imagine doing, then absolutely, be a photojournalist with all your being."

In all seriousness, working as a professional photographer is a hard road. And you have to *love* what you do, because the good, stable jobs are few and far between. Often it comes down to luck in securing a staff position. Freelancing takes a ton of work just to get to the point where people call you for projects. Make a niche for yourself, something that sets you apart from all the other photographers out there. Don't worry about awards or contests to make your name. Make it with your work.

Also, apply for jobs that sound interesting and sell yourself, even if you think you may not have every qualification or that the field isn't exactly where you thought you'd work. That's how I ended up at my job. I had only produced a handful of videos when I applied, but the position sounded interesting so I gave it a shot. Here I am, five years later. The more open you are to your definition of a "working photographer," the more opportunities you'll find.

What advice or warnings do you have for students who may not become professional photographers, but as communication professionals may sometimes need to take pictures or video?

I've seen this play out over and over with friends who work in communications. Two pieces of advice, for two different kinds of communications professionals. One for the trained photographer: use your knowledge of photography to lobby your boss in investing in imagery. If there's no camera on site, recommend one. If the one you have produces images that don't live up to your boss's expectations, make your case for why it's important to invest in the quality of your work. Remind them that professionalism goes a long way in both visual and written communications.

For the non-photographers who have just been asked to step outside their comfort zone: read, learn, and do. Find a book on photography 101 or take a basic course in photography for communicators. Borrow a camera and practice with it before the event/conference, etc. you need to photograph for work happens. Preparing in advance will make your shoot go more smoothly, just as athletes practice their skills before a game. As with my advice for photographers, lobby your boss for investment in your skills. Strong visuals make your communication work more effective, and are always worth the investment in time and money.

How do you predict that the practice of professional photography will evolve in the next decade?

If I had a crystal ball to see the future of professional photography, I probably wouldn't believe what I saw. If someone had told me ten years ago I'd be working in video and publishing to the internet, I would have laughed. So, to think about where professional photography could go—I honestly don't know. I can only hope that the need remains for high-quality imagery that can stand out among the din of millions of social media photos shared every day.

One thing I do know is that unless news organizations open their eyes and see that investment in their photographers (and reporters, too) is key to the

success and veracity of their products, we're only going to see the market for photojournalists continue to contract. Staff positions will be long gone, and everyone will be fighting one another for their tiny slice of the freelance pie. Even more graduates of photojournalism programs will be making the move to corporate communications and public relations, as it'll be the only way to make a living and support families. We see it already; I just hope the bottom isn't too much further.

Paul Wenham-Clarke

Bournemouth, United Kingdom
wenhamclarke.com

What is your current position?

I am a professor of photography at the Arts University Bournemouth in the UK. I work as a lecturer, research fellow, and commercial photographer. In the last 25 years, I have made advertising images for large corporate clients, and shot documentary research projects for charities and my university.

Why did you decide to become a photographer, and what background did you bring to your profession?

I wanted to be a photographer from the age of 10! I had no interest in a desk job, or working a nine-to-five day. My life was going to be interesting, and I was very lucky, as it certainly turned out to be. I have shot commercial images all around the world, including Australia, Egypt, Sri Lanka, and the United States. In the last ten years, I have been funded by charities and as a research fellow to explore social issues in the UK. This has led me to investigate some

Figure 9.8 Paul Wenham-Clarke with one of his favorite tools, a Hasselblad H5.

Credit: Mike Gibson

very unusual social groups such as the Westway Traveler Site in London, where a group of travelers live under an elevated highway.

I was not academic at all at school, and found classes uninspiring. Many of my teachers would have put a considerable sum of money on my never being able to spell, let alone become a professor. However, once I managed to reach art college things drastically changed and my very visual way of looking at the world was suddenly appreciated. I started to feel proud of what I could do, and it gave me huge amounts of confidence. I graduated and worked as an assistant photographer, doing all the mundane tasks but learning about the industry, and at 24 became a freelance corporate photographer. I have never been out of the industry since.

What does a typical workday look like for you?

My teaching days are a mixture of group sessions with students discussing ideas or practical workshops in the studio. I love teaching, as it is a real privilege to be with so many interesting and motivated young people. I think it has kept my own photography vibrant.

My own shoot days are very variable. Sometimes for a commercial commission I have to be up at 5 a.m. and don't return home until midnight. For documentary projects, I seem to spend an awful lot of time talking to and meeting people and not taking pictures. With these kinds of projects, it's all about the access. For instance, you can't just walk into the middle of a traveler site and take out your camera without expecting a hostile response. You have to win people over and become a part of the community. That takes time. Little by little the door to a hidden world that few people see opens, and in you step. It's a thrilling feeling.

What do you like most about your profession? Least?

Being a freelance photographer you never know what the next week or month will hold. You might get the best commission of your life, or nothing at all. This is exciting but at the same time when you're married with children this is scary. I found the balance of teaching and freelancing gave me a stability to my life that I enjoyed.

What is the biggest challenge you face in your work?

With my teaching, the biggest challenge is keeping up with changes in the industry and photography art world. With documentary work the challenge for me is to find a unique story that conveys a meaningful message about our ever-changing world. I look for social groups or activities that are on the cusp of disappearing, and I try to capture them before they are gone.

What advice or concerns do you have for students who may want to become photographers?

Over my long career I have learnt lots of important lessons, but probably the most important one is to have lots of strings to your bow. By this I mean you need multiple skills that each can generate income, either singly or

combined. Often you will hear that a photographer needs to be an expert at one thing, and this is true. However, as your career progresses you need to develop other specialisms by pushing yourself into new areas of photography previously unknown to you. This way you can find work more easily and be adaptable.

If you are a species that only feeds on one type of tree, you have a big problem if those trees disappear. However, if you feed on five different types of tree you stand a chance!

What advice or warnings do you have for students who may not become professional photographers, but as communication professionals may sometimes need to take pictures or video?

Keep it simple and look at the composition and light. Always remember what the goal of the shoot is, so that the narrative or message is not lost.

How do you predict that the practice of professional photography will evolve in the next decade?

Over my career the nature of professional photography has changed massively, but I think if you treat the changes as opportunities not threats then you will do well. During the nineties many photographers found the emergence of digital retouching hugely intimidating and, as a result, lost lots of work. I instead found it exciting and learnt how to use the software and the techniques for digital composites, and had many boom years as a result. The technology has continued to evolve, first with computer-generated imagery (CGI) and then more recently through the crossover of video and stills on many high-end DSLR cameras. Very recently advertisers have come to appreciate the power of social networks and the authenticity of camera-phone images made by their customers, and not professional photographers. This presents another set of challenges for the professional, but I suggest that work made by a trained eye employing good composition and use of light will stand out from the crowdsourced image. Always learn, adapt, and change. In conclusion, watch out for and embrace new ways of working and thinking. Try to ride these new waves of technology and communication.

Index

Page numbers in *italics* refer to illustrations; page numbers with the suffix 's' refer to information in sidebars.